GW00402505

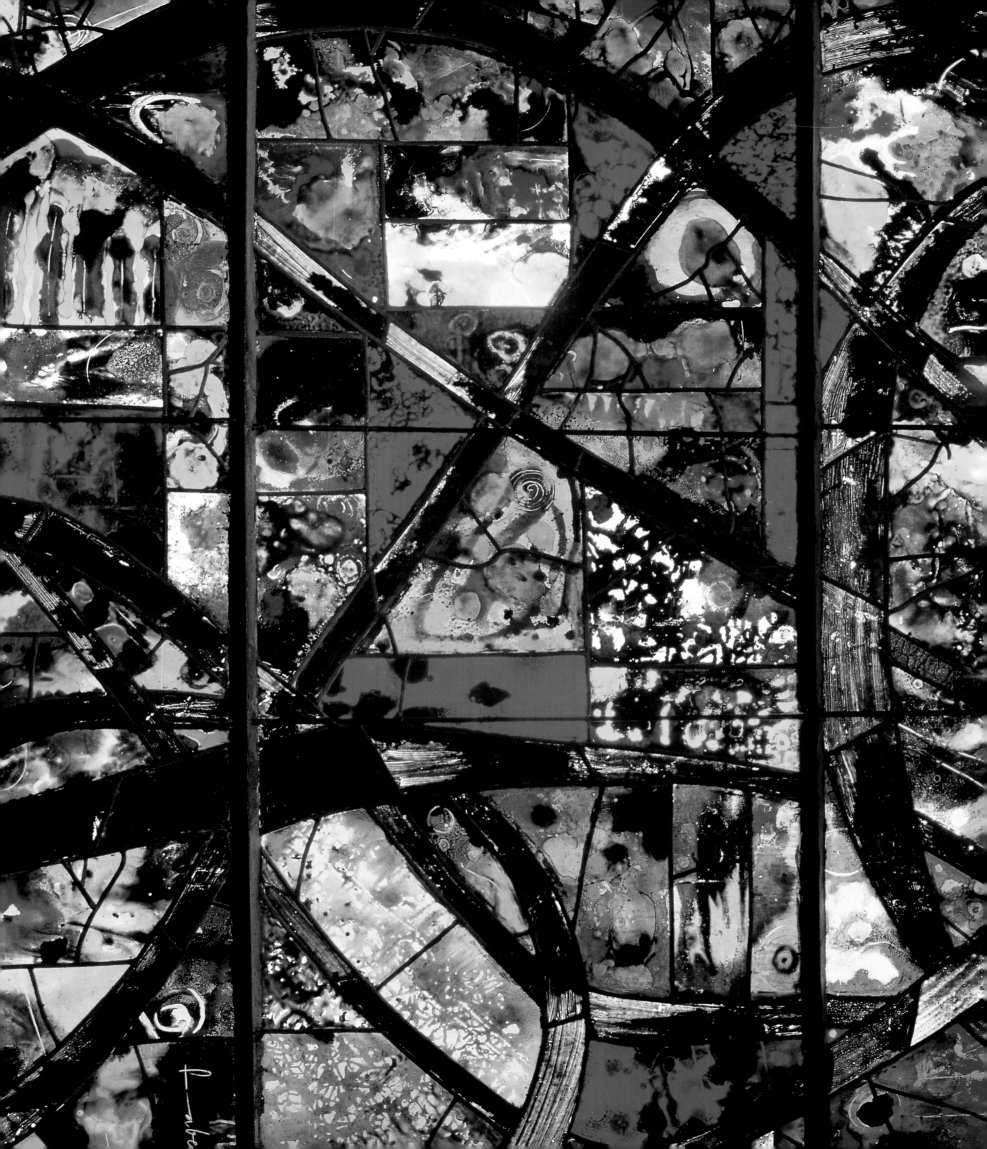

STAINED GLASS

STAINED GLASS

MASTERPIECES OF THE MODERN ERA

XAVIER BARRAL I ALTET

edited by

ANDRÉS GAMBOA

with 247 illustrations, 246 in colour

Thames & Hudson

Translated from the Spanish *Vidrieras contemporáneas* by Matthew Clarke

First published in the United Kingdom in 2007 by
Thames & Hudson Ltd, 181A High Holborn, London WC1V 7QX

www.thamesandhudson.com

First published in 2007 in hardcover in the United States of America by
Thames & Hudson Inc., 500 Fifth Avenue, New York, New York 10110

thamesandhudsonusa.com

Original edition © 2006 Lunwerg Editores
Original text © 2006 Xavier Barral i Altet
Photographs © 2007 the photographers
This edition © 2007 Thames & Hudson Ltd, London

British Library Cataloguing-in-Publication Data
A catalogue record for this book is available from the British Library

Library of Congress Catalog Card Number 2007900796

ISBN 978-0-500-51372-9

Printed in Spain

CONTENTS

INTRODUCTION

In modern society, the avant-garde has found it difficult to establish a dialogue with religious art. In 1911, when André Derain painted a large version of *The Last Supper* (now in the Chicago Art Institute), he would never have not imagined that even in 1922, the art dealer Paul Guillaume would consider that its religious subject made it unsaleable. Some years later, in 1940, an even greater master, Pablo Picasso, was offered a commission by Father Devémy to contribute to the decoration of his church in Assy (France), which boasts works by Rouault, Bonnard, Braque, Léger and Matisse. Picasso showed his visitor a painting and asked: 'Do you think this could be the Virgin?' Without any hesitation, the priest replied 'Certainly not!'– to which Picasso retorted: 'Well, I do!'

For some people, stained glass is the art of painting in space; for others, it is a way of transforming light into a combination of colours and images. The Swiss architect Le Corbusier argued that glass and windows were essential elements of new architecture. He once said: 'The material history of architecture shows that there was an insatiable struggle over the course of centuries in favour of light and against any obstacles imposed by the law of gravity: this is the history of the window.'

An architect, unlike other artists, discovers his or her essence in space, in a defined vacuum. A space marked out by walls cannot be perceived without light penetrating into it. To talk about architecture, therefore, we must not only discuss structures but also mention the light and shade that defines space. Light plays a key role in architecture and so must be taken into account when new projects are drawn up. An architect has to consider interior space and decide how to link it with the exterior, making use of elements that establish a communication between the two: windows, skylights, doors. Accordingly, glass – a transparent material through which light can pass – also takes on this communicative function.

Stained glass makes it possible to introduce variety into the light penetrating into architectural spaces. Colour, texture, transparency and placement are ele-

ments that enable an architect to create lighting effects that can enhance a setting.

In its early days, glass was made with clean river sand and potash. These materials were melted at very high temperatures to produce a vitreous paste. In the Middle Ages, glaziers would probably be responsible for the entire process of making a stained-glass window.

Various methods were used to manufacture coloured glass: substances such as metal oxides could be added to the molten vitreous paste, or the glass itself could be painted. In the earliest examples of stained glass, panes in different colours were superimposed to obtain new shades: favourite combinations were green plus red, red plus yellow and blue plus white. Red often made glass opaque, so a transparent layer would be added to introduce more light. Furthermore, when glass was blown, its thickness would tend to vary, thereby making the colours rather irregular.

Colour was also incorporated into stained glass by painting in brown or black, using grisaille, a mixture of pulverized glass, metal oxides and other colorants diluted in a liquid (originally wine was often used).

A stained-glass window would be assembled on a long, flat board covered with a full-scale sketch showing the design. This drawing would be marked with symbols indicating the colour of the glass and the instructions for treating it. The glass pieces would be cut directly on the board, using a red-hot tool. The grisaille would then be applied; this served several functions: to create outlines, to give figures volume or to modify a colour, as when strips of grisaille were added to blue to increase its opacity. Once the paint had been applied, the glass was fired once again, in order to fix the colours. The composition was then assembled by joining the glass pieces together with strips of lead (known as 'cames'), before being placed in an iron frame, prepared to fit the window. The best-known relic of this craft is the medieval glassmaker's board used for one of the central windows of the upper section of the presbytery of Girona

Cathedral in the 14th century; it is now conserved in the Museo Diocesano in Girona, Spain.

The beginning of the 14th century saw the introduction of silver stain, a colorant made of metal oxides that could be annealed to provide a wide range of yellows. Unlike the earlier grisaille, which was used to obtain different shades of a single colour, silver stain allowed craftsmen to include several composite colours on the same piece of glass. In the 16th century, when the art of stained glass was going through a period of decline, enamel was often used to decorate glass.

Stained glass was originally conceived merely to fill in windows and only later acquired a symbolic value, becoming a key feature of monumental decoration by creating a special relationship between light and space.

Stained-glass windows were one of the most important means of expression in medieval art. The innovative architecture of the Gothic cathedral was the ideal setting for stained glass, as it enabled the openings in the walls to establish a new kind of dialogue with the exterior. The first golden age of European stained glass occurred in the 11th and 12th centuries. The windows from this period are simple with bold images, often depicting saints and Biblical subjects, particularly the Virgin Mary, who was often portrayed as a queen. Ornamentation consisted of plant motifs and other decorative features that stylized the designs. Red and blue were the predominant colours in these early works. Notable examples of stained-glass windows from the 11th and 12th centuries have been preserved in France and Germany.

Midway through the 12th century, the first glimmerings of Gothic architecture could be seen, and one of the key figures in bringing it to fruition was Abbot Suger, by means of the renovation of his dilapidated abbey in Saint-Denis, France, from 1122 to 1151. Abbot Suger directly participated in the selection of the stained-glass windows created to complement the new concepts of the early Gothic style. Saint-Denis therefore ushered in a new era, resulting in a church with spectacular windows (many of which were destroyed during the French Revolution). The reconstruction of Canterbury Cathedral after a fire in 1174 is another masterpiece from this period. The most famous display of Gothic stained glass, however, is to be found in Chartres Cathedral.

It was in the 13th century that Gothic architecture spread beyond France and several major glassmaking centres were established. It reached a peak throughout western Europe due to the demand for buildings from new religious orders, but above all through the construction of cathedrals: Notre-Dame de Paris, Chartres, Amiens, Bourges, Reims and Rouen in France; Wells, Winchester, Salisbury and Lincoln in England; and Cologne, Freiburg and Regensburg in Germany. Spain was distinguished by the cathedrals of Toledo, Burgos and León; Italy, by that of Siena.

In the 13th century, stained-glass windows started to exhibit greater dynamism. The Gothic period saw a broadening of subject matter, embracing figures from bestiaries and stories from both the Old and New Testaments. The style was linear, but its lines were imbued with unprecedented expressiveness. Gothic architecture released walls from their previous rigidity, making it possible to create large windows that, in their turn, led to a new type of stained glass. This new style broke free from the darkness and enclosure of the Romanesque style, gradually spreading throughout Europe and acquiring specific characteristics in different countries. Whereas religious buildings in France became increasingly taller, in England they were distinguished by their length, and on the Iberian Peninsula by their width. Large windows were not popular in Italy and Spain, as the climate and sunlight are different from those in northern Europe, where windows took on greater dimensions, in a quest to create distinctive atmospheres involving an array of colours. These explosions of colour were sometimes frowned upon, however, as when windows with coloured images were banned from Cistercian monasteries; this obstacle was overcome by using lead cames to create geometrical forms.

Meanwhile, both France and England began incorporating roundels and, above all, rose windows, into their cathedrals, as in Chartres, Notre-Dame de Paris, Lyons

The south transept in Chartres Cathedral, France. The iconography centres around the figure of Christ, who is accompanied by his mother in the lower section and dominates the centre of the rose window.

and Lincoln. These rose windows later incorporated figurative images that complemented the stained glass in the main windows.

The epitome of French Gothic architecture is Chartres Cathedral, an enormous building with 170 multicoloured stained-glass windows, some of them dedicated to the Virgin Mary (the city's patron). This sanctuary was rebuilt in 1194, after several fires, and devotional windows depicting saints and the Virgin were fitted between 1215 and 1240. The stained glass in Chartres is dominated by blue, which changes shade according to the incidence of sunlight (p. 11). Its windows show the great importance attached to the cathedral by its benefactors, as they bear references to over fifty trade guilds who contributed to its construction.

Other notable examples in France from that period are Bourges Cathedral and the Sainte-Chapelle in Paris, which exhibit all the characteristics of the authentic new Gothic style in its stained-glass windows.

In Germany, where Romanesque churches were still being built in the Gothic period, the outstanding example of a Gothic cathedral with stained glass is to be found in Cologne, which was a pilgrimage site, as it housed bones reputed to belong to the Three Magi. The stained-glass windows are therefore dedicated to this Biblical trio. Cologne Cathedral is not, however, the only example of German Gothic architecture with striking stained glass, as notable windows were also installed in the cathedrals of Freiburg and Strasbourg and the church of St Elizabeth in Marburg.

English Gothic architecture was also distinguished by impressive stained glass. Thomas Becket, who played a key role in the English Church as the Archbishop of Canterbury, was canonized and is shown on the windows of the Trinity Chapel in Canterbury Cathedral. Also of interest in this cathedral is the group of windows depicting the so-called Bible of the Poor, although only three of the twelve original windows have survived until today. Each one combined an image from the Old Testament with another from the New (a common iconographical device in manuscripts from the period). Grisaille was frequently used in English stained glass, as seen in the Salisbury Cathedral and York Minster, which boasts the country's most famous grisaille work in the form of *The Five Sisters*, a superb set of lancet windows.

The 14th century was marked by the emergence of flashed glass, which made it possible to cover one colour with another to create a new combination. Linear images were forsaken in favour of greater expressiveness and perspective started to be used in some compositions. France had almost lost the role it had enjoyed in the previous century as a driving force in architecture, but it still produced interesting stained glass, as in the Church of Saint-Ouen in Rouen and Évreux Cathedral, where several donors are depicted on the windows (a common practice at the time).

In England, the 14th century proved to be a golden age for art in general and architecture in particular. York became an important centre for stained glass, as it contained many of the country's workshops and attracted craftsmen of a high standard. As a result, many of the cities' churches were fitted with beautiful stained-glass windows, while York Minster is a veritable treasure house with windows from various centuries, in a range of styles. Gloucester Cathedral and Westminster Abbey also boast fine examples of stained glass, while the fashion for windows with canopies provided embellishment for buildings like the antechapel in New College, Oxford.

Italy was a case apart, as stained glass took longer to establish itself there and the Gothic style developed its own distinctive features. The stained glass made in Italy did not follow the northern European model as the light there is completely different. Furthermore, it was painters, rather than glaziers, who supplied the preparatory drawings. The church of St Francis in Assisi has particularly noteworthy examples of stained glass.

In Switzerland, the now-ruined church of the Königsfelden Monastery, near Zurich, was built in honour of King Albert, whose Habsburg dynasty was heavily featured in the stained-glass windows. In Germany, the verticality and spaciousness of the Gothic style led to a breakthrough in artistic expression. Windows ablaze with reds, greens and yellows were installed in the imposing cathedrals of Regensburg, Erfurt and Freiburg – a city that was host to one of the country's earliest glass workshops. This was responsible for the windows on the façade of Freiburg's north transept, as well as one of the most outstanding elements of this 14th-century cathedral – *Christ on the Cross* with a gentle mother pelican (a symbolic image found elsewhere in medieval art).

Strasbourg, which has been claimed by both France and Germany, was an important centre for stained glass and it possesses one of the most impressive Gothic cathedrals in the whole of Europe. Rebuilt after a fire in 1176, it displays stained-glass windows from various eras, in a range of styles. The earliest date from the Romanesque period; the transition to the Gothic age is reflected in the series of kings depicted on the windows. After another fire in 1289, new windows were commissioned, the most striking being those portraying the six apostles, made from 1331 to 1332 and set in St Catherine's Chapel

The 15th century can be considered both the end of the Middle Ages in some parts of Europe and the start of the Renaissance in Italy. Humanist philosophy gradually began to emerge as a challenge to ideology revolving entirely round religion. A period of bloody warfare gave way to an age of prosperity, which was mirrored in art. The first stained-glass windows of this century barely differed from those of the late Gothic in their elaboration and extravagance. All this would change, however, under the influence of the Flemish painter Jan van Eyck. His highly realistic style was difficult to translate into glass, so traditional techniques faded away as stained glass increasingly became a mere imitation of painting. This process was difficult to reverse, as more and more designs for stained glass were commissioned from painters and sculptors, including van Eyck himself. It was also in this period that stained glass started to appear in domestic architecture, as decoration in the halls of the mansions being built on the estates of wealthy landowners. The favourite subjects were historical or allegorical scenes, often heavily laden with heraldic symbolism.

The aristocrats of the 15th century took on the role of patrons of the arts. Flanders, in particular, emerged as the nerve centre of European art, largely thanks to the efforts of Philip the Good, the Duke of Burgundy, who took van Eyck under his wing. In France, the court of the Duc de Berry, in Mehun-sur-Yèvre, near Bourges, was a magnet for artists and intellectuals, including the Limbourg brothers, who produced the illuminated manuscript known as the *Très Riches Heures du Duc de Berry*. Bourges itself was home to another famous artistic patron, the merchant Jacques Coeur (c. 1395–1456), who donated a stained-glass window of the Annunciation to the city's cathedral. This work is characterized by a com-

bination of Gothic opulence and details in the faces and angel's plumage that show the influence of Flemish painting. Coeur was one of the first to put stained glass into his own house (preserved as the Jacques Coeur Hotel in Bourges), with its magnificent window depicting a ship at sea. Bourges Cathedral was also given works of stained glass by other patrons: the Duc de Berry contributed five windows to the crypt, while Simon Aligret and Pierre Trousseau also made generous donations. France also witnessed a growing interest in incorporating subjects that were not strictly religious into the windows of churches: Angers Cathedral, for example, included images of the signs of the zodiac and the types of work undertaken in different months of the year.

The 15th century was also a boom period in Spain, and this was reflected in its monumental art. Spain had no early tradition of stained glass as the Arab presence in much of the peninsula had limited the construction of churches. This situation changed with the arrival of the Catholic Kings; the reign initiated by the marriage of Ferdinand of Aragon and Isabel of Castile encouraged many artists from abroad to settle in Spain, and specialists in stained glass could be found in Barcelona, León and Seville, where Enrique Alemán worked on the cathedral windows. Toledo Cathedral was also embellished by remarkable stained glass in this period, with the help of craftsmen from France and Germany. It has over seventy decorated windows, dominated by the large rose window in the south transept that depicts an open rose with sixteen petals. In the north transept, the oldest of the building's three rose windows portrays the Crucifixion, surrounded by the figures of the Virgin Mary, St John, prophets and angels.

England was an important artistic centre in the 15th century. The cities of York and Newcastle possess fine examples of late Gothic stained glass, on account of their abundance of parish churches. Especially striking in Norwich is the Church of St Peter Mancroft, with its large window illustrating forty-two scenes from the Bible, while All Saints' Church in York exhibits windows showing a cycle of seven works of charity. Most English stained-glass windows of this time are characterized by stylized figures, in keeping with the advances being made in local Gothic architecture, and an increasing use of pale, luminous colours.

The richness of the stained-glass windows made in Germany in the 15th century is a good indicator of the prosperity enjoyed by the country's cities. The foremost artist in this field was Peter Hemmel von Andlau, who was based in Strasbourg but produced windows for cathedrals and churches in Ulm, Munich, Nuremburg, Frankfurt and Freiburg. The crowning achievement of this golden age was Nuremburg Cathedral, one of the few German places of worship that has preserved its original stained glass to this day. Its windows do not seem to be dictated by any overall iconographical scheme, as each explores a separate theme (chosen by the donors who sponsored them).

In Italy, the artistic powerhouse was Florence, with its superb cathedral built by Filippo Brunelleschi, who managed to solve the technical problems involved in erecting its enormous dome. The building's construction involved some of the most influential artists of the day, including Lorenzo Ghiberti, Donatello, Cuello and del Castagno, who were commissioned to design the eleven stained-glass ox-eye windows. Florence also contains many churches with stained-glass windows, such as those of the Santo Spirito and Santa Maria Novella, featuring spectacular work by the painter Pietro Perugino. Over the course of the 15th century, artistic patronage moved from the trade guilds into the hands of the Medici family; meanwhile, in Milan the main promoters of artistic creation were the Sforza and Visconti families. The construction of Milan's cathedral was embroiled in controversy from the outset, as none of the plans put forward satisfied local tastes – until it was decided to install an array of stained-glass windows in the huge building. Few of these have survived until the present, and most of those now on display are restorations – or reinventions – from the 19th or 20th centuries.

The 16th century was distinguished by the spread of styles and subject matter through printing, resulting in modifications to European iconography. This period also witnessed changes in glassmaking techniques, as the development of new paints increased the range of design options. Enamel began to be used, allowing artists to apply several colours on a single piece of glass; it had the disadvantages, however, of blocking out light and quickly peeling off. Another innovation was the emergence of panels for secular use, often featuring heraldic shields or historical figures; these were usually made as personal gifts. This type of panel originated in Switzerland, before spreading to Germany and the Netherlands, where it sparked a profitable industry that evolved in line with the artistic fashions of the day.

In the Netherlands, the 16th century was marked by conflicts between Protestants and Catholics, the latter represented by the Spaniards Charles V and his son Philip II, who mercilessly pursued all those who did not share their faith. In contrast with this political chaos, art flourished, under the leadership of all-round artists like Bernard van Orley, Pieter Coecke and Michiel Coxcie. They were equally adept in painting, tapestries and stained glass, where their work reflected the trends in contemporary painting, concentrating on scenes with figures set against a landscape.

The use of stained glass and roundels in private homes gradually became more widely accepted, although there was a drop in production halfway through the century. The most important examples of Dutch stained glass are to be found, however, in the striking work of the Crabeth brothers for Gouda Cathedral (a building that contains windows illustrating both Catholic and Protestant themes, as it has served as a place of worship for both confessions). It had been burned down in 1551, but a magnificent replacement was put up in its stead, with over sixty stained-glass windows, donated by kings, clergymen and nobles. This system of sponsorship was common at the time, and donors were usually depicted on their windows, alongside religious images.

In Spain, the 16th century was marked by long-running wars with France, but artistic creation nevertheless found a fertile breeding ground (although many of the leading figures came from abroad, particularly Flanders and the Netherlands). The cathedrals in Granada, Toledo, Seville and Avila all provided opportunities for painters working with stained glass. That of Seville is particularly notable for the contributions of Arnao de Vergara and Arnao de Flandes, who forged an

Andrea del Castagno (c. 1420–57), Deposition from the Cross, *window in the drum of the dome, anonymous glass worker, 1444. Santa Maria del Fiore, Florence, Italy.*

innovative style that drew on the Italian Renaissance and Flemish painting, while adapting to the Spanish conventions of the time.

In England, the Renaissance was short-lived and many earlier stained-glass windows were smashed during the upheavals of the Reformation. Most of the stained glass created thereafter was designed by artists, many of them from Flanders (reflecting the close relationship between the two countries). The Dutchman Dirck Vellert was commissioned to produce the windows in King's College Chapel, Cambridge; Henry VIII made no secret of his admiration for Dutch artists and appointed one – Barnard Flower – as a Master Glass Painter, along with the Englishmen Symond Symondes, Francis Williamson and James Nicholson. Much of the country's stained glass from this period is characterized by its Flemish influences, as can be seen in Fairford Church, Gloucestershire, and All Saints' Church in Hillesden, Buckinghamshire.

The Flemish style also made its presence felt in Germany, even though the leading artist of the day, Albrecht Dürer, introduced ideas from the Renaissance after travelling to Italy. Dürer worked in many fields, including stained glass, and was commissioned to design the windows for the Schmidtmayer chapel in St Lawrence's church in Nuremburg. Some of his disciples also went on to be major stained-glass designers, as in the cases of Hans Baldung Grien and Hans von Kulmbach, although the discipline continued to be heavily influenced by painting.

Stained glass in 16th-century France was characterized by its substantial output and its splendour, with major influences coming from Flanders and Italy, as throughout the rest of Europe. Arnoult of Nijmegen, who worked under the name of Arnoult de la Pointe, introduced the Flemish style into France in general, and Renaissance forms into Normandy in particular. He was commissioned to create the windows for Tournai Cathedral in Belgium and the churches of St Godard and St Ouen in Rouen. Also worthy of mention are the Le Prince brothers, who produced work influenced by Dürer and Dutch art in their workshop in Beauvais. Their craftsmanship can be admired in the churches of St Stephen in Beauvais and St Vincent in Rouen. The glassmaking centres of Troyes and Châlons-sur-Marne were also

An artist working on stained-glass window designs for a Polish church in Buffalo, New York, 1930–50.

noted for the quality of their designs. In Metz, Valentin Busch, who was entrusted with many of the city's stained-glass windows, displayed a late Gothic style mixed with Renaissance elements. Stained glass also experienced a boom in Paris in the early part of the century, largely through the patronage of the Montmorency family.

Italian stained glass, however, went through a lean period in this century, as it struggled to adapt to the ideas of the Renaissance. The major figure was Guillaume de Marcillat, who worked in Rome, Cortona and Arezzo, where he produced his most outstanding works, although these can almost be considered frescoes painted on to glass with enamel. The German artist Corrado Mochis also succeeded in prospering in this unwelcoming climate by designing some of the windows for Milan Cathedral.

In the mid-17th century, England was the European country most affected by the conflicts between Catholics and Protestants. Images of the Virgin Mary and the Holy Trinity were banned, while many churches were sacked

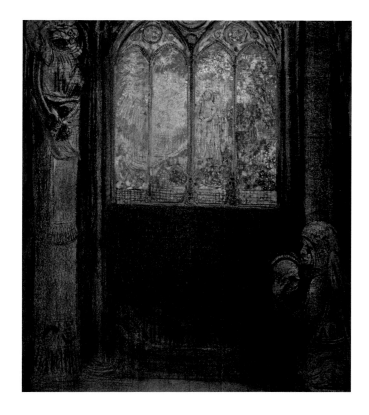

A gouache by the artist Odilon Redon, who tried to capture the spirit of a medieval interior by embellishing it with a stained-glass window with a religious subject. Musée d'Orsay, Paris.

and had their stained-glass windows destroyed. Canterbury Cathedral was particularly badly hit by this vandalism.

The Counter-Reformation also triggered the destruction of stained-glass windows. Many German and French workshops were closed during the religious turmoil. This situation led to the virtual disappearance of coloured glass, to the benefit of transparent glass or decorations painted with enamel. The Counter-Reformation fostered a baroque Gothic style that spread throughout Europe and reached its apogee in Germany and Austria in the late 17th century. Churches sought as much light as possible, to show off all their decoration, so stained glass was ruled out and gradually went out of fashion as its production dwindled.

The year 1607 marked the founding of the first glass-making workshop in the New World – in Jamestown to

be precise. There are records of various commissions in America for windows for religious and civil buildings over the course of the 17th century. One of the most prominent artists was Evert Duyckinck, who used enamel and silver stain to create a variety of motifs, including coats of arms for private houses.

The 18th century was marked by further destruction of stained-glass windows in France. Most of those that had managed to survive the Counter-Reformation succumbed to the French Revolution, which in its turn sparked off a wave of sackings of religious buildings in Europe. The only nation that remained untouched by this upheaval was Great Britain, and so some stained glass from continental Europe was shipped there for safekeeping (and much of it has remained there ever since). The 18th century was also distinguished by an almost total collapse of the production of stained glass. So it was that one of the most important chapters in European applied arts, stretching back to the Middle Ages, finally drew to a close. It was only in the following century that the technique would be revived.

The history of stained glass is inextricably linked with that of architecture. In its early days, in the Romanesque period, windows served merely as a means of allowing light and air inside buildings, and only the wealthiest patrons could afford to insert glass into them. Gradually, however, windows also began to be used to modify light, sometimes by dimming it, and at other times by intensifying it. The apogee of stained glass in religious buildings arrived with Gothic architecture, which revelled in light and height – giving rise to rose windows, side windows in naves and rows of stained-glass windows running along transepts. In this context, the height of churches was offset by new elements and entire walls were increasingly transformed into expanses of coloured glass. The addition of flying buttresses to naves made it possible to reduce the thickness of the walls and thus incorporate more windows.

Unsurprisingly, the subject matter for medieval stained glass was largely drawn from the Bible (both the Old Testament and the New Testament) – the same source of inspiration for the illuminated manuscripts and frescoes of the period, with which stained glass also shared stylistic similarities. The invention of printing broadened the medium's possibilities by eliminating the need to

make sketches on boards, as designs could now be committed to paper and stored indefinitely. Meanwhile, etching helped to spread a new iconographic language.

The Gothic style was also characterized by the emergence of tracery, the small stonework divisions which divided a larger window into smaller segments, and stained glass had to adapt to this new development. Rose windows also grew in importance. These first appeared in Romanesque cathedrals as small round openings with simple, radiating tracery, set in the western façade of the building. As building techniques became more sophisticated, so rose windows grew bigger and served as a basis for large-scale iconographic compositions and floral decoration with different forms and colours. It is important to differentiate between rose windows proper and simple oculi which lack stone tracery, their glass being supported by a grid of parallel metal bars.

Rose windows often glorify the Virgin or the Christ of the Apocalypse, but they may also portray secular subjects, such as the signs of the zodiac, the agricultural tasks performed each month or plant motifs. The emphasis in this type of window is on the luminous effect of the colours, rather than on realism or draughtsmanship. One notable example of this is the 13th-century rose window in the central nave of Reims Cathedral, in which figurative design is subordinate to the configuration of colours arranged for maximum visual effect.

After the Gothic period's passion for height and light, stained glass increasingly declined until the era of Romanticism, when a renewed interest in the Middle Ages fomented a revival of this ancient art. However, the enthusiasm for copying medieval stained glass, technically and stylistically, often resulted in little more than pale imitations of the past.

The 20th century, with its revolutionary approach to both materials and methods, finally breathed new life into stained glass. Metal structures, reinforced concrete and other technical innovations have bestowed a new prominence on windows. Walls can be freed from their role as load bearers and even be made entirely of glass. On both sides of the Atlantic, new construction techniques have integrated thick windows directly into the structure of buildings.

In the last quarter-century, a host of stained-glass windows have been installed in both new buildings and old churches in Europe, sometimes under the supervision of major figures from the world of art. This phenomenon has attracted little research, however, despite the abundance of exhaustive studies on medieval stained glass, and the creation in 1952 of an international project to catalogue it: the *Corpus vitrearum medii aevi*. As yet there is no equivalent project for stained glass in the modern era, and so in this respect the present work is a pioneer in the field.

A contemporary image of the stained-glass exhibit at the Great Exhibition of 1851 in London. The renewed interest in stained glass in the 19th century struck a chord with the general public.

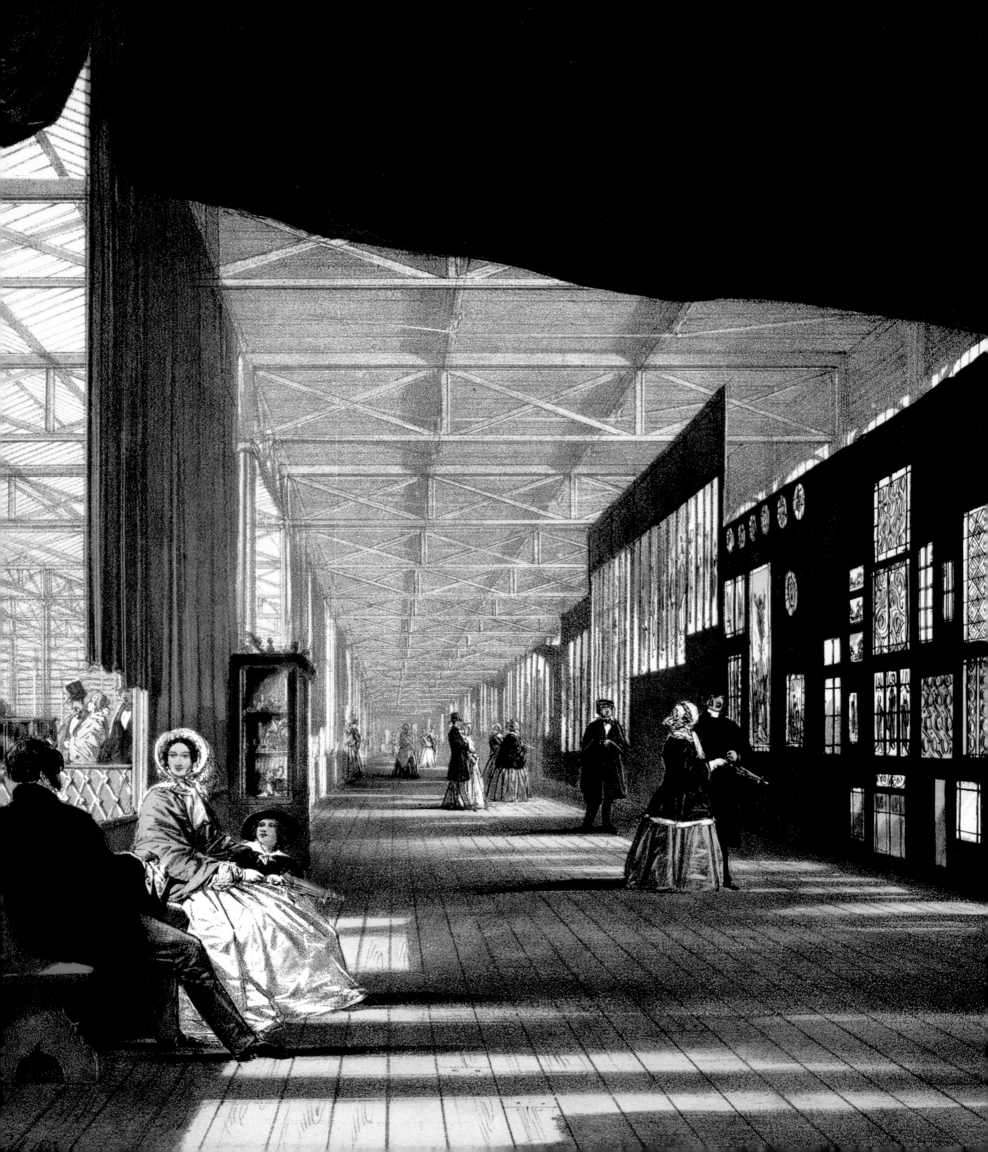

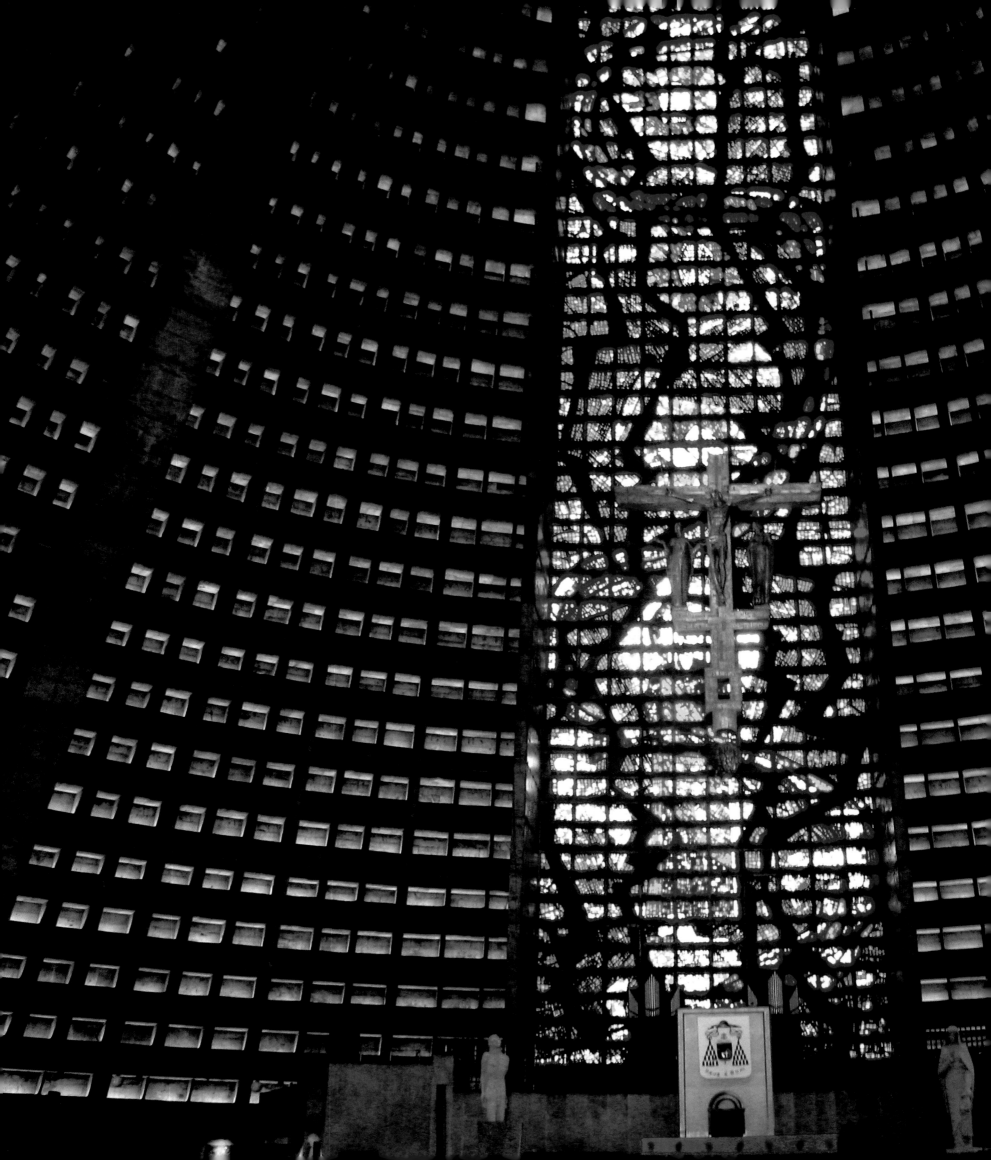

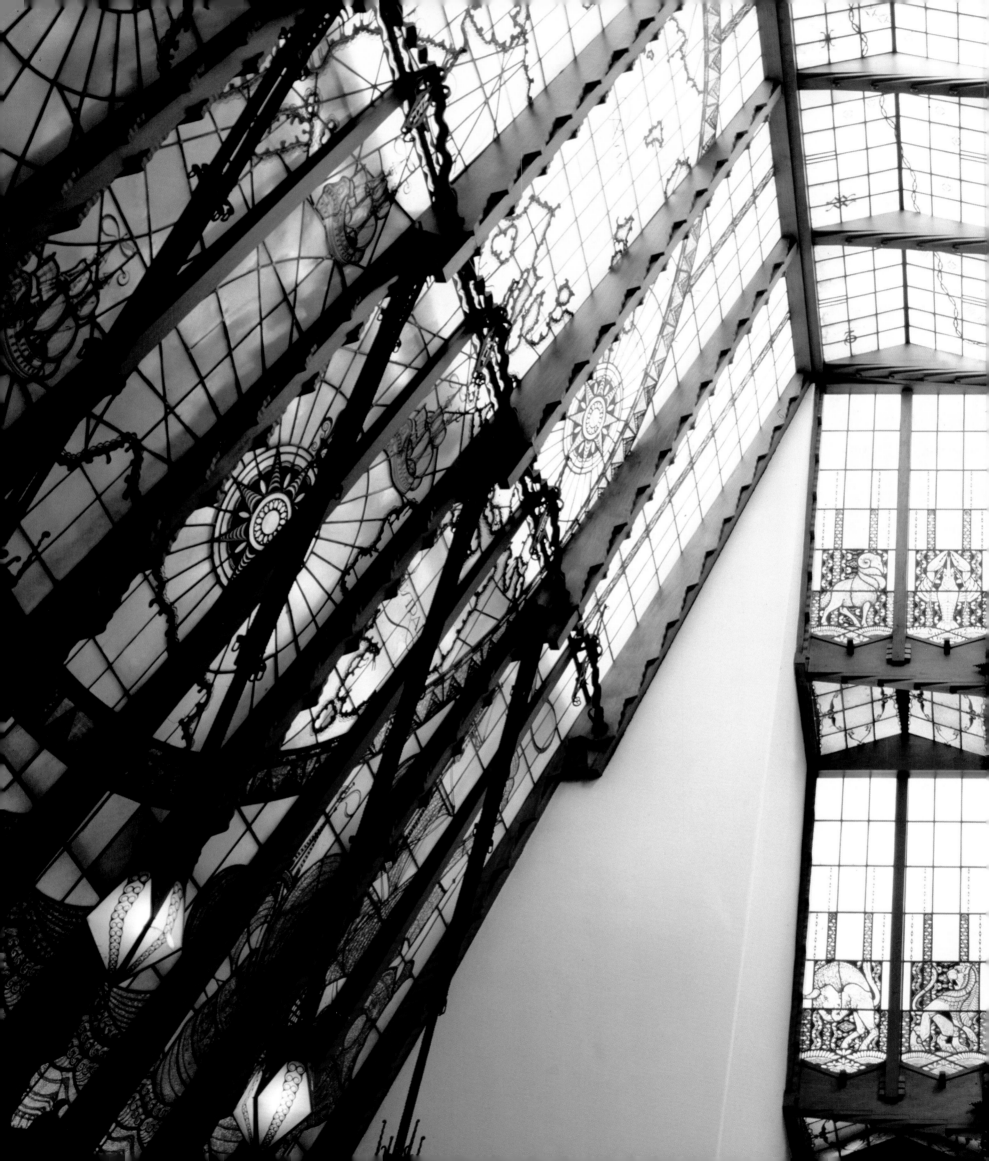

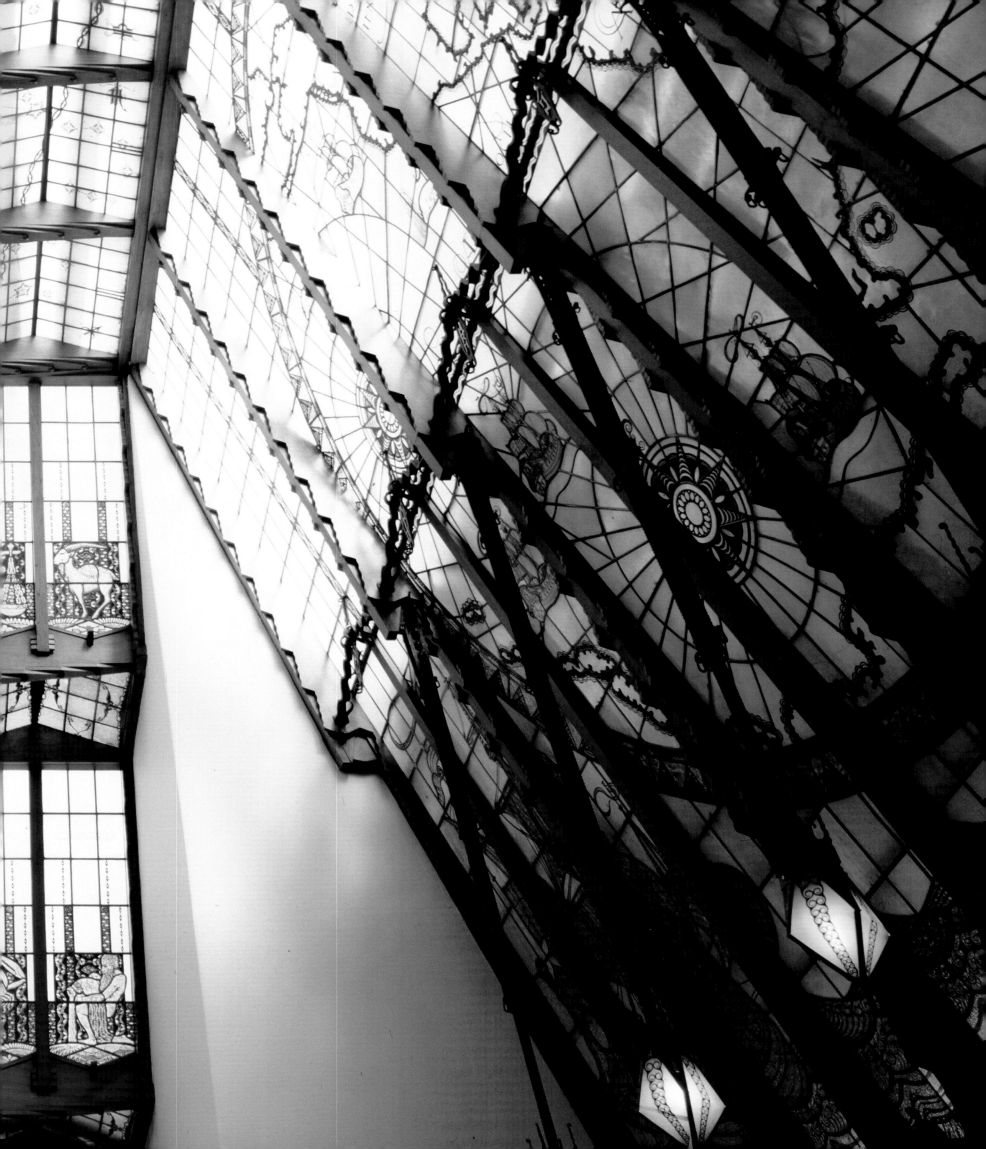

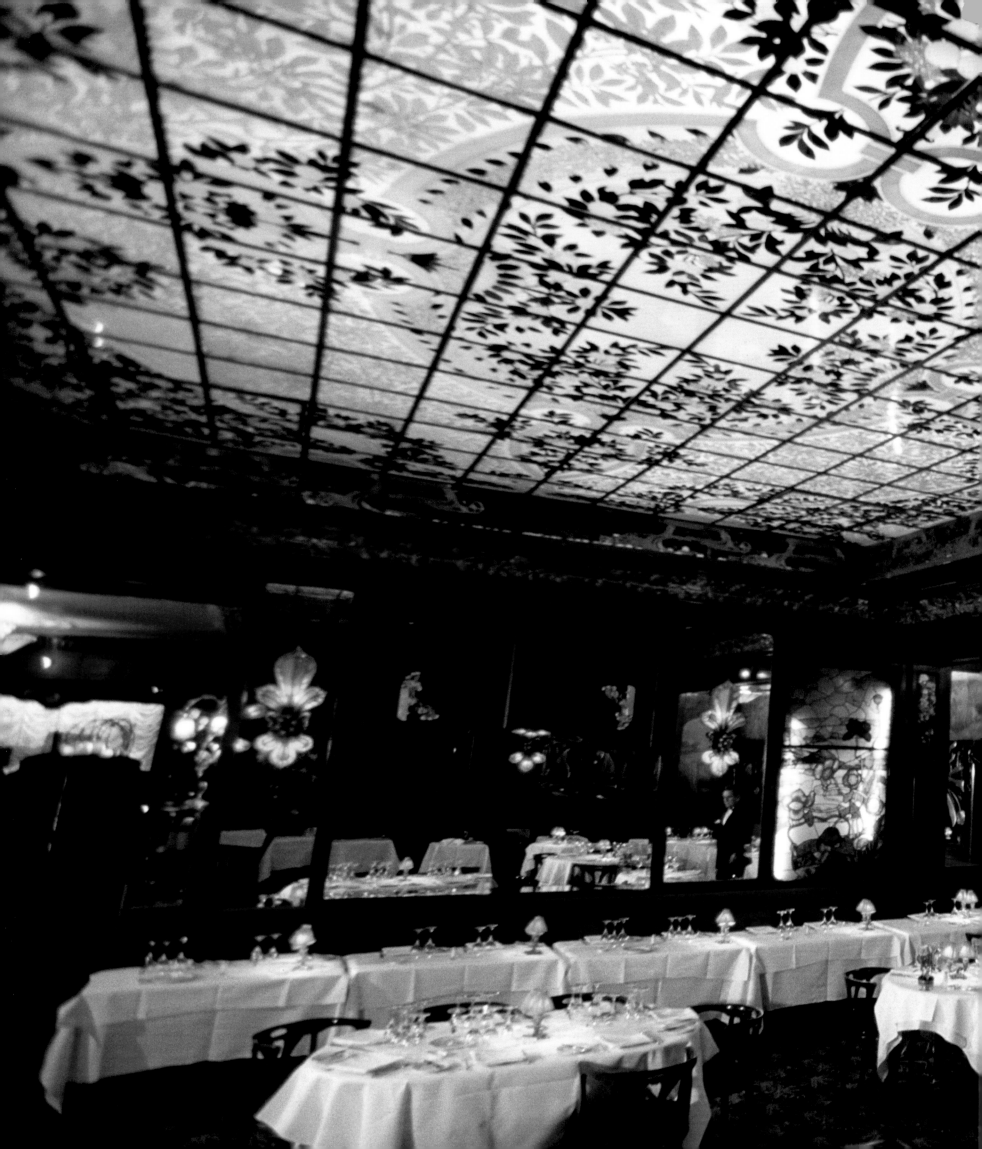

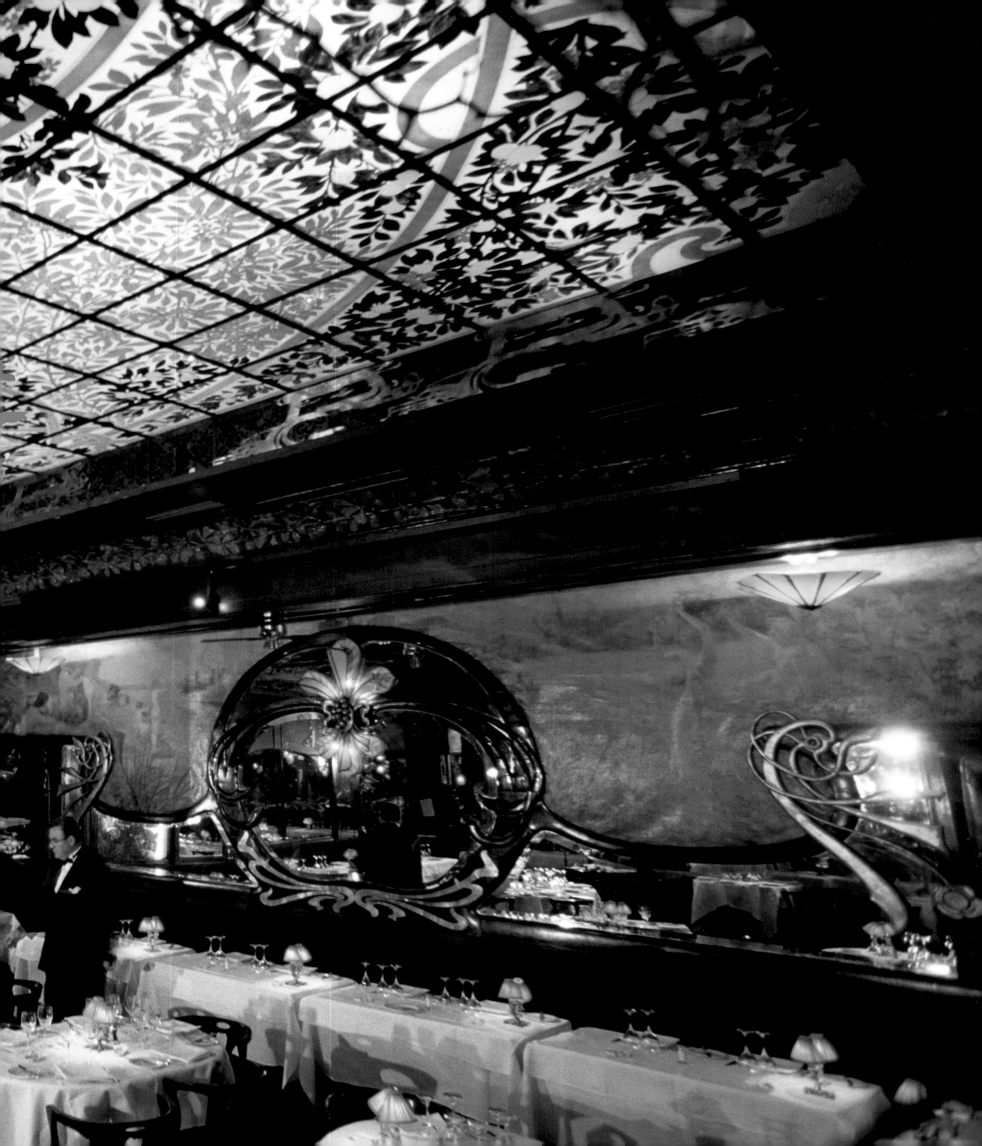

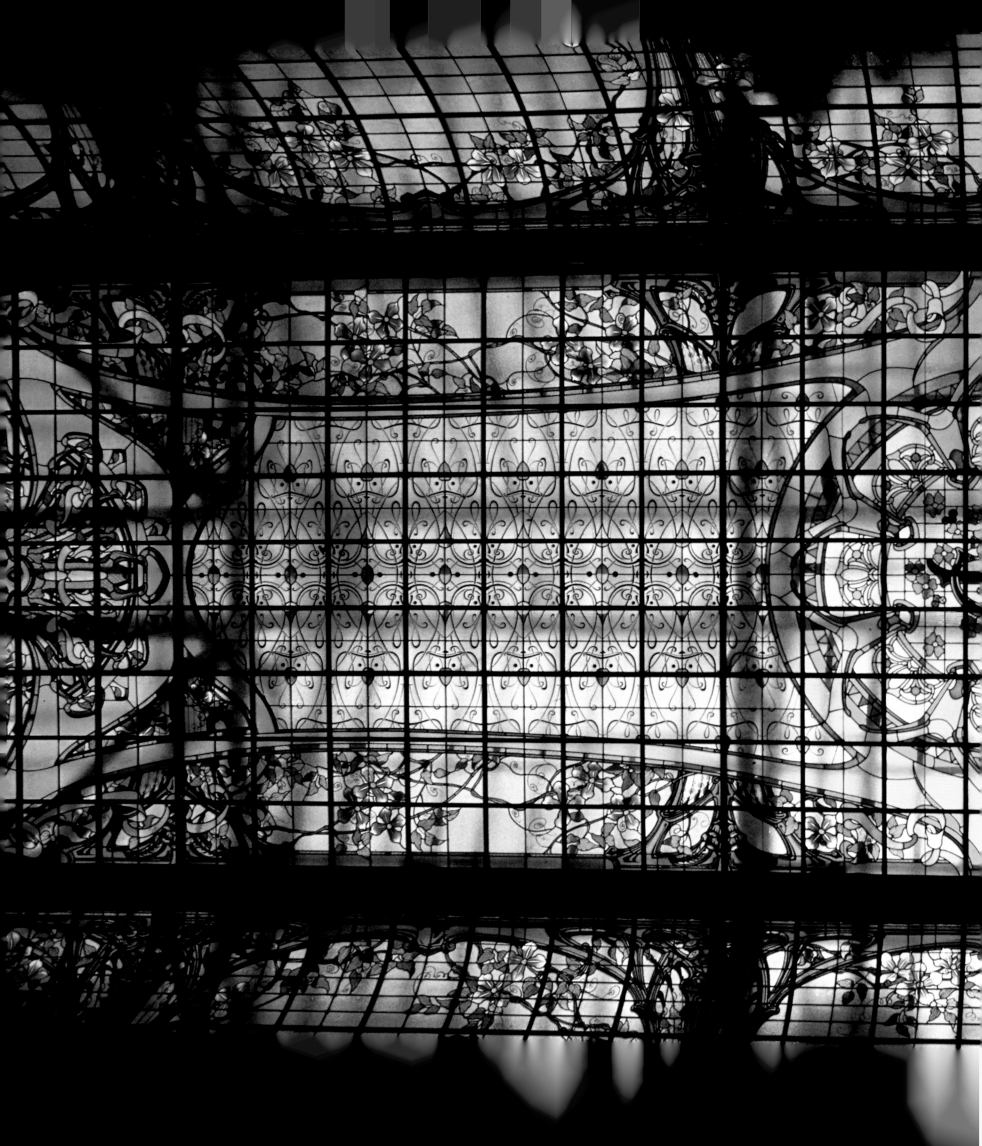

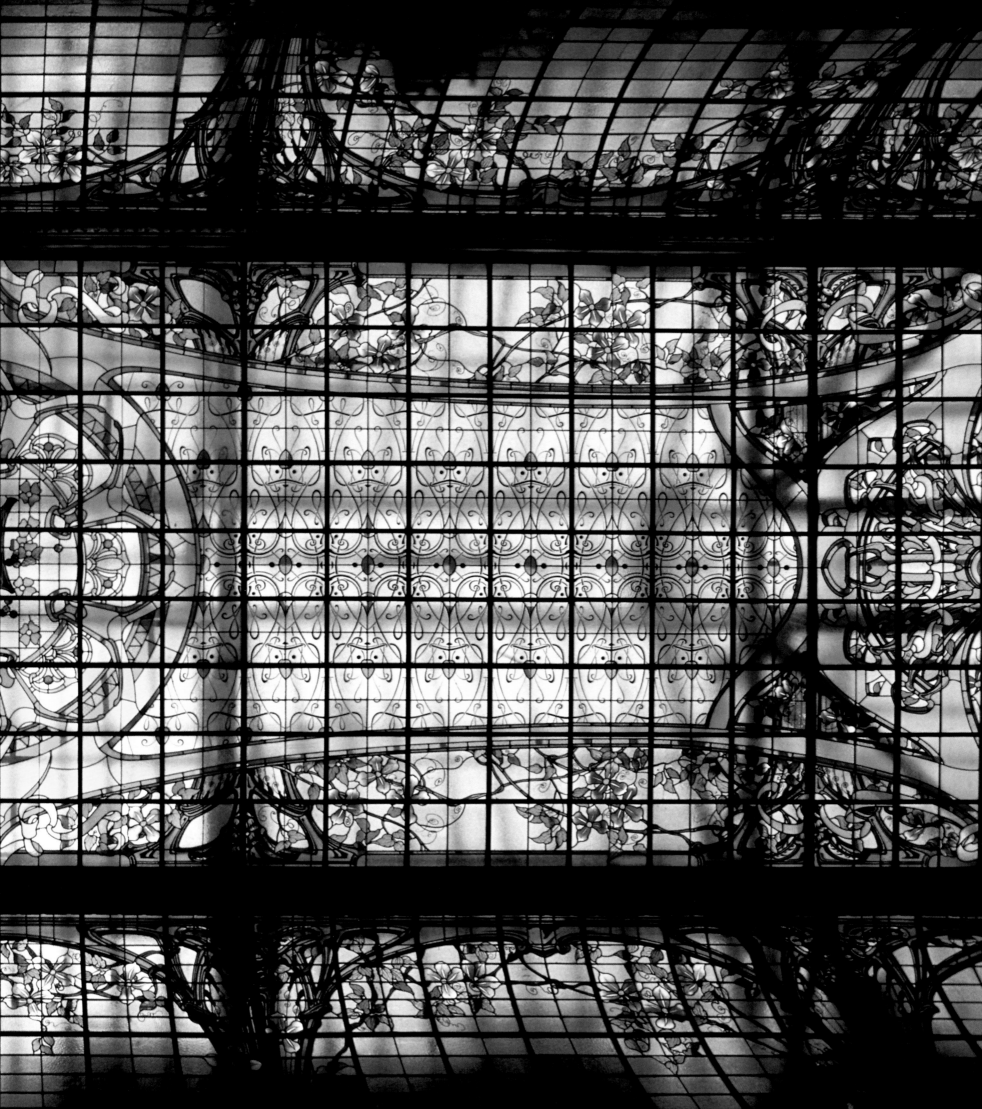

p. 8

p. 20

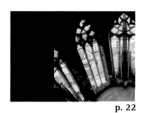
p. 21

p. 22

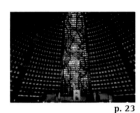
p. 23

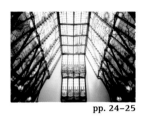
pp. 24–25

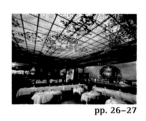
pp. 26–27

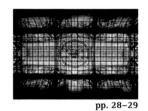
pp. 28–29

p. 8
Detail of the stained glass in Maxim's restaurant in Paris. The decorative motifs echo the floral designs by Émile Gallé that dominate the main dining room.

p. 20
In the 20th century, stained-glass windows have successfully combined medieval architecture and non-figurative art. Light and line are fused to create a new spirituality, as in this window from the baptistery at Reims Cathedral.

p. 21
An example of a geometric motif based on the juxtaposition of pieces of glass to create a design. St Philbert's chapterhouse in the Romanesque church in Tournus, France.

p. 22
The church in the marketplace of Goslar, Germany, retains the skeleton of its Gothic architecture but has lost its stained glass. Many such windows were dismounted or destroyed during the two World Wars.

p. 23
The Metropolitan Cathedral in Rio de Janeiro combines large closed areas with splashes of colour that heighten the effect of the designs on the stained glass by creating effects of contrast and perspective. Many 20th-century churches make use of these decorative devices.

pp. 24–25
These stained-glass windows, decorated with a mapamundi and the signs of the zodiac, set off the distinctive architecture of the hall in Maritime Syndicate building in Amsterdam (designed by J. M. Van der Mey Scheepvaarthuis) by accentuating the slope of the glass panes and the gradual intensification of the light as they move upwards.

pp. 26–27
Plant motifs decorate the ceiling of the famous Parisian restaurant Maxim's – an example of the use of large areas of glass to cover rooms that have blocked out sunshine in favour of indirect artificial light.

pp. 28–29
The headquarters of the Credit Lyonnais bank in Lorraine, France, preserve their glass ceiling designed by the renowned master Jacques Gruber.

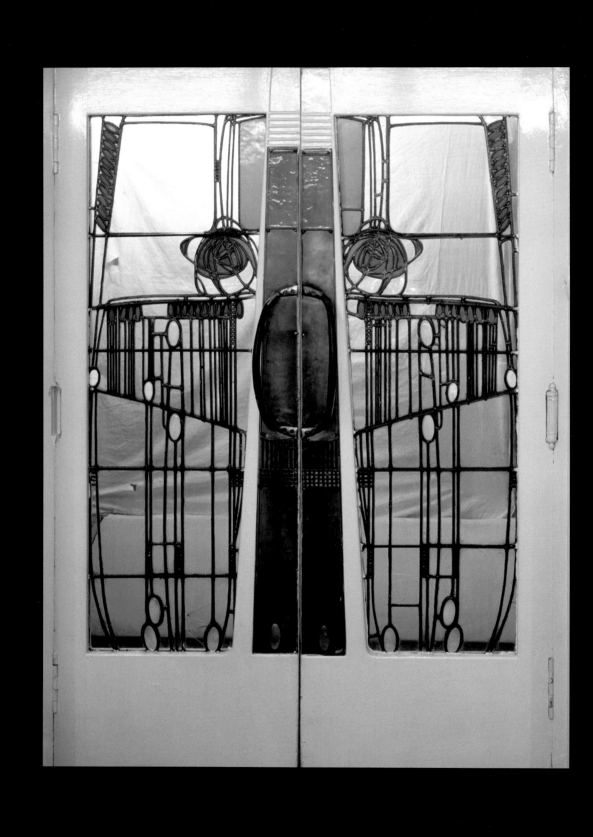

THE REVIVAL OF STAINED GLASS: FROM ROMANTICISM TO MODERNISM

After the lean years of the 17th and 18th centuries, the 19th century rediscovered the beauty of coloured glass, sparking a resurgence in the art of stained-glass windows. The Middle Ages were examined with new interest and efforts were made to recover the techniques and imagery of this period. The pioneers of neo-Romanesque and neo-Gothic architecture enthusiastically embraced the concepts of medieval stained glass and integrated them into a contemporary setting.

The first quarter of the century was marked by experiment and the emergence of a new breed of craftsmen, keen to rediscover the techniques of medieval times. Their quest was supported by scientific research into the chemical composition of glass. Particularly prominent in this respect was Charles Winston, an English lawyer who collaborated with the Whitefriars glass workshop James Powell & Sons to produce coloured glass of a quality that almost surpassed that of medieval churches.

In France, a glass-painting workshop was set up in the Royal Factory in Sèvres in 1828. The chemist Alexandre Brongniart (1770–1847) was commissioned to find the formula for medieval stained glass, but his research was unfruitful and the workshop had to make do with using enamel to paint glass. This workshop remained in operation until 1845 and was of crucial importance in the development of stained glass in France. It received commissions from the aristocracy, such as the windows for the funeral chapel of the Orléans family in Dreux, and it realized designs by major artists such as Eugène Delacroix and Eugène Viollet-le-Duc. Its work mainly revolved around copying paintings onto glass, as in the Royal Chapel in the Château d'Ambroise, with its eleven windows reproducing Spanish and Italian masterpieces from the Louvre.

The 1830s saw the emergence of another workshop – that of Thibaud and Thévenot in Clermont-Ferrand (1831) – which made windows for Bourges Cathedral, based on the style and iconography of its existing stained glass. This workshop used medieval techniques and developed the concept of 'archaeological' stained glass, devoted to imitating models from the Middle Ages. The first windows of this kind were installed in the apse of Saint-Germain-l'Auxerrois, Paris, in 1839.

The French government sponsored a workshop that for a long time was devoted only to copying old paintings and designs by famous artists. This focus on imitation sparked protests, however, from a group of architects and medieval scholars, including Eugène Viollet-le-Duc, Jean-Baptiste-Antoine Lassus, Adolphe-Napoléon Didron and Prosper Merimée (who worked as an inspector for the Service of Historical Monuments). All these figures were responsible, in the mid-19th century, for major restoration projects involving stained glass, and their commitment fostered a new generation of master glass artists. France's three glassmaking workshops soon mushroomed into thirty, including those of Antoine Luzon, Henri Gerente and Maréchal de Metz. The latter was responsible, in 1844, for a window depicting the *Baptism of Christ* for the church of St Vincent de Paul in Metz, which is now in a private collection.

In England, the recovery of stained glass was spearheaded by the artist Thomas Willement, who specialized in heraldic windows commemorating heroic deeds, although his primary inspiration for stained glass came from the 14th century, when the art was at its peak. The first years of the 19th century witnessed new experiments in stained glass by figures such as the architect A. W. N. Pugin, one of the instigators of neo-Gothic architecture in religious buildings, who produced numerous designs for windows in conjunction with the glass artist John Hardman. The renewed interest in stained glass had yet to be matched by glass of sufficient quality, however. As we have already mentioned, it was Charles Winston who first analysed the composition of medieval glass in a chemical laboratory, and he went on to present the fruits of his research in 1851 at the Great Exhibition in London.

The 19th century also witnessed the rise of the Oxford Movement, which sought to recover the splendour of the

Church of England, thereby incidentally creating a new demand for stained glass. Several major workshops, such as Burlington & Grylls and Clayton & Bell, came into being during this period, although it is sometimes difficult to ascribe authorship to Victorian stained-glass windows, on account of the sheer volume of production and the fact that most parish registers recorded only the names of their donors rather than the craftsmen responsible for making them.

The 1840s were boom years for stained glass throughout Europe, prompting many outstanding glaziers, such as Giuseppe Bertini in Milan, to open workshops. The German Nazarene painters were a great source of inspiration, as their work featured large blocks of colour surrounded by bold outlines. The quest for glass of a greater luminosity continued, and in 1845 the French chemist Gustave Bontemps revived the technique of flashed glass, which involved covering a clear glass base with a thin layered of coloured glass that could be removed by abrasion to create different shades on the same sheet. He and other researchers began to publish the results of their experiments, allowing craftsmen to build on their discoveries.

In France, this period was marked by major restoration work on stained-glass windows in big cathedrals (in Le Mans and Bourges, for example). This led to great technical progress, as it enabled master glaziers to study the composition of medieval glass and reproduce its characteristics in a modern setting. In contrast to this archaeological trend, there was also a new desire to work with large expanses of glass, untrammelled by the subdivisions created by leading. Charles Maréchal de Metz was the first to use square panes of stained glass – a development that attracted many other artists, although it involved a complex manufacturing process.

Europe was in the throes of reconstruction, partly prompted by the Romantic yearning to recover the past to allow every nation to forge its own identity. Romanticism marked a crisis, a convulsion of the European spirit, a rebellion against restrictions of any kind. This movement gave rise to Symbolism, which took root in various countries, including France, Britain and Germany. In France, Odilon Redon (1840–1916) drew *The Stained-Glass Window* (1904; p. 17), depicting a Gothic setting with a window embellished by a figurative design. In

England, the Pre-Raphaelites were particularly attracted to the art of stained glass. This group was founded in 1848 by William Holman Hunt (1827–1910), John Everett Millais (1829–96) and Dante Gabriel Rossetti (1828–82); it gradually attracted other painters into its ranks, before breaking up after less than ten years. The Pre-Raphaelites were influenced by the Nazarene painters, as well as by William Blake (1757–1827). They sought to work solely from nature, paying meticulous attention to even the minutest detail. In 1856, the original Pre-Raphaelite Brotherhood began to disintegrate, and Rossetti left to join forces with William Morris and Edward Burne-Jones (1833–98).

In the late 19th century, the English Cloisonné Glass Company launched a new material that it claimed to have invented. This type of glass, obtained by using a technique based on the cloisonné process previously used for enamel, was initially only available in London, but it gradually spread throughout Europe and eventually reached the United States (albeit still under an British patent). Despite these travels, however, its production remained very limited. The firm offered a range of 800 different types of glass, in various shapes, sizes, colours, textures and transparencies. Cloisonné glass found special favour with the Barcelona firm J. Vidal, which used it to decorate interiors.

The revival of stained glass in Germany was fomented by Michael Sigismund Frank (1770–1847), under the auspices of Louis I of Bavaria. Frank produced his first stained-glass window in 1804 and in 1827 he went on to be appointed director of the Royal Glass-Painting Studio, founded by Louis I. This state-sponsored workshop would become the driving force behind the resurgence of German stained glass. Its output was influenced by 16th-century Italian art, and its most popular subjects were taken from the Bible. Other prominent figures were Max Emanuel Ainmiller (1807–70), who created stained-glass windows for Cologne Cathedral in 1848, and Franz

Modernist stained glass was a means of expression that could combine religious subjects (the Three Magi) with elements from everyday life. This Milanese poster advertises cloisonné artistic glass, produced by Adolfo Hohenstein.

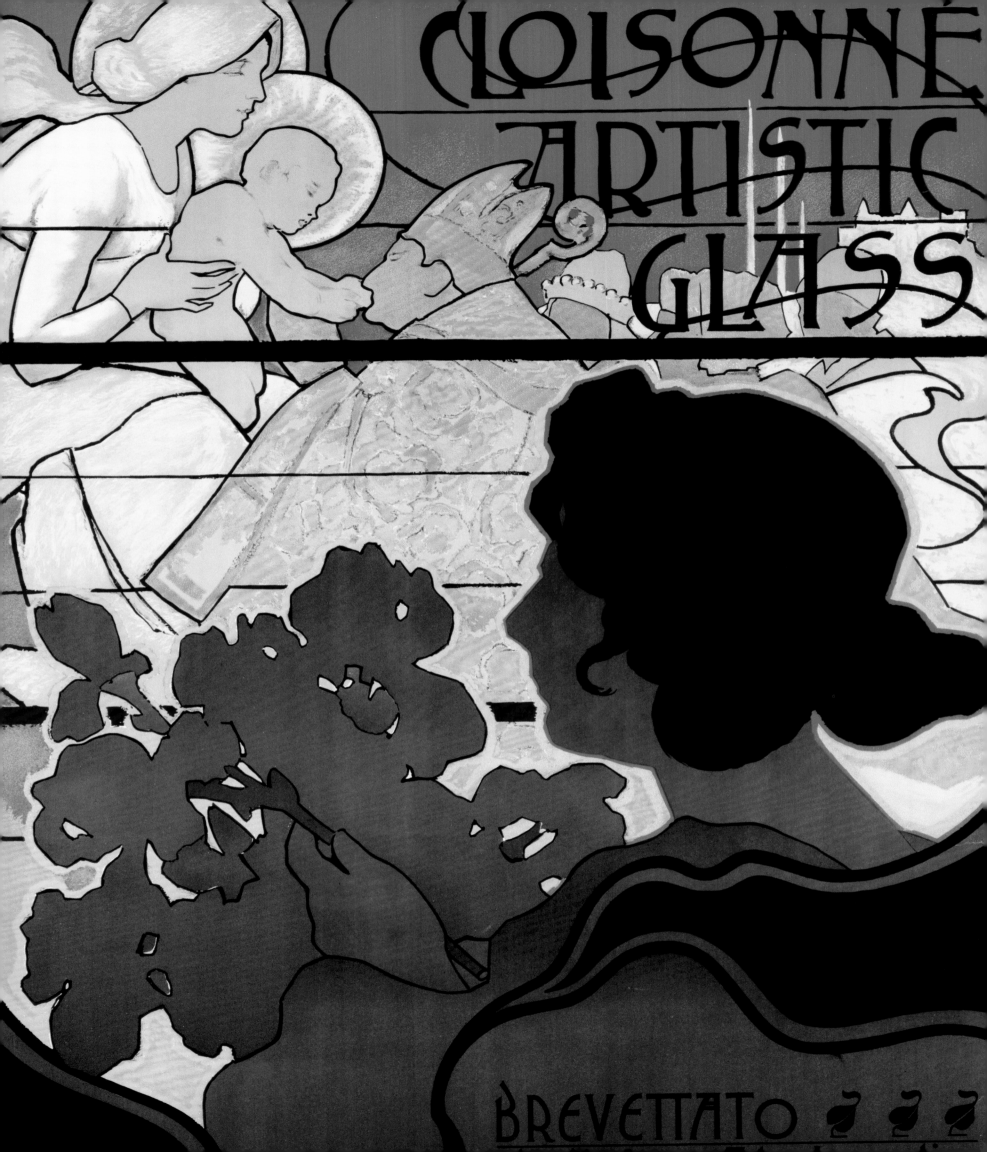

Mayer (1848–1926), who ran a studio that made marble sculptures and altars but decided to branch out into stained glass in 1860. Mayer's work in this field soon won him an international reputation, both as a restorer of medieval windows and a creator of new ones. He set up studios in London and New York, which remained open until the outbreak of World War I. Mayer's windows were distinguished by their heroic scenes from the lives of the saints.

In the United States, the poor quality of the glass available in the 19th century again sparked a quest for improvement. The initial efforts of John La Farge (1835–1910) and Louis Comfort Tiffany (1848–1933) proved disappointing in this respect, however, as they only succeeded in increasing its opacity! Undeterred, La Farge eventually came up with some intensely coloured, opalescent glass discs, after experimenting with the Francis Thill glass company in Brooklyn, in collaboration with the Manhattan-based glass artist James Baker. Tiffany went on to perfect the technique of making opalescent glass, and his friendship with La Farge came to an abrupt end after disputes over the rights to the new material. La Farge eventually patented it in 1880 and went on to obtain a variety of different colours and mouldings from a single piece of glass, which allowed him to achieve great heights of realism and more faithfully reproduce the natural models that inspired his work. In the early 1880s, other artists, such as Thomas Wright (1856–1918) and John Calvin (active 1881–1912) were attracted by the new invention of opalescent glass, and went on to devote their entire careers to it.

In 1889, La Farge was made a Chevalier of the Légion d'Honneur at the Universal Exhibition in Paris for his Watson Memorial stained-glass window in the Trinity Church in Buffalo, New York. Another of La Farge's major works in this field is the *Peacock Window* (1892–1908) in the Worcester Art Museum, Massachusetts. Around the turn of the century, he designed the lovely stained-glass window *Spring* (p. 59), portraying a winged figure floating amidst natural scenery dotted with flowers.

The introduction of stained-glass windows into American houses can be attributed almost entirely to Louis Comfort Tiffany. He was born in 1948 into a family of jewellers, but he rejected this profession at an early age and instead threw himself into painting. During a stay in Paris in the winter of 1868 to 1869, he was introduced by the French artist Léon Bailly to the colourful exuberance of Arabic art. He set off on a journey to North Africa and Spain, where he noticed that the medieval stained-glass windows were excessively dark and would benefit from brighter colours. He was also influenced by the writings of the art dealer and critic Samuel Bing, which taught him the importance of focusing on the quality of glass itself just as much as the artistic input into a stained-glass window. Tiffany's examination of Gothic windows spurred him to look for means of improving this quality in order to merge the colours found in medieval windows with the textures achieved in Oriental glass. After various experiments with oxides and different annealing methods, Tiffany invented Favrile, a mixture of different colours of glass that were fused at great heat, resulting in the iridescent material that would become his trademark. This type of glass was suitable for making both windows and art works. It was introduced into Europe, via France (at the instigation of Samuel Bing), and in some places, such as Catalonia, it was known as 'American glass'.

Tiffany believed that the decorative arts were of greater importance than fine art, and accordingly he formed a company in New York that specialized in interior decoration and would become a trendsetter in this field. Meanwhile, he indulged his passion for stained glass by opening a workshop dedicated not only to designing but also to making glass, as none of the examples on the market satisfied his exacting standards. This workshop sought to breathe new life into the medium by combining opalescent and traditional glass, as in the window it made for the Episcopal Church in Islip, Long Island. Other experiments involved the superimposition of layers of glass to widen the palette of colours. This made Tiffany's windows very thick, as they used three or four times more glass than their contemporary European equivalents, but they nevertheless still managed to maintain their transparency.

Tiffany's decorative windows abound in floral motifs, as can be seen at the extensive collection at the Charles Hosmer Morse Museum of American Art in Winter Park, Florida (pp. 50, 58). The floral motifs are often combined with elements of Arabic inspiration, and the colour

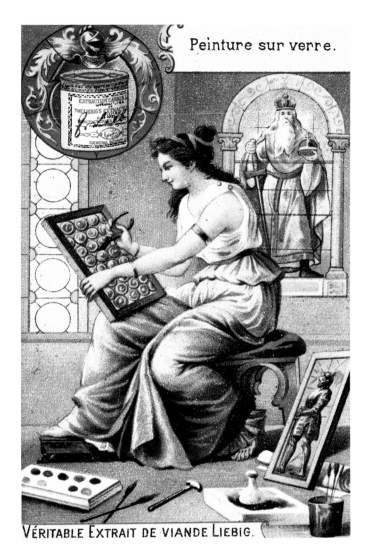

Advertising poster for Liebig meat extract, c. 1900. The fanciful image shows a female figure preparing a window in a stained-glass workshop.

scheme are frequently dominated by browns and ochres. Tiffany's fame led to a commission to decorate the Lyceum Theatre in New York. This project proved a resounding failure, however, but he soon recovered from this blow and in 1889 he went to cool his heels in Paris, at the invitation of Samuel Bing.

Tiffany's large studio employed hundreds of people, including a department of artists – including Edward Sperry, J. A. Holzerm, Agnes Northrop and Frederick Wilson – whose job was to design windows. Wilson concentrated on Gothic stained-glass windows with imposing figures, while Northrop specialized in elaborately detailed landscapes.

Tiffany took on large-scale projects like the chapel for the Universal Exhibition in Chicago, the Teatro de Bellas Artes in Mexico City and the modernist-style Laurelton Hall in Long Island, but he also turned his attention to small objects, particular the famous Tiffany Favrile lamps, which launched a fashion craze and met with enormous commercial success.

Tiffany and Bing admired William Morris, although they did not share his aversion to mass production, as they did not consider it incompatible with artistic creation and believed it could play a positive role in enriching popular tastes. Imbued with this democratic spirit, they commissioned ten preparatory designs from French artists that would later be realized in glass. The artists in question were: Pierre Bonnard, Eugène Grasset, Henri-Gabriel Ibels, Paul Ranson, Ker-Xavier Roussel, Paul Sérusier, Henri de Toulouse-Lautrec, Félix Valloton and Édouard Vuillard. Most of them belonged to the Nabis group, who experimented with the use of large blocks of colour. The resulting works were exhibited in the Salon du Champ-de-Mars, with a catalogue containing an article by Bing that proclaimed the superiority of American glass.

Tiffany was a key figure in the development of glass, thanks to the imaginative opulence and technical expertise he brought to his work, as well as his assimilation of the influences of both Oriental art and Romanticism. He had a rebellious spirit, however, and this often made him a difficult person to deal with. As time went on, he became increasingly eccentric and his reputation suffered as a result. He had been largely forgotten by his death in 1933, but the excellence of his output subsequently led to a reappraisal of his huge contribution to decorative art.

Back in Britain – where, as we have seen, the renewed interest in the Gothic style that emerged in the late 18th century was reflected in the domestic architecture of A. W. N. Pugin and his collaborator John Nash – more and more churches had been built or restored, and these needed stained-glass windows. The 1851 Great Exhibition in London also awakened the public's interest in

stained glass (p. 19). Various firms and artists exhibited their work in the Crystal Palace, a glass building spanning over 70,000 m² in Hyde Park, designed by Sir Joseph Paxton. Although the stained glass on show was produced by contemporary artists, most of their work harked back to bygone eras by imitating Elizabethan or early English styles. Stained glass had clearly been a medium to reckon with for at least fifteen years, giving rise to window designers like John Richard Clayton and Alfred Bell, but one figure stood out from the throng: William Morris (1834–96). In keeping with the precepts of the Pre-Raphaelites, Morris paid meticulous attention to detail and worked from nature. He was less sympathetic towards Romanticism, however, as he considered it overly academic, and he espoused a return to the authenticity of the Middle Ages. Morris was also politically active as a champion of socialism; in fact, his view of art grew directly from his political beliefs, which he expounded in his book *News from Nowhere*. Morris considered art as a natural human activity, and so in an egalitarian society everybody could be an artist.

In 1861 he created the company Morris, Marshall, Faulkner & Co., in response to his inability to find furniture suitable for the new house that Philip Webb (1831–1915) had built for him. The firm's work embraced not only furniture, however, but also wall decorations, designs with architectural motifs, metalwork, embroidery and, above all, stained-glass windows. The company had customers all over Europe, and its roster of artists included illustrious figures like Ford Maddox Brown, P. P. Marshall, Edward Burne-Jones (pp. 54, 57), Dante Gabriel Rossetti (p. 55), Philip Webb (p. 56) and C. J. Faulkner, as well as Morris himself. They all revelled in the working conditions, inspired by a deep respect for craftsmanship and a close study of nature.

Morris was particularly attracted by the Gothic style and craft techniques that had been lost by the modern world, and he played a crucial role in the revival of stained glass. In 1861, he produced the stained-glass window of *St Paul Preaching in Athens* for All Saints' Church in Selsley, Gloucestershire, following the same iconographic and formal patterns that Rossetti used in another window for the same church (p. 55).

The company proved to be a very fruitful association of artists, capable of producing major work like the stained-glass windows in Oxford Cathedral. Morris decided not to make windows for buildings he considered 'monuments of Ancient Art', as this involved nothing more than restoration. He was personally responsible for selecting the glass that would bring to life the designs of Philip Webb. The firm's ornamental repertoire initially abounded in echoes of the Middle Ages, but by 1870 these had given way to a very modern stylization of forms that presaged Art Deco. In that same year, for example, it produced a window entitled *Woman Eating Fruit*, and another that used the letters of the alphabet as decorative motifs.

The firm Morris, Marshall, Faulkner & Co. closed shop in 1875, leaving in its wake a body of work that strengthened the position of stained glass in Britain and also exerted an influence on the British colonies and the United States. Morris set up on his own as a creator of stained glass, although he still drew on the talents of Burne-Jones and Webb. After Morris's death, his business passed into the hands of John Henry Dearle (1860–1932), who had spent many years working as Burne-Jones's chief designer.

Most of the stained glass produced by Morris is now on display on British museums. His work is characterized by depictions of flowers, leaves and other subjects taken from nature, but above all by his use of silver stain to broaden his palette. His portrayal of human bodies is marked by its technical perfection and the meticulous detail of the designs on the clothing.

Morris created many stained-glass windows in conjunction with Edward Burne-Jones, but the latter already had experience in this field before their collaboration. His first designs, dating back to 1857–61, were given form by James Powell & Sons, and they reveal far greater energy and intensity of colour than the work he would produce with Morris.

The late 19th century witnessed the emergence of a new artistic movement, modernism, intent on breaking down the barriers between different artistic disciplines. Modernism proved short-lived but had a great impact, particularly on architecture and its relationship with the applied arts. The Pre-Raphaelites, Morris's circle and the Scottish architect Charles Rennie Mackintosh (p. 32) laid the foundations of this new trend, distinguished by its undulating lines and stylized decoration inspired by

natural forms. It spurned the academicism then prevailing in the art world by using new materials and investigating original approaches to light. This artistic movement arose in various countries at the same time, under different names. In France it was called Art Nouveau; in Italy, *stile floreale* or *stile Liberty*; in Germany, *Jugendstil*; and in Catalonia, *modernisme*. Architects like Mackintosh, Antoni Gaudí, Hector Guimard and Victor Horta brought stained-glass windows into their own by eliminating the distinction between a building and the artistic elements decorating it, so that individual features took on a new importance in the overall design. At the same time, the iconographic repertoire of the decorative arts was broadened as artists turned to nature, particularly the world of plants, for their subject matter. These stylistic developments in stained glass were made possible by the technical innovations that were being made in several cities.

The first house in Europe that can be fully described as modernist was the Maison Tassel in Brussels, designed in 1893 by Belgian architect Victor Horta (1861–1947). Stained-glass windows formed an essential part of its decoration. Brussels was also home to Henry van de Velde (1863–1957), who created several buildings in which stained glass played a major role.

In France, Art Nouveau gave a leading role to the art of stained glass, which was given new life by the upsurge in Catholicism in the late 19th century. The hub of production was the Nancy School. Nancy had become a major artistic centre in 1870 when many artists from Alsace and Metz settled there after fleeing from the Franco-Prussian War. The two most outstanding figures were Jacques Gruber (1870–1933) and Émile Gallé (1846–1904).

In 1893 a workshop run by the Daum brothers started making objects according to a process developed by Gallé that involved applying layers of coloured glass to a colourless base. This technique was then adapted for windows by Gruber, who also experimented with new configurations of leading. Gruber's work is marked by evocative sensuality, as seen in his ceiling for the Crédit Lyonnais bank (pp. 28–29). One of the most famous examples of Art Nouveau stained glass, however, is the window *Spring*, designed in 1894 by Eugène Grasset (1845–1917), now on show in the Musée des Arts Deco-

ratifs in Paris. This shows a wintery landscape, offset by elements such as swifts and tree blossom that herald the imminent arrival of spring. The composition is full of movement, which is heightened by the flowing clothes of the young female figure and the irises that are blowing in the breeze that seems to engulf the scene.

Art Nouveau was greatly indebted to Japanese art, which had become particularly popular with collectors at the time. In 1896, Samuel Bing, one of the main dealers in this field, opened a shop specializing in stained glass called L'Art Nouveau, which gave the movement its name. Two years later, he faced competition from van de Velde's Maison Moderne. These stores provided work for artists such as Frank Brangwyn, John La Farge and Louis Comfort Tiffany.

Art Nouveau made its presence felt, particularly in France, in places aimed at an exclusive clientele. This was the era of the great chefs, who worked in prestigious new restaurants that rivalled long-established classics and made Paris an international leisure capital. One of the newcomers was Maxim's in Paris (1890), which was the epitome of the Art Nouveau restaurant, with its wood panels, leather, mirrors, tiles, red velvet – and stained glass (pp. 8, 26–27). Another of these great restaurants was Le Train Bleu in the Gare de Lyon, which opened in 1901 and is now listed as a historic monument, with all its original decor intact. Its salons are adorned with beautiful murals of stucco and leaded glass, designed by major artists of the day.

Modernism also flourished in Italy, where it was known as the *stile Liberty*. In 1902, a major exhibition of Art Nouveau in Turin had a profound effect on Italian artists. One example of this new influence can be seen in the allegorical stained-glass windows created in 1905–7 by Giovanni Beltrami (1860–1926) for the casino in San Pellegrino. The medium proved an inspiration for many other artists, including Lindo Grassi, responsible for *The Hunter* in 1915.

In Germany, Jugendstil also prompted experimentation with stained glass in the context of civil architecture. Although the decoration was mainly naturalistic, some of the country's output was influenced by the ideas of the architect Peter Behrens (1868–1940).

In Austria, the Secession group was formed in 1897 to follow the precepts of Art Nouveau, although it also drew

on ancient pagan mythology. The painter Kolo Moser (1868–1918) applied these new concepts to the church of St Leopold am Steinhof in Vienna. One of its stained-glass windows provided a new twist to the old format of the pediment by displaying a monumental figure of *God the Father* within a triangular composition. In 1909, Otto Barth (1876–1916) created stained-glass windows for the Herzogshof Hotel in the spa of Baden (p. 48).

In Spain, modernism played a crucial role in the revival of stained glass, although the level of production varied greatly from region to region. In Madrid, modernist stained-glass windows were inserted into older buildings of a different style, as in the Casa Villameal, which in 1906 received windows with allegorical depictions of the seasons, made by the company Maumejean (founded 1860). Meanwhile, the Casa Conrado, on the city's Calle Major, flaunted arabesque motifs on its cloisonné windows (this technique had been introduced to Spain in 1899 by J. Vidal, via Barcelona). Madrid also developed a penchant for wrought iron domes fitted with stained glass. The earliest of these – an example of pure modernism made in 1902–3 by José Grases Riera (1850–1919) – crowned the Palacio Longoria. Its structure comprised six ribs that crossed in the middle to form a hexagon. The glass, which was coloured but not painted, formed a central sun surrounded by plant motifs. Another striking dome, in the central hall of the Westin Palace Hotel, is decorated with garlands and other typical modernist motifs, albeit with hints of the classical, geometric forms that would be the hallmark of Art Deco. The stained glass here was once again the work of Maumejean, and dates from around 1912. Later on, Art Deco would hold sway over stained glass in Madrid, as in the windows made by Maumejean in 1931 for the extension to the Bank of Spain. Allegorical subjects were again chosen, with pride of place being given to *Progress* on the skylight. The glass has an almost sculptural texture and gives the composition the three-dimensional quality of a collage.

It was in Catalonia, however, that modernism came into its own, in its local variant, *modernisme*. At the end of the 20th century, this movement provided an injection of nationalism and marked one of the golden ages in Catalan history, characterized by a drive towards progress and artistic innovation. This was coupled by a return to the origins of the nation and a recovery of traditions, albeit with a groundbreaking spirit that sought to break down the rigid barriers between artistic disciplines and forge a more imaginative, completely new art. So, different fields came to collaborate on an equal footing. It was no longer acceptable, for example, to put up a building without giving thought to the decoration and so craftsmen such as carpenters and glaziers became fully involved in the creative process, adding a wealth of detail often imbued with fantasy. The art world was totally committed to shaking off the shackles of academicism, but its striving for the new was paradoxically accompanied by a desire to master techniques that had long been forgotten.

In this context, the art of stained glass re-emerged as a basic element of modernist architecture by endowing it with sinuous, undulating forms. At first, Catalonian stained glass was strongly influenced by William Morris, but it later fell under the sway of Tiffany; in both cases, however, these influences were filtered through local traditions. The subject matter often reflected the love of floral motifs so typical of the period, but it also drew on medievalism and the nationalist feelings that were rampant at the time. Stained glass was also used in religious architecture, particularly in the windows designed by Antoni Gaudí for Palma Cathedral in Majorca (pp. 114–15), and by Josep Maria Pericàs (1881–1965) for Montserrat Monastery.

It is important to distinguish between the artists working in stained glass in the pre-modernist era and those who were considered fully fledged modernists. In the years prior to the flowering of modernism, some glassmakers had started to study Gothic windows and produced their own versions, mostly distinguished by their marked academicism. The leading figures at this time were the Amigó family, who created windows for the side chapels of the Sanctuary of the Mare de Déu in Montserrat, and Josep Maria Jujol, whose windows for

St Vitus's Cathedral in Prague provides a Gothic setting for the work of 20th-century artists. The renowned Czech artist Alphonse Mucha (1860–1939) was responsible for these densely figurative windows.

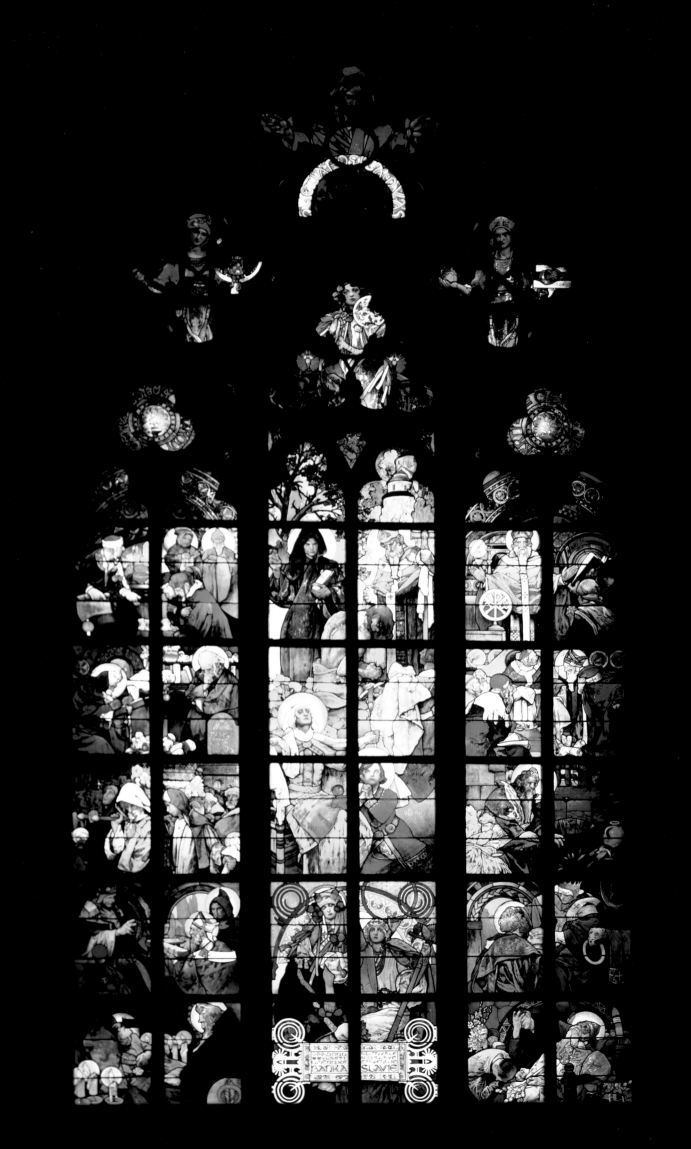

the oratory for the Martínez-Domingo residence are now on show in the National Museum of Art of Catalonia. Another glassmaking dynasty was that of the Espinagosa family, who are not very well known as they often omitted to sign their work. One member of this family, Joan Espinagosa i Farrando, is acknowledged as a pioneer of modernist stained glass. His work can be seen in the Pradell pharmacy in Carrer Sant Pere més Baix in Barcelona, as well as in some of the modernist houses in the city's Eixample district. He also worked in Britain, Germany, France and Italy, and he passed his business on to his three sons at his death. Other prominent Catalan stained-glass artists involved in the modernist movement were Antoni Aymat i Segimon, Joan Sagalés and the Granell family.

The architect Jeroni F. Granell i Manresa (1868–1931) formed a fruitful partnership with the glazier Antoni Rigalt i Blanch that married the latter's respect for the past with Granell's quest for modernity. The family tradition was continued by Jeroni Granell i Bartomeu, who collaborated with artists like Francesc Labarta, Pere Pruna and Antoni Vila Arrufat. (The Granell firm still exists today.) The Maumejean family, whose workshop was industrial in scope, also produced some very significant stained-glass windows, such as those for the Caixa d'Estalvis in Sabadell, with huge allegorical depictions of *Trade*, *Industry* and *Agriculture* undertaken in a highly realistic manner, and, in a similar style, the large representation of *Faith* in the Pérez Samanillo residence in Carrer Balmes, Barcelona. Josep Maumejean i Guereta is also known for his religious windows in the Astorga Episcopal Palace in León. Another family specializing in stained glass was the Oriachs. Lluís Oriach was working during the height of *modernisme*, collaborating with architects like Raspall, Jujol and Martinell and producing windows, in conjunction with members of his family, for the cathedrals in Vic and Girona, as well as the churches of Santa Maria del Pi and Santa Maria del Mar in Barcelona. Other outstanding modernist glass artists included Antoni Bordalba, Miquel Riera i Tosquellas, V. Tur and Luis Gargallo, but pride of place must go to the most important of all the dynasties of Catalonian glass artists in this period: the Rigalts.

Antoni Rigalt i Blanch (1850–1914) was born into a family of artists. An extremely cultured man, he was elected a member of Barcelona's Academy of Science and Art and exhibited his work several times in the city's annual exhibition of Fine Art and Industry. He also collaborated with the architect Lluís Domènech i Montaner on the windows for the Palau de la Música Catalana, a concert hall in Barcelona. Rigalt was the very embodiment of *modernisme*, with his love of the Gothic period and his passionate belief that stained glass should form an integral part of the architecture that it decorates. His writings showed that he aspired to the Romantic ideal of allowing feeling and emotion to prevail over technique. His son, Luis Rigalt i Corbella, continued the family glassmaking tradition and eventually ended up running the Granell company.

Stained glass gradually ceased to be a mere decorative element to become an artistic medium in its own right, encouraging painters such as Enric Monserdà i Vidal (1850–1926), Joaquim Renart (1879–1961), Antoni Estruch (1872–1957) and Joaquim Mir Trinxet (1873–1940) to experiment in this field, often in conjunction with experienced glass artists.

Let us now turn our attention to some of the major modernist architects. Antoni Gaudí (1852–1926) commissioned stained-glass windows on several occasions, as can be seen in the Bellesguard residence, the crypt of the Colonia Güell, the Casa Batlló and Palma Cathedral in Majorca (pp. 114–15). These windows convey all the mystery and sinuosity of Gaudí's style and provide perfect complements for his architecture. Josep Puig i Cadafalch (1867–1956) almost always included stained-glass windows in his buildings to make a strong visual impact, as can be seen in the Casa de les Punxes. Meanwhile, other Catalan architects, such as Eduard Maria Balcells (1877–1965) and Joan Rubió i Bellver (1870–1952), took direct responsibility for the stained glass featured in their work.

An entire chapter could be devoted to Lluís Domènech i Montaner (1850–1923), who was not only an architect but also a historian and politician, as well as being one of the key figures of *modernisme*. His fervent nationalism found its full expression in the movement, and his interest in stained glass breathed new life into the medium. The team that he assembled in his workshop (El Castell dels Tres Dragons in the Parc de la Ciutadella) explored an array of artforms and brought them together

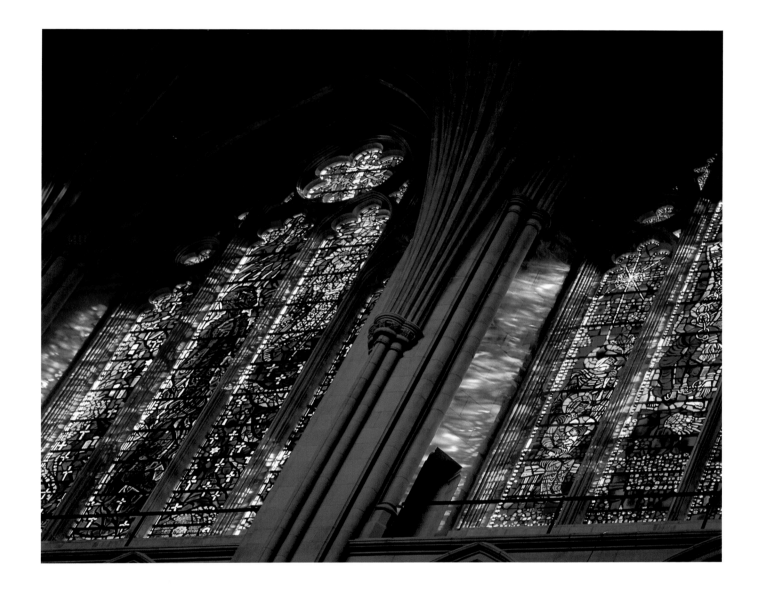

Washington National Cathedral in the US is a neo-medieval building begun in 1907. Throughout the 20th century, various artists in different decorative fields worked on it, with the intent of expressing Christian themes in a medieval context. Stained glass was a key part of this decorative scheme.

on his buildings. Domènech regularly collaborated with Antoni Rigalt, resulting in decorative windows for the Casa Thomas (1895–98), the Casa Navàs (1901–7) and the Casa Lleó Morera (1905; p. 49) in Barcelona. The crowning glory of their partnership, however, was the Palau de la Música Catalana. Here, architecture and glass were perfectly integrated, with the latter even serving to make partitions. In the auditorium, windows create distinctive lighting effects that enhance the sense of occasion. The bay window also shows the importance of stained glass in the overall design, as it serves to accentuate some of the architectural elements. The most outstanding decorative feature inside the Palau is the

central skylight (see opposite), an inverted dome made up of thousands of pieces of glass that is considered one of the foremost examples of modernist art in Europe.

Another major building in Domènech's output was the Hospital de Sant Pau in Barcelona, which also contains decorative windows, created in conjunction with the artist Francesc Labarta (1883–1963). The budget was smaller than that of the Palau, however, and Domènech mainly had to make do with transparent glass and was unable to devote so much attention to detail. This hospital stands as a testimony to the waning power of *modernisme* in its later years.

Opposite and overleaf:
The masterpiece of the architect Lluís Domènech i Montaner, the Palau de la Música Catalana is dominated by the magnificent glass ceiling in the concert hall, created by Antoni Rigalt in 1908. It is one of the most famous examples of Catalonian modernisme.

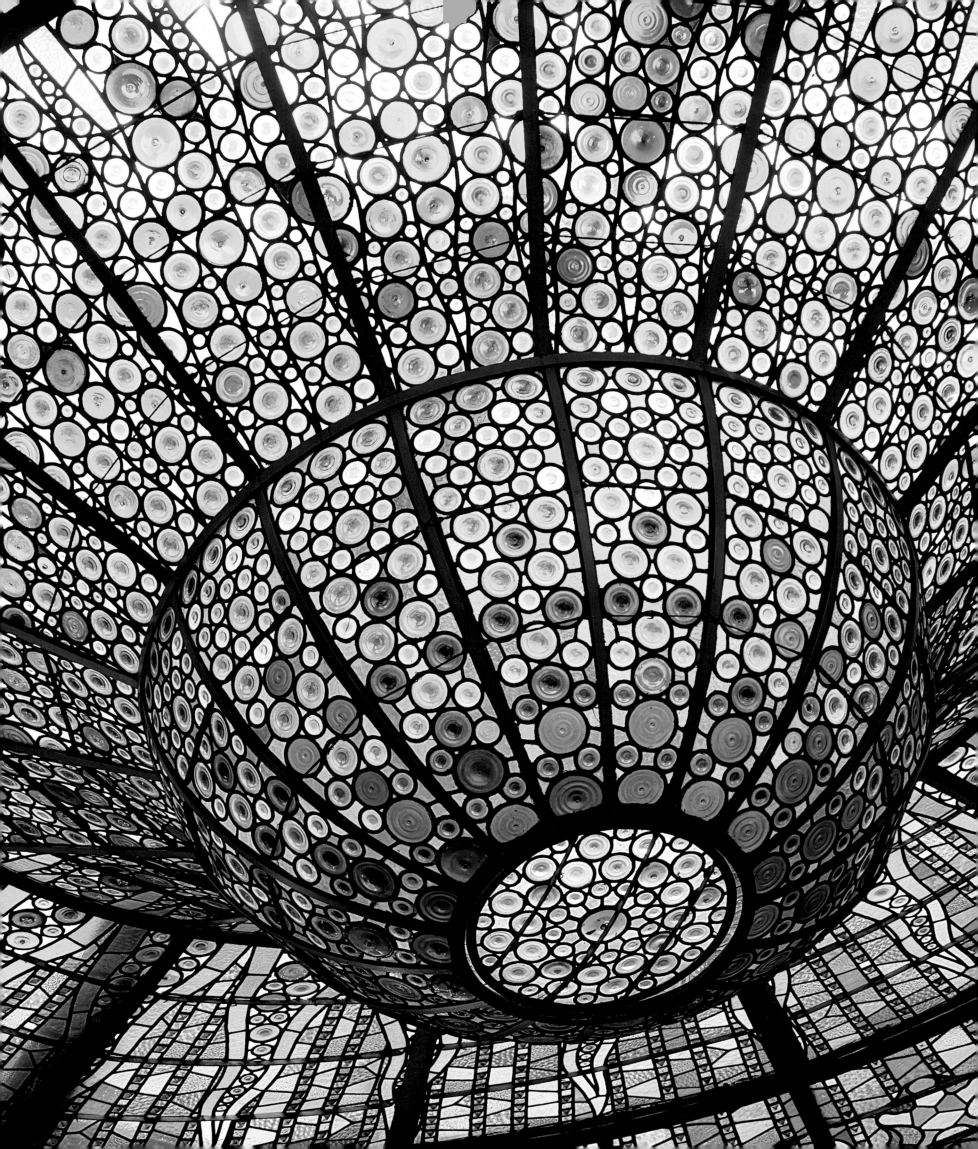

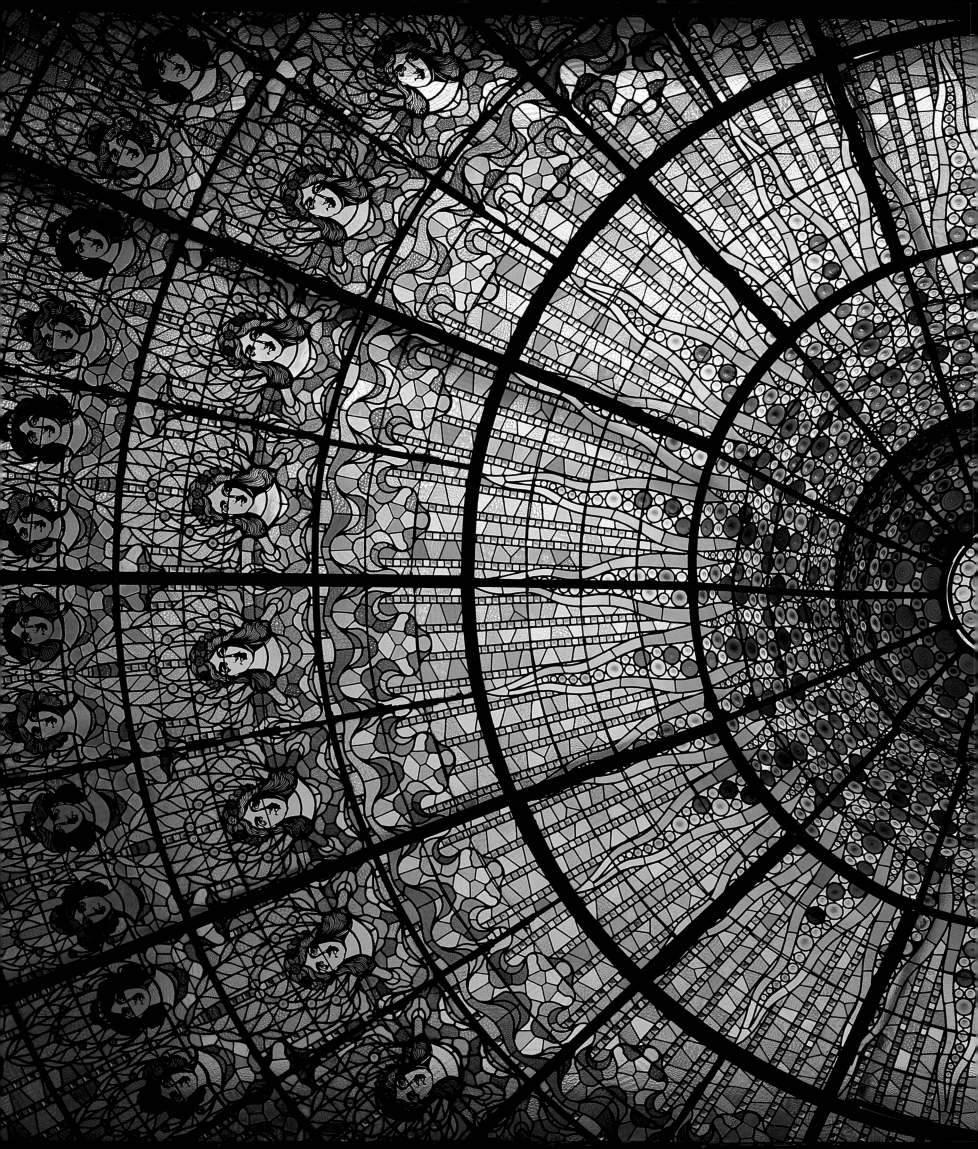

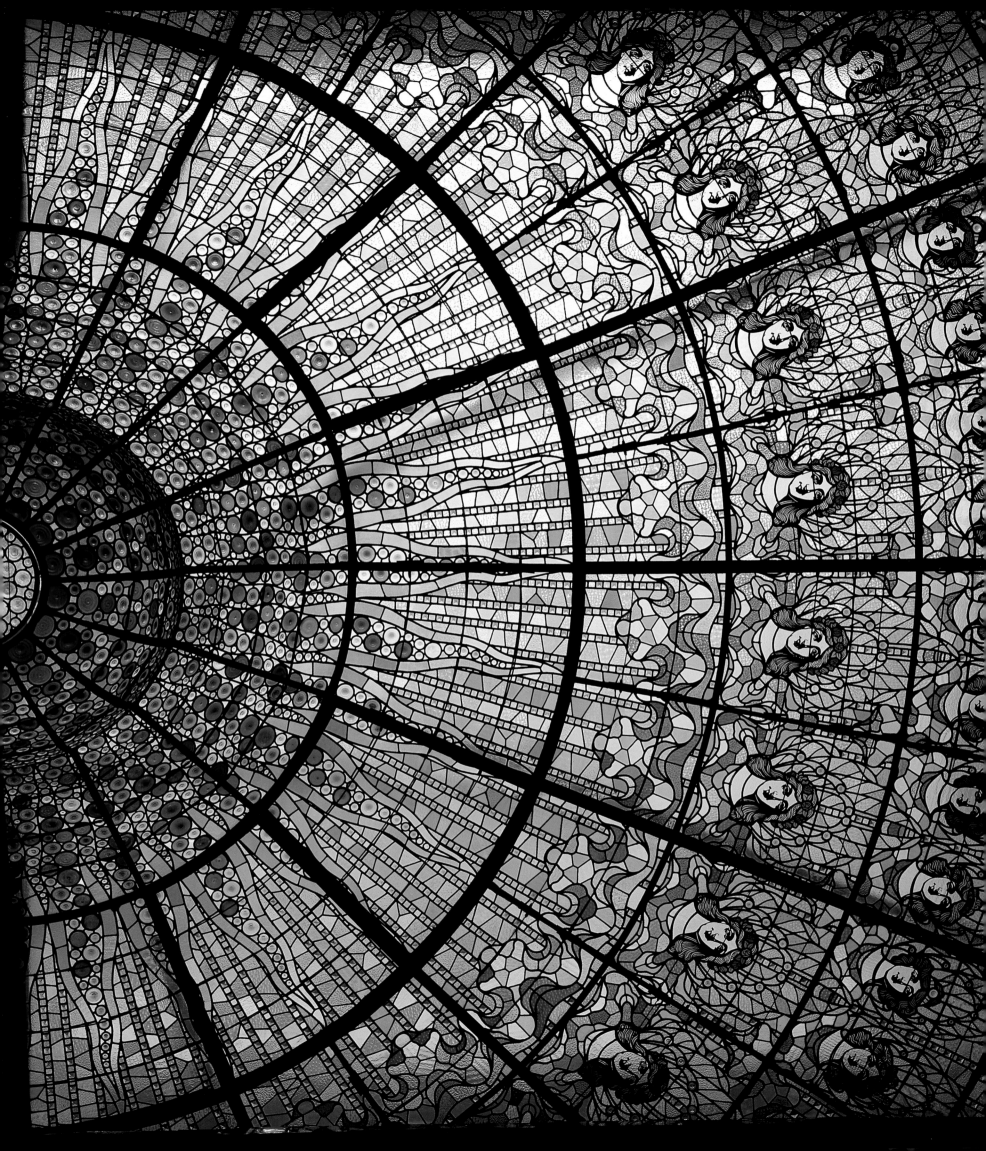

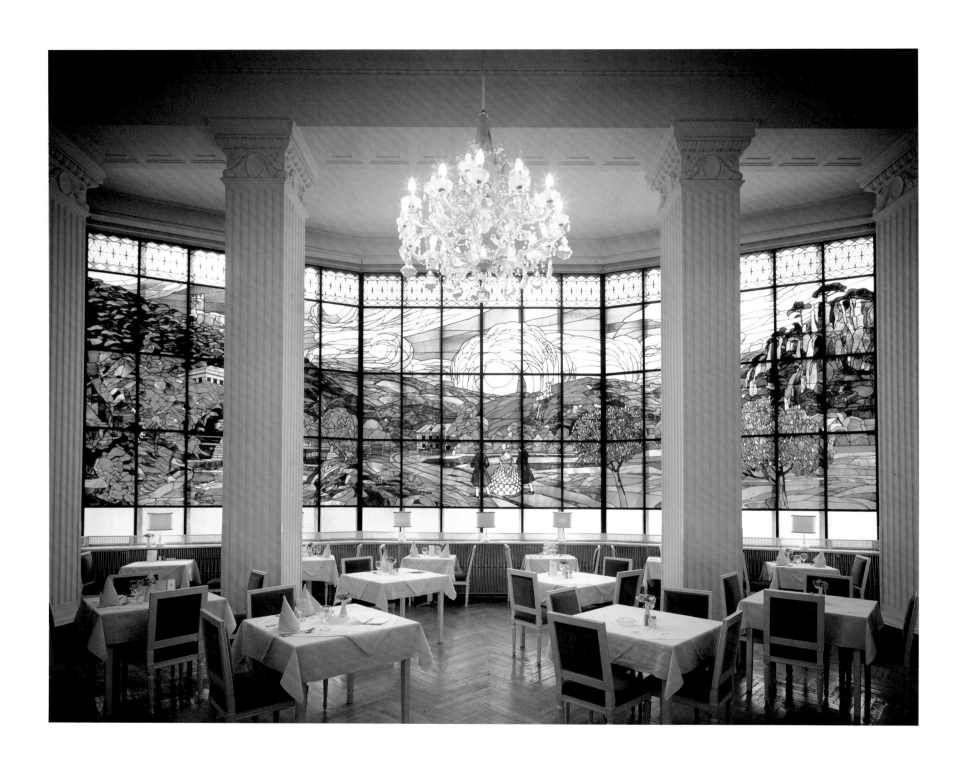

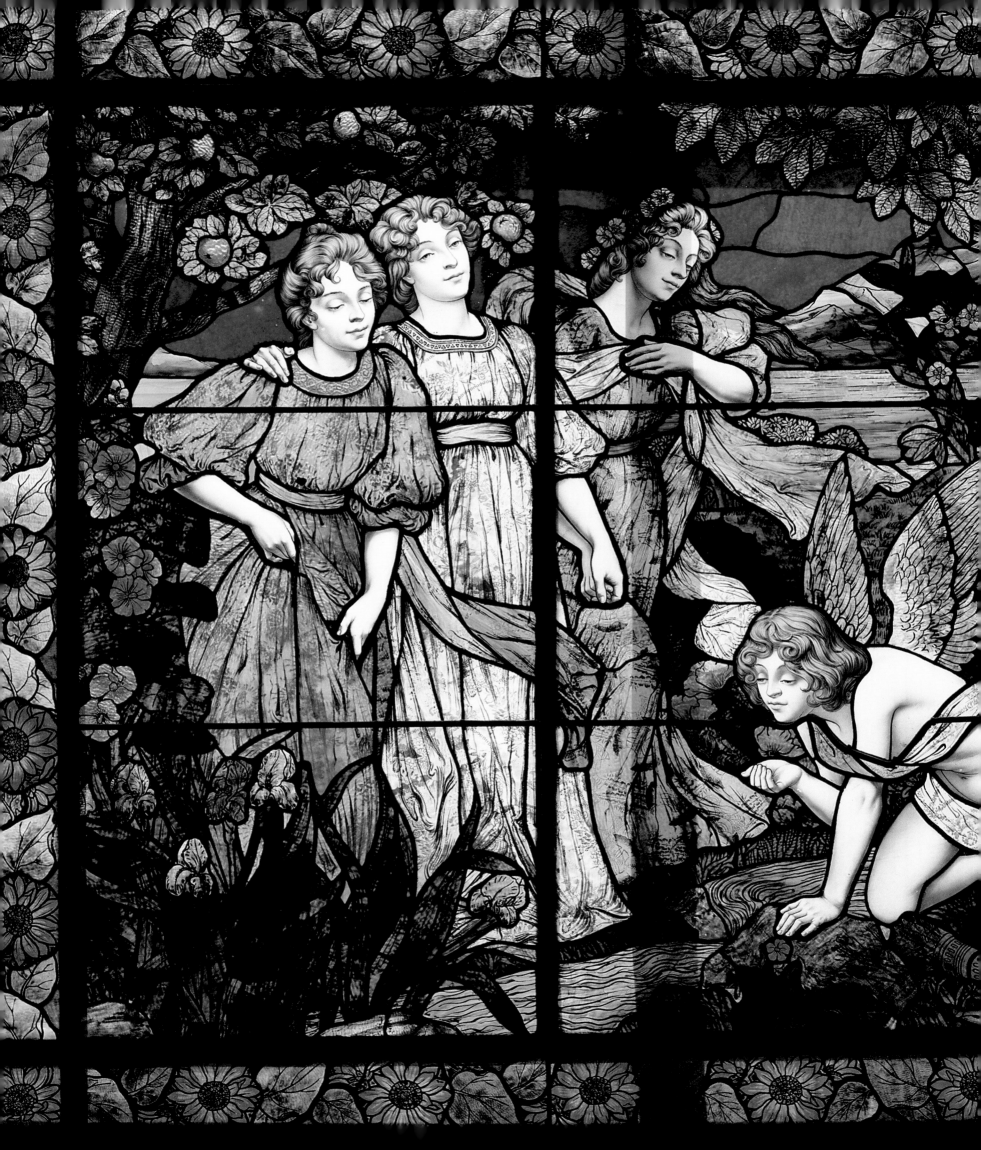

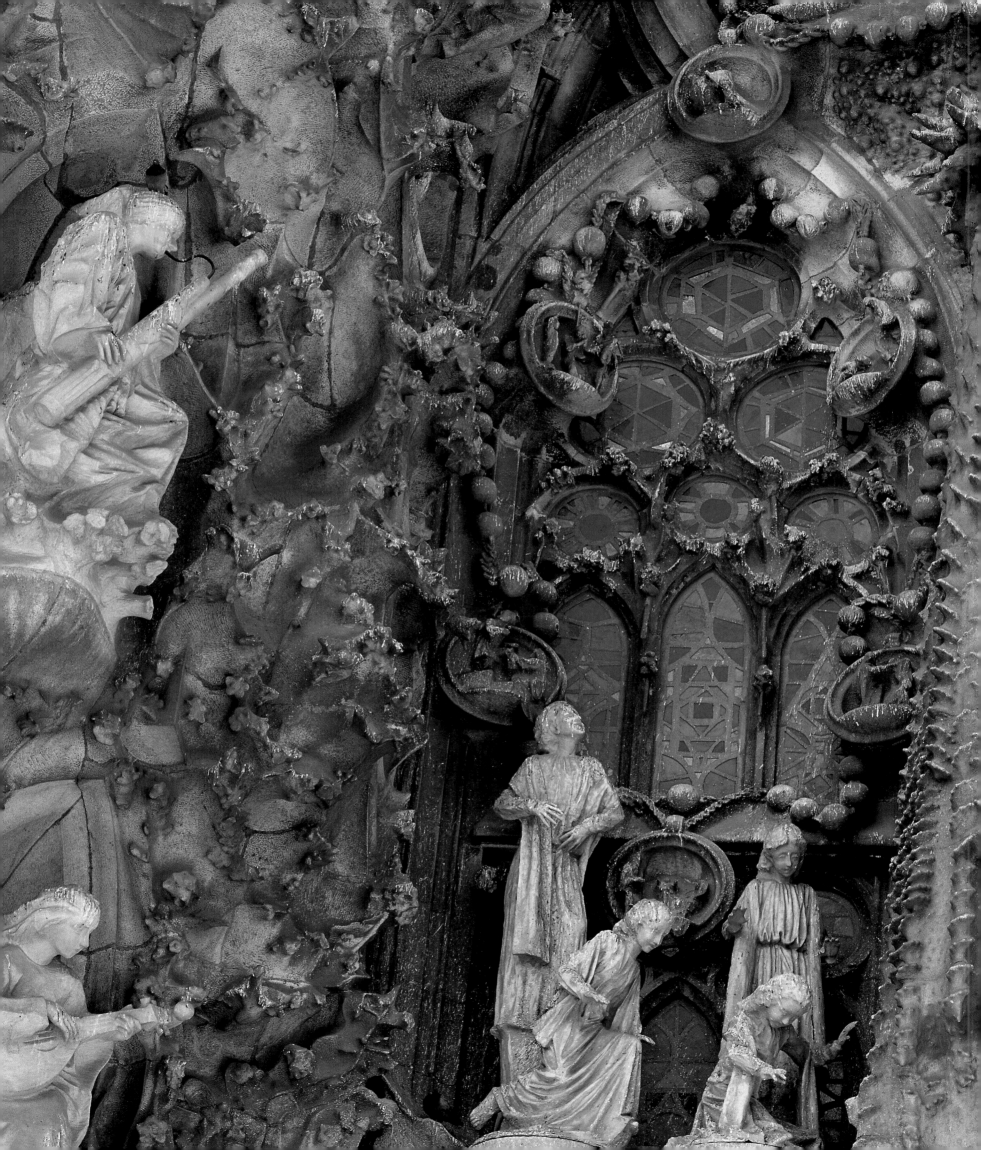

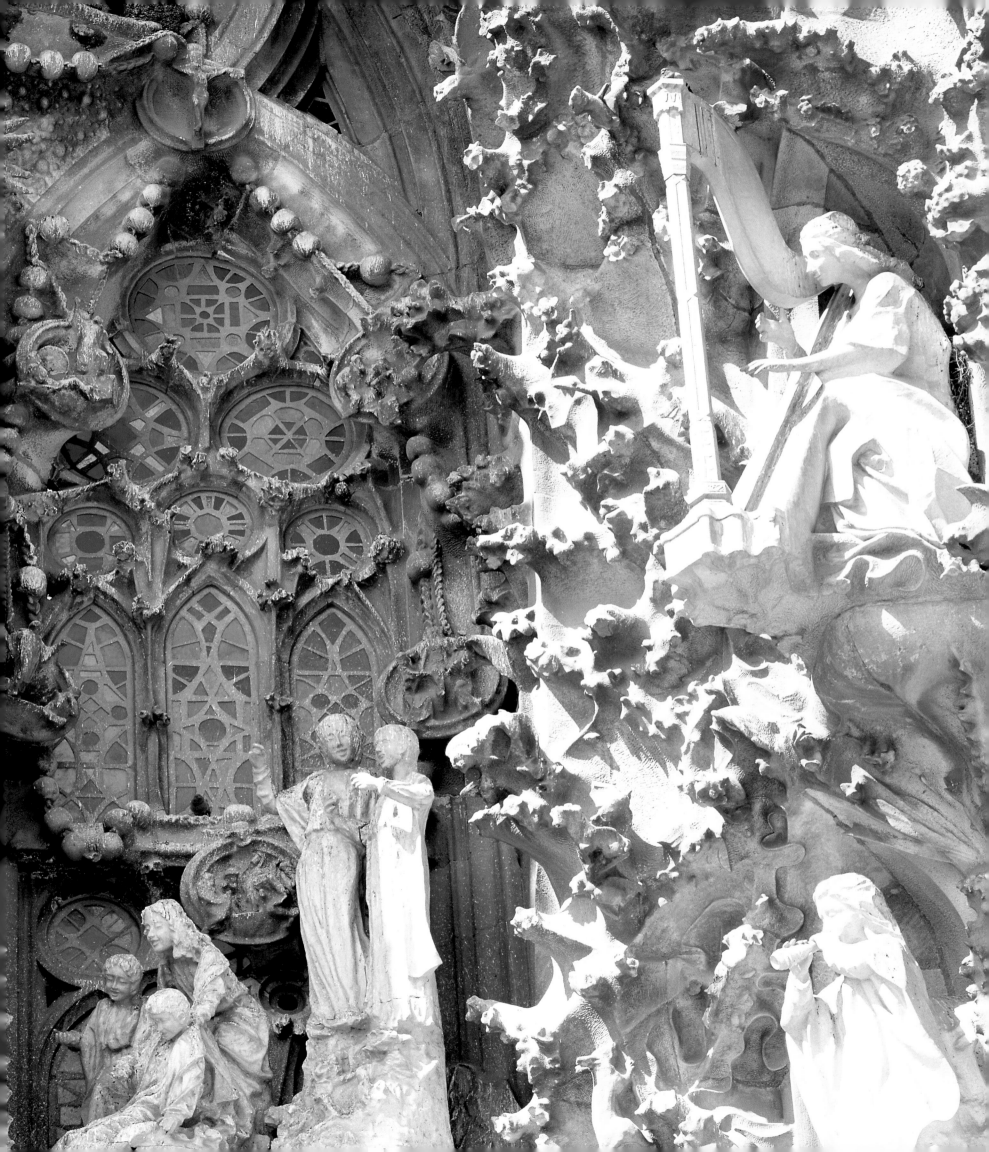

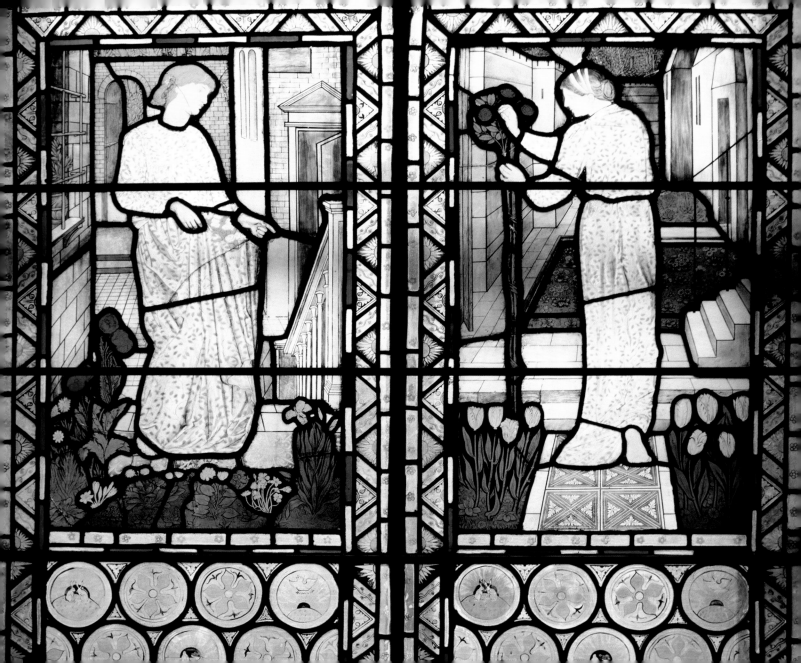

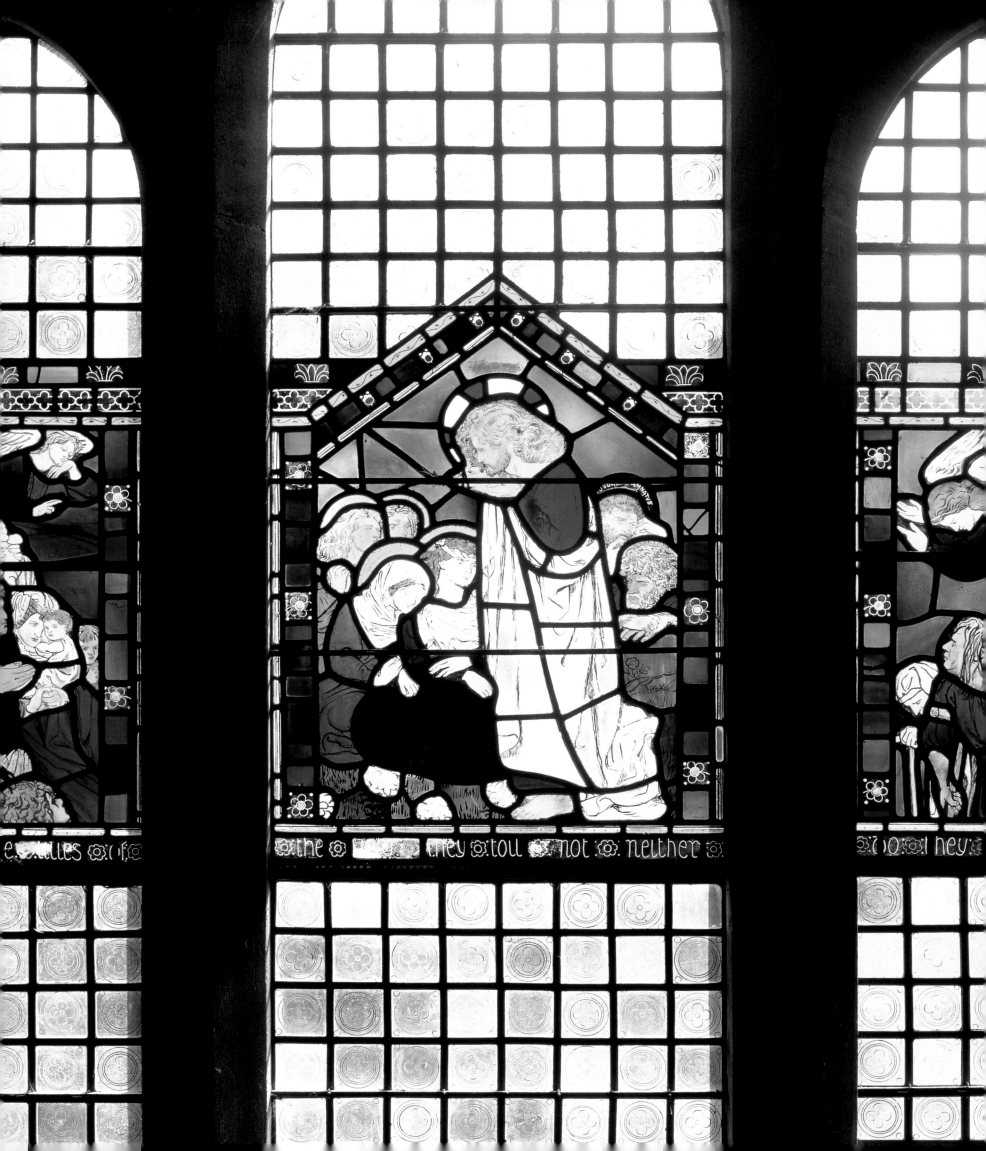

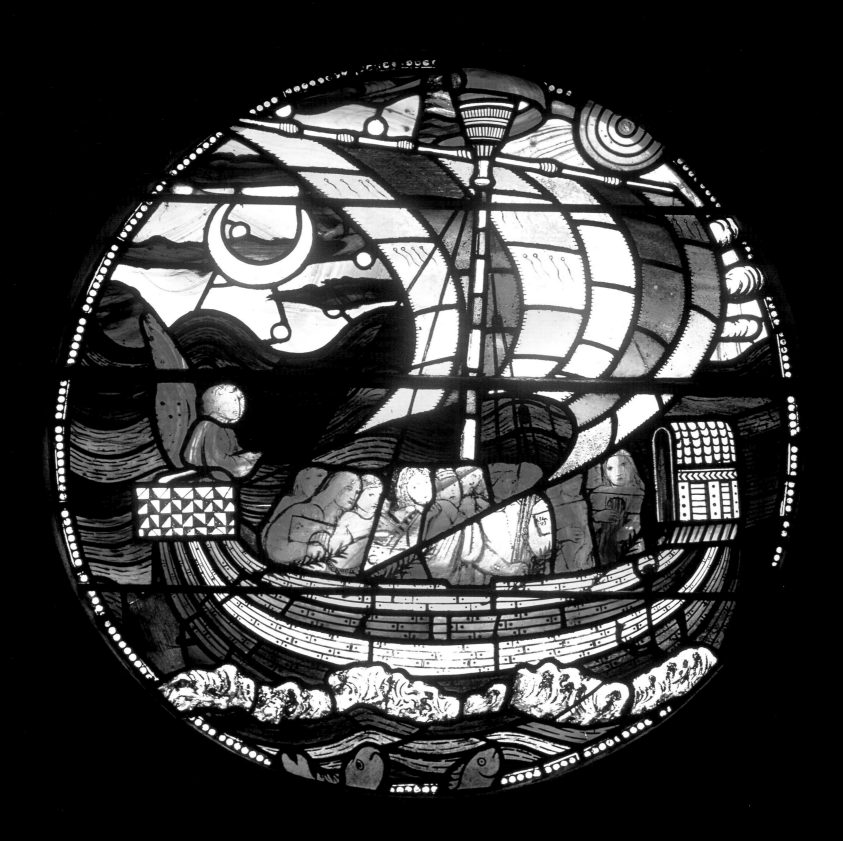

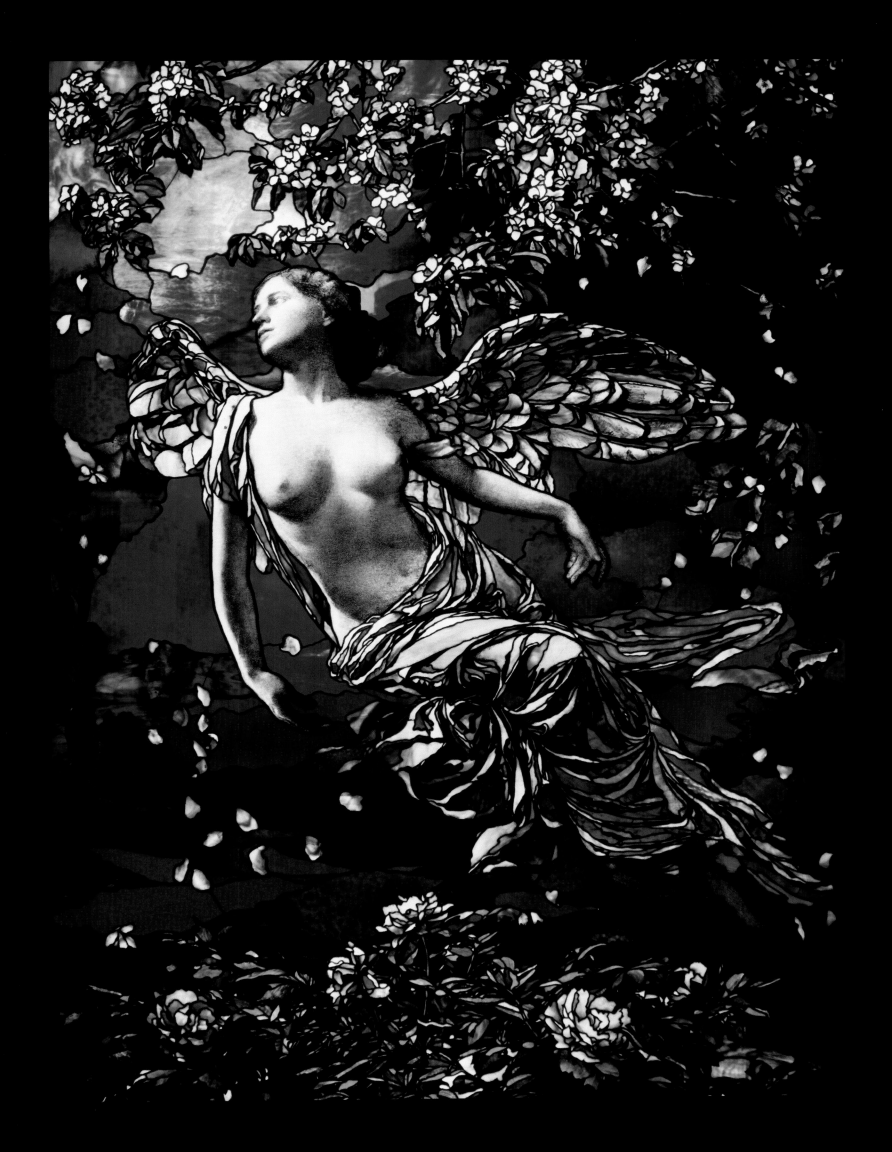

p. 32 p. 48 p. 49 p. 50

p. 51 pp. 52–53 p. 54 p. 55

p. 56 p. 57 p. 58 p. 59

p. 32
The famous architect Charles Rennie Mackintosh designed these decorative doors with glass panels for the Willow Tea Rooms in Glasgow between 1898 and 1903.

p. 48
In the early 20th century, many spa buildings incorporated stained-glass windows to portray idyllic landscapes. The Herzogshof Hotel in the Austrian spa of Baden was built by Otto Barth in 1909.

p. 49
The Casa Lleó Morera in Barcelona (1902–5) by the architect Lluís Domènech i Montaner, retains a fine gallery with modernist stained-glass windows (now fully restored). Electric lighting allows an outside view of the glass decoration, which was designed to be viewed from the inside in natural light.

p. 50
Detail of a window made by Louis Comfort Tiffany in around 1904, now on show in the Charles Hosmer Morse Museum of American Art in Winter Park, Florida.

p. 51
A stained-glass window advertising the spa in Aix-les-Bains, France. The decorative profusion of the frame, with its almost baroque plant motifs, contrasts with the Art Nouveau feel of the central picture. The presence of water in the background conveys tranquillity in a pastoral setting that celebrates the beauty of nature.

pp. 52–53
The Catalan architect Antoni Gaudí conceived the Sagrada Familia in Barcelona as a masterful stone shell that would contain spaces dominated by glass and colour in a style reminiscent of the Middle Ages. Some of the windows were completed in Gaudí's lifetime, while others were added later.

p. 54
Stained-glass window by Edward Burne-Jones, in the collection of the Victoria & Albert Museum, London. The spirit of the Pre-Raphaelites is reflected in the combination of medieval and classical elements.

p. 55
Detail of the stained-glass window The Sermon on the Mount, *designed by Dante Gabriel Rossetti for All Saints' Church in Selsley, Gloucestershire.*

p. 56
Detail of the stained-glass window The Creation *(1861) designed by Philip Webb for All Saints' Church in Selsley, Gloucestershire.*

p. 57
Detail of a stained-glass window (c. 1859) designed by Edward Burne-Jones for the Latin Chapel in Christ Church Cathedral, Oxford.

p. 58
Detail of a stained-glass window (c. 1904) designed by Louis Comfort Tiffany and now preserved at the Charles Hosmer Morse Museum of American Art in Winter Park, Florida.

p. 59
Spring (1901–2), designed by John La Farge and now on show in the Philadelphia Museum of Art.

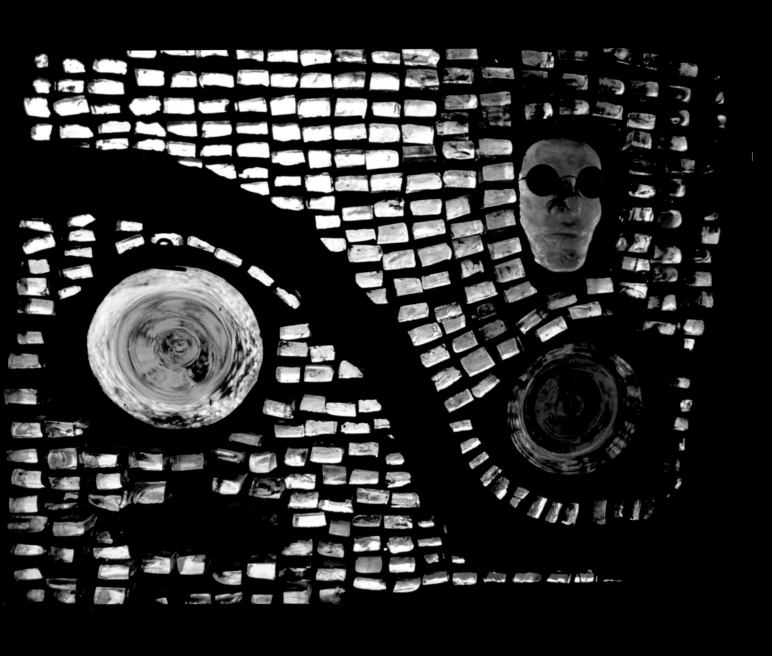

THE 20TH CENTURY:
NEW PROBLEMS, NEW SOLUTIONS

In the first half of the 20th century, stained glass did not extend beyond the limits of the 19th-century revival, but the art remained alive and was associated not only with religious art, as it had been in the past, but also with individual artistic expression.

Over the course of the century, several technical innovations emerged. Contemporary architecture's emphasis on purity of line, and its use of new materials such as steel and concrete to challenge classical preconceptions, opened up spaces that could be filled with glass. Entire walls, or even most of a building's structure, could now be made of glass, but this was only made possible by new technical developments. Contemporary artists rarely make their own glass and instead buy it straight from specialist manufacturers. Almost any kind of glass can be used in a modern window, sometimes in combination with others to produce an array of different textures. One such type is so-called 'cathedral glass', distinguished by one smooth face and one textured face, which can be varied according to the cooling and flattening processes that are used.

Lead cames can now be eliminated by fusing transparent molten glass with the pieces of coloured glass making up the design. Another innovation is in fact a revival of an ancient technique from the Byzantine Empire; it involves embedding a sheet of glass, two or three centimetres thick, directly into a building's structure – with the aid of cement or epoxy resin – to create a window. In recent years, artists have also experimented with painting glass on both sides and combining glass with plastic and mirrors.

As in the past, stained glass in our times is closely linked with architecture, as it fits perfectly into volumes and adds a harmonious finish to spaces. Glass is responsible for providing a connection between a building's interior and exterior, as well as controlling the amount of light that enters. The glass worker plays a key role in choosing the type of glass most suited to a particular building, bearing in mind both its functional role and its artistic intent.

The 1980s were particularly important for promoting research into stained glass, giving rise to several specialist magazines in Europe (*Revue de Verre* in Prague, *Neues Glas* in Dusseldorf, *Stained Glass* in New York and *Revue de la Céramique et du Verre* in France). Several major museums (the Metropolitan Museum of Art in New York, the Musée des Arts Décoratifs in Paris, the Victoria & Albert Museum in London) and leading art galleries in Paris, New York, London and Brussels organized exhibitions of stained glass, while Barcelona mounted the first International Glass Competition as a tribute to Joan Miró in 1985.

The two world wars also played a crucial role in the development of stained glass, as many church windows were destroyed by bombing and needed to be replaced. Many public authorities, particularly in France, decided to commission designs from contemporary artists – although some of the more innovative proposals were rejected. Louis Barillet (1880–1948), for example, wanted electric lighting to be switched on at night both inside and outside one church to achieve striking refractory effects, but the idea was considered to detract from the required atmosphere of meditation. For the first time, however, there was a concerted effort to incorporate modern works into old buildings, and stained glass was at the forefront of this movement, as in the commemorative windows designed by Maurice Denis for the architect Auguste Perret's church of Notre-Dame in Raincy (1922–23), which sparked a renewed interest in sacred art. Denis further demonstrated his ability to combine personal expression with the demands of religious art in the churches of Notre-Dame and St Paul in Geneva and the chapel in the priory in Saint-Germain-en-Laye (p. 117), for which he produced fourteen cartoons for windows in the upper part of the nave; eight of these were made by Marcel Poncet (1894–1953), and six by Charles Wasem, in collaboration with Poncet. These windows portray popular saints, such as Mary Magdalene, Martha and John, as well as others with local relevance, such as St Francis of Sales. A competition was

held in 1918 to design stained-glass windows for Lausanne Cathedral. Marcel Poncet was the winner, but his ten windows aroused great controversy as soon as they were completed. In 1928, another competition was organized for the cathedral's remaining windows, which were assigned to artists such as Alexandre Cingria, Charles Clément and Edmond Bille.

Meanwhile, Abbot Dusseiller was looking for contemporary artists capable of injecting new life into the representation of Catholic doctrine for the church of Notre Dame in Geneva. As a result, this church became a laboratory of new ideas, giving rise to what are known as neo-Impressionist and Cubist stained-glass windows. This undertaking was continued by the Abbot Vogt, who commissioned designs for windows in the transept from Maurice Denis. Alexandre Cingria also produced work for this church, under the auspices of both abbots, and in an article entitled *The Catholic Life* (4 April 1925) he placed special emphasis on his work for Notre-Dame, particularly with respect to the use of colour. The windows in this church feature scenes from the Old Testament that presaged events in the New Testament, such as Solomon predicting the coming of the Virgin and Isaiah announcing to the people of Israel that the Messiah would be born of a virgin.

In 1919, Maurice Denis also co-founded, along with Georges Desvallières, the Sacred Art Studio in Paris, which became a meeting point for artists from various disciplines. Out of this melting pot came the glass artist Marguerite Huré's collaborations with Pierre Couturier on his earliest windows and with Maurice Denis on a church in Nancy in 1923 (one of the first examples of abstract stained glass in a religious context).

World War II, like the Great War, was followed by the reconstruction and redecoration of damaged churches, as well as the commissioning of new religious buildings. The churches that emerged in the forties and fifties often went beyond architecture in the strictest sense, however, and attempted to embrace various art forms, above all stained glass, in a single whole. Henri Matisse (1869–1954) was one of the leading figures in this respect; from 1948 to 1951, he designed a chapel in Vence, complete with murals and stained-glass windows.

Jacques Le Chevalier was another artist who contributed to the renewal of stained glass. He was born in Paris in 1896 and studied in the French National School of Applied Arts from 1911 to 1915. On graduation, he went to work at Les Artisans de l'Autel, the stained-glass workshop run by Louis Barillet – a partnership that would endure until 1945. Along with Théo Hanssen, this team produced Cubist compositions in black and white, set off by fluting, mirrors and other materials. Although these works attracted fierce criticism, Barillet's workshop was a leader in the field of religious stained glass, as his windows scrupulously respected the sanctity of their surroundings. In 1945, Le Chevalier opened his own stained-glass studio in Fontenay-aux-Roses. He saw the medium as a marriage of intimacy and monumentality, and he applied this philosophy in his work of a number of French churches that were rebuilt after World War II – including Doullens, Roche-Posay, Condé-sur-Noireau and Saint-Hilaire-du-Harcouêt – as well as cathedrals in Besançon, Toulouse and Angers. He also designed windows for Echternach Abbey in Luxembourg and various churches and chapels in Switzerland and Belgium. In 1948, Le Chevalier established a Sacred Art Centre, in conjunction with Maurice Rocher.

Other pioneers in the French revival of stained-glass included Jean Hébert-Stevens and Pauline Peugniez, who opened a studio shortly before the 1925 Exhibition of Decorative Arts that sought to apply painterly expertise to the medium. In 1939, Hébert-Stevens organized a similar exhibition in Paris, featuring experiments by painters such as Georges Rouault, Marcel Gromaire and Jean René Bazaine in the field of stained glass, but these explorations were cut short by the outbreak of World War II.

The project that ultimately gave contemporary art a key role in the religious sphere was, however, the restoration of Notre-Dame-de-Toute-Grâce in Assy (1938–49), promoted by Father Marie-Alain Couturier, who managed to enlist the services of Matisse, Bonnard, Rouault and Léger, among other artists. This initiative paved the way for Matisse's chapel in Vence and Léger's

The Virgin and Child depicted in the Gothic windows of Chartres Cathedral are echoed in this contemporary design from the same city.

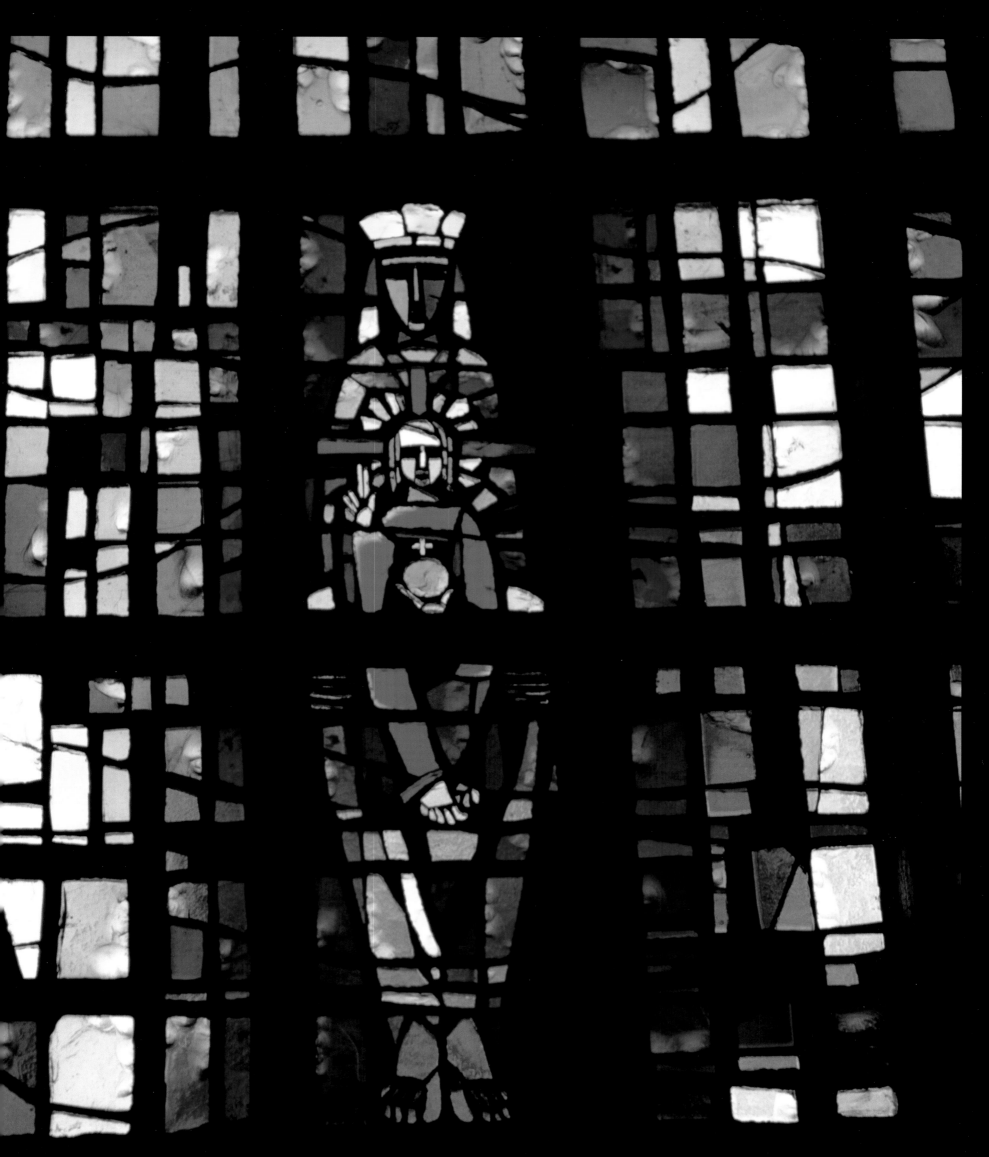

substantial involvement in the church of Sacré-Coeur in Audincourt.

Another French artist who worked with stained glass in the post-war years was Alfred Manessier (1911–93). He first went to art school in Amiens and subsequently moved to Paris in 1931 to continue his training at the School of Fine Arts. In 1945 he began to turn away from figurative expression and went on to forge a reputation as a master of abstraction in religious art. He was the first artist to create monumental, non-figurative windows for a religious building (the Bréseux Chapel in Franche-Comté in 1948), on the recommendation of Abbot Ledeur of Besançon. His other work includes windows for the chapel of Notre-Dame-de-la-Paix in Le Pouldu, Brittany and the church of Saint-Sépulcre in Abbeville (pp. 94, 122–25). Manessier saw stained glass as an integral part of architecture and his windows were characterized by thick black lines set against brightly coloured backgrounds to form geometric compositions.

Reims proved an important focal point for stained glass in the 1960s, thanks to the windows made for its cathedral from 1965 to 1975 by Marc Chagall (1887–1985; p. 109) and those designed for the Foujita Chapel in 1965 by the Japanese painter Léonard Foujita (1886–1968), who converted to Christianity in 1959. Foujita's work attempted to conform to the structures and rules of Romanesque architecture while conveying the fruits of his long personal experience as an artist. Another famous artist who turned his attention to a French religious building in this period was Joan Miró (1893–1983), who decorated the windows in the chapel of Saint-Frambourg-de-Senlis.

The trend continued in the 1970s, for example in the windows designed for a church in Noirlac by Jean-Pierre Raynaud from 1975 to 1976. More recently, in 1991–92, Pierre Buraglio completed a series of works – a *Via Crucis*, abstract paintings and stained-glass windows – for the church of Saint-Germain-des-Prés in Paris. Perhaps the most striking example, however, is that of the windows created by Pierre Soulages for the Romanesque abbey church of Sainte-Foy, Conques; his bold, geometric designs (pp. 164–67) strived for a modern vocabulary for this ancient art. Other French artists on a similar quest included Valentine Reyre and Gérard Garouste.

The painter Valentine Reyre (1889–1943) constantly sought new means of expression. She saw the lead cames on her stained-glass windows as not just a mere criss-crossing of black strips but as an integral part of the composition that served to bring out colour. Her work was imbued with a spirituality verging on mysticism.

Gérard Garouste is another outstanding figure in this field. He collaborated with the master glass artist Pierre-Alain Parot on forty-five windows for the church of Notre-Dame-de-Talant, which include a depiction of the Nativity. These windows are comprised of two layers of glass, one made by traditional means, the other with new technology.

Unlike France, Bohemia and Venice had longstanding traditions of glassmaking that had earned fame all over the world. Spain, however, found itself in a similar situation to France after the Civil War, which brought artistic production to a halt and witnessed the destruction of many buildings, particularly churches with stained-glass windows. These were replaced by new ones, often designed in a neo-Gothic style that was now totally outdated and impeded the search for innovative techniques and imagery. Nevertheless, some exceptional examples of innovative work did emerge, particularly the windows of the Santuari de la Salut in Sabadell, created by Antoni Vila Arrufat, and the church of the Redentorista order in Barcelona (1904–7), designed by the painter Pere Pruna.

In Catalonia, one of the most outstanding glaziers working in the decoration of churches in the fifties was Joan Vila-Grau, who created almost fifty works spread over the whole region, from Caldes de Montbui (1957) to Vilassar (1963), from La Pau parish church (1964) to, more recently, the windows in the upper section of the church of Sant Gregori Taumaturg (1995), both in Barcelona. Also in Spain, the windows made by Albert Ràfols Casamada for the church of the Virgen del Camino (1959), near León, are particularly noteworthy for their spirit of innovation.

The sixties and seventies were marked by a trend towards open-plan churches in which stained-glass windows, mainly of geometric design, played an important role. A representative example in Catalonia is the chapel in the school run by the Madres de la Consolación in Reus (1974), built by Josep Maria Español Boren as a bright space for young people to come together.

Even today, contemporary artists are still using medieval churches as a springboard for their imagination. David Rabinowitch, for example, has recently completed stained-glass windows, tapestries and furnishings for Notre-Dame-de-Bourg, an outstanding Romanesque church in Digne, in south-east France, while in Perpignan, the chapel of St John the Evangelist known as La Funeraria has been endowed with stained glass created by Shirley Jaffe (born 1923), an American artist resident in Paris, that fill the apse and an oculus with brightly coloured geometric designs (p. 106). Not very far away, the Capallet de Ceret, in the region of Vallespir, also boasts some exceptional windows, designed by Alfred Manessier.

In Germany, the period following World War II saw the emergence of a group of artists intent on forging a genuinely German style of stained glass. It was spearheaded by Ludwig Schaffrath (born 1924), Wilhelm Buschulte (born 1923) and Johannes Schreiter (born 1930), with Georg Meistermann (1911–90) acting as a link to the production of the pre-war years. In fact, the work of Meistermann eclipsed the efforts of his younger colleagues with its compositions caught between realism and abstraction, often suggesting meteorological phenomena like storms and lightning, but without ever defining them clearly (pp. 136, 142). These qualities are clearly seen in his window for the south nave of St Mary's Church in Kalk, Cologne, and in his coloured glass wall for the Westdeutscher Rundfunk radio station in Cologne, entitled *Tonal Colours of Music* (1952) and strongly influenced by Joan Miró, with its sinuous black lines surrounding blobs of colour (p. 185).

The work of Johannes Schreiter, in contrast, is distinguished by its linear austerity. His windows, usually crossed by lines, were conceived as extensions of their environment, particularly in the case of the walls of the chapel in the Johannesbund Convent in Leusterdorf, where the opalescent blue glass reflects the geometric purity of the surroundings.

Ludwig Schaffrath made windows that are the antithesis of the traditional colourfulness of stained glass, as can be seen in his work for Aachen Cathedral. Schaffrath was known for combining striking moulded glass cylinders with areas of cement, as in St Michael's Church in Schweinfurt,

Wilhelm Buschulte's stained glass is less imposing than that of his two colleagues, while his limited colour range and draughtsmanship put him in the mainstream of modern German production. A typical example is his window for Essen Cathedral, with a palette restricted to black, white, blue and yellow, applied in irregular lines tracing organic forms.

In post-war religious art in Britain, the rebuilt Coventry Cathedral (1962) is notable for the monumental Baptistry Window (pp. 148–49) by John Piper and Patrick Reyntiens. They broke with tradition and introduced modern elements into the new building – not without some controversy. This pair of artists were reunited to create windows for Liverpool's Metropolitan Cathedral, built by Frederick Gibberd. This building again broke with tradition through its circular layout and concrete structure, supported by flying buttresses that give it a tent-like appearance. The lantern is finished off by pinnacles that incorporate the windows designed by Piper and Reyntiens. One of the dominant themes is the Holy Trinity, represented by three patches of colour against a motley background.

All in all, the increased activity in the field of stained glass in recent years has captured the public imagination and brought glass work to the forefront of decorative art. It is too early to predict the role of religious art in the 21st century, but at the moment it is thriving, especially in France, where it has been promoted for the last fifteen years, despite some opposition, by the National Centre of Sacred Art and the Office of Plastic Arts. Pierre Soulages has been recognized for his stained glasswork at the abbey church of Sainte-Foy in Conques. François Rouan and Jean-Michel Wilmotte have designed windows and furnishings for St John the Baptist's Church in Castelnau-le-Lez, while François Rouan, Jean-Michel Alberola, Gottfried Honneger and Claude Viallat have contributed windows to Nevers Cathedral.

Abstract art made its first appearance in stained glass in 1926 through the windows designed by Jean Arp and his wife Sophie Taeuber for the Café Aubette in Strasbourg, built by Theo van Doesburg. (Most of these windows have now been lost.) It was not until the 1950s, however, that abstraction took centre stage in France, when artists set about systematically restoring the national heritage after the destruction of World War II.

At first, attempts were made to revive traditional methods but the results were not always convincing, as the search for technical perfection and the recycling of hackneyed iconography failed to bring out the potential power of the medium. Many architects still considered stained-glass windows to be a mere decorative element and did not allow their designers to give full rein to their expression. In order for stained glass to recover its former glory, it required the freedom to develop in keeping with the requirements of a new age. Jean Hébert-Stevens was particularly active in promoting new work in the field, particularly through his publication of Georges Desvallières's cartoons for the windows in a charnel house in Douaumont.

We have already mentioned the Dominican priest Father Couturier's defence of the introduction of modern ideas into religious stained glass in the windows of Notre-Dame-de-Toute-Grâce, where figurative representation was totally usurped by geometric design. This gave rise to a generalized use of abstraction, albeit often imbued with evocative Christian symbolism. Father Couturier had in fact anticipated this trend in the magazine *Art Sacré*, which he began to edit in 1937. The following year he wrote an article about the role of stained-glass windows that had sharply divided opinion between lovers of figurative art and supporters of abstraction. In retrospect, this article can be seen as opening up a new path for religious stained glass.

In post-war Germany, stained glass acquired new energy, under the strong influence of the Bauhaus School. Wilhelm Buschulte specialized in religious art, searching for harmony and unity through his use of bold geometrical designs. His work can be seen in the cathedrals of Aachen and Frankfurt. Innovation and experiment were also crucial to the stained glass designed by the artist Jochem Poensgen (born 1931), who used leading not just as a mere structural element but as an essential part of the composition. The windows he created for the St Andreas church in Essen-Rüttenscheid in 1998 are particularly worthy of note. Other important German artists working in this field today include Johannes Schreiter, Renate Gross (born 1956) and Karl-Martin Hartmann.

In Spain, the major practitioners of stained glass in recent times include José Fernández Castrillo, Luis García Zurdo, Keshava, Carlos Muñoz de Pablos, Nini Hernández, José Ignacio Pertegaz, Pere Valldepérez Ripollés and, as previously mentioned, Joan Vila-Grau.

In the 1950s, Vila-Grau began to bring stained glass into line with the latest artistic trends. One particular striking example is the work he designed for the baptistery and parish church of La Pau in Barcelona in 1964. His entire output was marked by a desire to endow stained glass with all the expressiveness of contemporary painting. Luis García Zurdo, who trained in Germany under Josef Oberberger, saw the medium as a fusion of colour, light and materials, as seen in his windows for the residence of the Marista brothers in Vigo (1993). Carlos Muñoz de Pablos is an expert restorer of stained glass – as evidenced by the windows he installed in the cathedrals of Pamplona and Vitoria – as well as an adventurous creator of new work, particularly the sky-light in the vice-chancellor's offices in the Fundación Euroárabe in Granada (1990–91), various free-standing glass panels and a series entitled *Female Portraits*, which enriched traditional techniques with innovative light effects. Nini Hernández and José Ignacio Pertegaz use stained glass as an architectural element or as a means of expression in its own right, sometimes incorporating strips of tin and copper, as in the panel *Glass II* (1989).

The abstract windows produced by the artists Enrique Barrio, Santiago Barrio and Ximo Roca have explored the expressive range of stained glass. The introduction of an abstract window always involves a transformation of its surroundings and the architect Antonio Luis Sainz Gil (born 1952), working under the name of Keshava, confronts this challenge head-on by creating glass works such as *Awakening of the Planet* (1993). Set into an office block at 640 Avenida Diagonal, Barcelona, this work comprises a stained-glass window measuring 24.5 x 21.6 m, depicting the planet Earth, and is accompanied by a glass sculpture entitled *Permanent Eclipse*.

The work of José Fernández Castrillo revolves around transforming the image portrayed by stained-glass

Detail of a contemporary stained-glass window in Pilbara, Australia, its forms and colours capturing the hues of the Australian landscape.

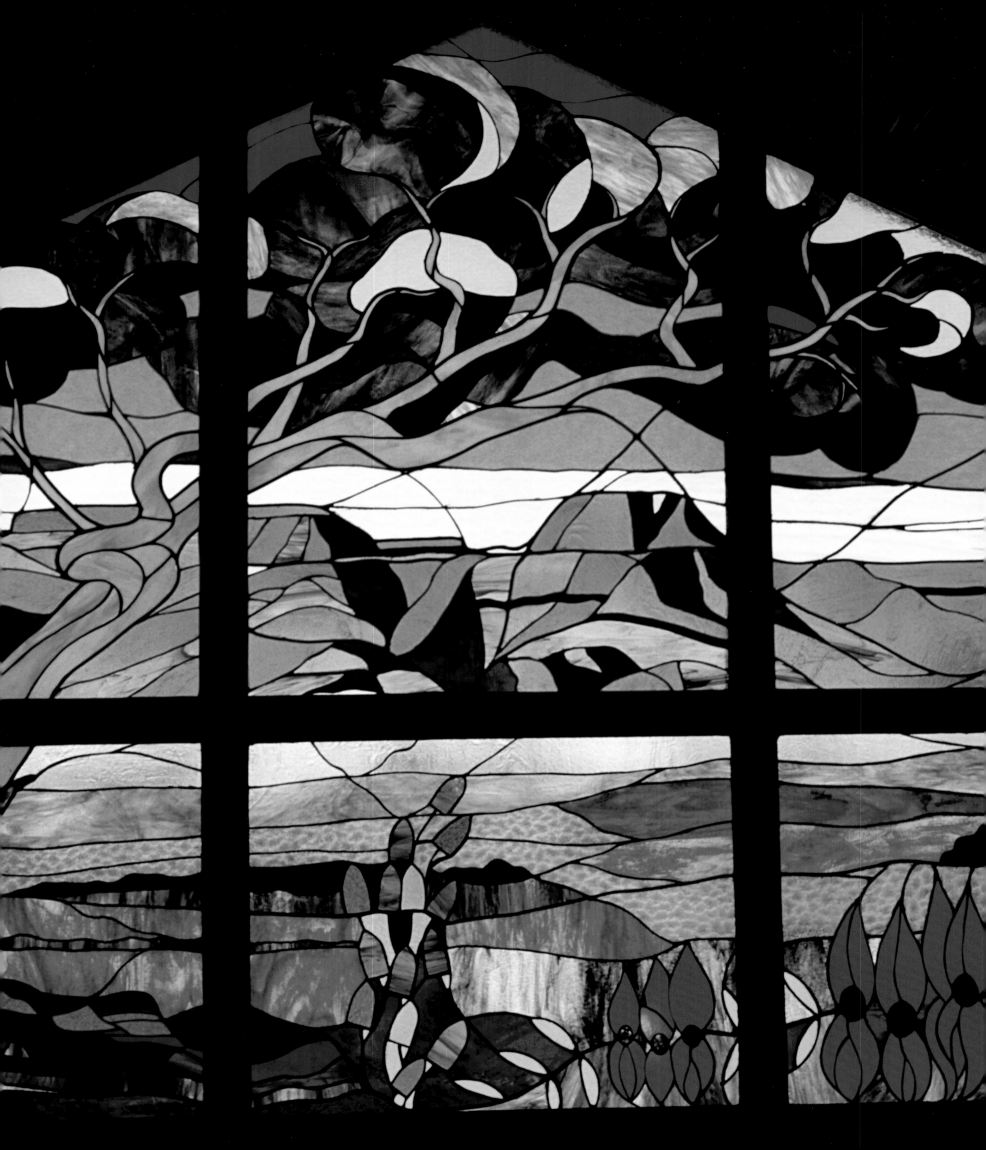

windows through the addition of other materials. The highly symbolic *Alpha-Omega*, commissioned by the Barcelona Funeral Service in 1987, and *Science and Nature*, created for the Barcelona branch of the Bayer pharmaceutical company in 1996 (p. 184), illustrate his predilection for combining geometric and organic elements, as well as applying materials like silicone, glue and resin to join together pieces of glass. Fernández Castrillo also contributed windows to Barcelona's Church of Santa Maria in 1995.

In Britain, the 20th-century revival of stained glass was linked with experimentation from the outset. It was from this context that the extremely colourful and internationally renowned work of Brian Clarke (born 1952) emerged. One of his most exceptional projects was realized in 1982 for the King Khaled International Airport in Riyadh, Saudi Arabia, with over 2,000 m² of stained glass that playfully combines geometrical forms and Islamic decorative motifs. In 1996, Clarke designed 14 windows (made in Franz Mayer's studio in Munich) for the Abbaye de la Fille-Dieu in Romont, Switzerland. These windows harmonize perfectly with the almost monochrome building but subtly add splashes of colour to enliven the interior.

An artist famous for his bold innovations is Alex Beleschenko (born 1951), who works from a studio in Swansea. He was responsible for the stained-glass windows at Stockley Park, Hillingdon, London, completed in 1986. Another leading British artist in the field is Graham Jones (born 1958), who shares Clarke's exuberant sense of colour. In 1992, Jones was commissioned to design a window for Westminster Abbey in London, which was fitted two years later. It is dominated by shades of blue and inscribed with the names of great English poets. In the last decade, Jones has been extremely prolific, receiving commissions from clients as diverse as Stockport Shopping Centre (1995) and for the Harlow offices of the SmithKline Beecham pharmaceutical company (1997).

In Italy, technical innovation was not a strong point in 20th-century stained glass, despite notable individual efforts over the decades. In 1900, for example, the craftsman Giulio Cesare Giuliani (1882–1954) founded Vetrate d'Arte Giuliani in Rome, and his high-quality glass soon found an international market and attracted major artists

from all over Europe. Giuliani's heritage still thrives today. In 1997, the company created stained-glass windows for the Villa Torlonia in Rome, following original designs drawn up over a century earlier. It also collaborates with major contemporary artists, including Paolo Portoghesi, Luigi Ontani and Piero Dorazio, and it has led the quest for a new idiom in Italian religious art. Particularly outstanding in this respect are the abstract window on the theme of the *Pietà* designed in 1971 by Father Tito Amodei (born 1926), and the series of windows created in 1970 by Father Costantino Ruggeri for the church of Sacro Cuore in Pavia, based around the evocative power of light and colour.

The insertion of new stained-glass windows into pre-existing buildings has sparked a variety of responses from Italian artists. Michele Canzoneri (born 1944), for example, stresses the symbolic function of light and colour at the expense of figurative representation, thereby moving close to abstraction. In 1990 he created forty-two windows for the Duomo in Cefalù, Sicily, based on the Biblical books of Genesis, the Acts of the Apostles and Revelations. Other Italian artists of note in this field are Giuliano Giuman (born 1944) and Roberto Alabiso, founder of the Studio Iride in Palermo.

The Hungarian Giovanni Hajnal (born 1913) is a modern artist who has created numerous stained-glass windows in various countries. His work is distinguished by its adventurous use of colour and its debt to expressionism. Hajnal has created windows for the Duomo in Milan (1954 and 1988) and the rose window for Palma Cathedral in Majorca (1955).

As we have already seen, France stands at the forefront of the contemporary output of stained glass, and many of its glass artists have forged an international reputation. One of these was Olivier Debré (1920–99), whose work was loaded with dynamism and elegance, often achieved through the use of a limited colour palette. His windows can be seen in the chapel of St Maudé in Morbihan, Brittany (1996–97), the church of Notre-Dame-de-Lugagnac, in Lot-et-Garonne (1998) and at Notre-Dame-de-Grande-Puissance in Lamballe (1999; designed in conjunction with Geneviève Asse).

Claude Rutault (born 1941) recently created monochrome windows (in red, blue and yellow) for the church of Saint-Prim in Isère, where the different colours of the

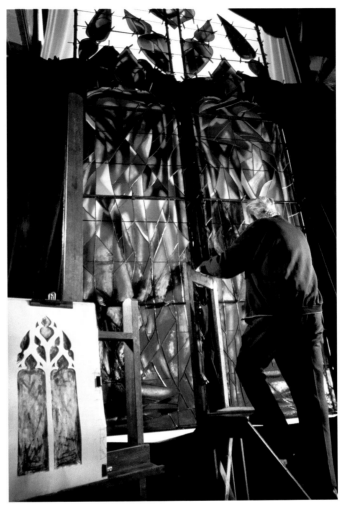

stained glass mark out the various interior spaces. Pierre Zurich is a painter with a restless curiosity for all forms of visual expression, including stained glass. His work in this field can be seen as a meditation on light and the atmospheres that it can evoke. Some of his stained glass is inspired by Matisse, whose simplicity of colour and form, combined with a fine sense of rhythm, has exerted a strong influence.

Outside Europe, contemporary stained glass has particularly flourished in the United States. The boom sparked by Tiffany was followed by a slump; it was not until well into the 20th century that a revival took place, which began to produce large, Gothic-style cathedral windows. Charles J. Connick (1875–1945), the leading figure in this trend, rejected iridescent glass in favour of transparency. Most of his religious windows featured a blue ground, as in those for the neo-medieval chapel of Princeton University.

The revival of stained glass in the United States owed a great deal to the enthusiasm of the architect Frank Lloyd Wright (1867–1959). While still a student in the University of Wisconsin, he read the work of John Ruskin and adopted the ideas of A. W. N. Pugin as the guiding principles of his work. Wright believed that materials should not be disguised but allowed to display their natural qualities, while buildings should blend with both their surroundings and their furnishings. He saw windows as an integral component of architecture and from 1886 to 1933 he designed around 150 houses that incorporated leaded glass. These include the Coonley House (p. 182), where he created glass discs reminiscent

Above left:
Restoration of a window designed by John La Farge, in Hoboken, New Jersey, in 1993.

Above right:
The painter Jacques Simon adds the final touches to a stained-glass window in his studio in Reims in September 1968. He uses the time-honoured method of enlarging a small sketch to scale.

of children's balloons, and the Martin House, which had over a hundred windows and a skylight made of amber squares that created a warm, inviting setting. In 1954, Wright used stained glass in the Danforth Chapel at Florida Southern College in Lakeland (p. 132).

American architecture gradually began to adopt the combination of faceted glass and concrete. The first building based on this technique was the First Presbyterian Church in Stanford, Connecticut, which was completed in 1958. After this first experiment, it became increasingly common to find sheets of stained glass being set in concrete by glass workers such as Emil Frei (1896–1967) in Saint Louis, Bernard O. Gruenke (born 1913) of the Conrad Schmitt Studios in Milwaukee and Roger Darricarrere (1912–83) in Los Angeles. This technique was not confined to places of worship but also extended to striking examples of civil architecture, such as the illuminated glass and aluminium mural in the KLM building in New York, designed by Gyorgy Kepes (1906–2002). A whole new generation of young American glass artists also emerged, with Paul Marioni (born 1941) at the helm, capable of creating challenging work in a secular setting.

Meanwhile, in Canada, the first stained-glass workshop had been founded in Toronto in 1850 by Robert McCausland, who had studied traditional techniques in Ireland. He went on to dominate stained-glass production in Canada for decades and his company still works in the field today. Another figure of similar importance in the 20th century was Yvonne Williams (1901–97), who learned her craft in the United States and opened her own studio – again in Toronto – in 1934. Many of the outstanding Canadian glass artists of later years served their apprenticeship with Williams.

The origins of stained glass in Mexico date back to a window created by the Italian-Swiss glazier Claudio Pellandini in 1875. Twenty-five years later, he opened the first stained-glass workshop in the country and later joined forces with the American Wineburgh studio. Pellandini based his work on medieval models, with few technical innovations but iconographical variations suited to the new setting. A greater spirit of adventure would be displayed by the architect of the Teatro de Bellas Artes in Mexico City, the Italian-born Adamo Boari (1863–1928), who commissioned a decorated fire curtain, firstly from the Hungarian Géza Mároti, then (having rejected Mároti's design) from Tiffany Studios. The end result, designed by Harry Stoner in 1909, is a monumental mosaic of opalescent glass depicting a Mexican landscape with two volcanoes, seen through a window frame. Mároti later endowed the auditorium with a large circular ceiling of iridescent stained glass depicting Apollo and the muses, although the 1910 Revolution delayed its installation until 1924. Another landmark in the development of stained glass in Mexico proved to be the Art Nouveau roof designed by Jacques Gruber for the Centro Mercantil department store in Mexico City in 1908 (now the Gran Hotel). It is highly colourful and features an array of plant motifs, arranged around three oval shapes running lengthwise across the composition.

In 1920, Villasén set up a stained-glass department in the Architecture School in the University of Mexico City. In 1929, Diego Rivera produced sketches for the windows in the Palace of Health, which were brought to life by Villasén himself. Jumping forward to 1982, the painter Rufino Tamayo designed El Universo, a laminated glass mural measuring 57.6 m², made up of 30 glass panels, and made by the Glasindustrie Van Tetterode, in Amsterdam. The largest laminated work of art in the world, it is on display at the Planetario Alfa in Mexico City.

Nowadays, however, contemporary Mexican artists are confronted by the prohibitive cost of working with stained glass. One way round this problem is the use of pieces of transparent glass, which are bevelled one by one before being put together, allowing light to create effects along the joins and contours of the glass. This technique is often used in contemporary Mexican architecture. Another alternative consists of fusing pieces of coloured glass to a transparent base.

One particularly striking example of modern stained glass in Mexico is the window depicting the Virgin that runs along the upper section of a wall in a church in Ciudad Juárez (p. 95). Of the Mexican artists currently working with stained glass, one of the most interesting is Armonía Ocaña, who is especially interested in harnessing the effects of reflection.

Going to other continents, Japan does not have a long tradition of stained glass. Its first studio was opened in 1899, by the country's pioneer in the field, Unozawa,

The decorative spirit of Native American art is reflected in this mural on the façade of the Seneca Niagara Casino, near Niagara Falls, in New York State.

who was trained in Germany. In 1930 he merged his firm with that of Matsumoto. Stained glass became very popular in Japan after World War I. Although it maintained its own production, it also imported both work and artists from elsewhere, as in the case of the *Symphonic Sculpture* (p. 191) created by French artist Gabriel Loire (1904–96), which is on show at the Hakone Open-Air Museum, near Tokyo. This is a spectacular 21-metre tower with 480 brightly coloured glass panels portraying the world of children's fantasies, complete with flowers, stars, animals, moons and clowns that can be enjoyed from the spiral staircase running up the centre. Other stained-glass windows by foreign artists include those of St Anselm's Catholic Church in Tokyo, made by the Willet Studios, and those of Kyoto Cathedral, designed by Swiss artist Hans Stocker (1896–1983).

Although stained glass does not have the same standing in Japan that it does in Europe, particularly in religious art, some noteworthy modern windows have nevertheless been produced there – in the Fujiya Hotel in Hakone, for example. Japan can also boast a promising young exponent of the craft – Yoshiro Oyama, who trained in Montpellier, France, and worked with Patrick Reyntiens on the windows of Washington National Cathedral.

Australia is a young country, and so is its art, but it has the advantage of having been enriched by influences from all over the world. Australia started importing

stained glass (suitably decorated with local flora and fauna) from Britain in the 19th century, but the first stained-glass workshops did not open until the 1930s. The most outstanding Australian artist in the field is Leonard French, born in Melbourne in 1928, who trained in Europe, where he was influenced by the work of Léger, Manessier and Delaunay. French's early windows did not tackle religious subjects, but his subsequent creations have increasingly revealed a spiritual bent. His 50 x 15 m ceiling for the National Gallery of Victoria in Melbourne, made up of 224 panels of glass, depicts a large sun surrounded by birds and tortoises, which French described as the 'bearers of life'.

The Australian cultural awakening of the 1950s bore fruit in this field in the seventies, with the emergence of several artists keen to promote stained glass.

Moving on to Africa, Paul Blomkamp (born 1949) is one of the leading practitioners of stained glass in South Africa. He has been obliged to adjust his technique to the resources available; in his early days, for example, he was unable to find lead came and so replaced it with resin bonding, thereby leading him to use thin glass rather than thick dalles. Earlier impressive work from South Africa includes the windows of the St Peter's Church (1913) in Sabie, Mpumalanga, designed by Sir Herbert Baker, that are distinguished by their bright colours and the bold black lines that trace the Christian symbols of bread and wine, thus stressing their geometric elements. In Liberia, the American artist Reid Harvey has taught the art of stained glass to local students, and together they created windows of great formal simplicity, based on indigenous motifs, for a church in Monrovia.

In Cuba, some public buildings, private houses and administrative offices have been fitted with stained-glass windows influenced by the Spanish modernist movement. Many foreign artists came to the island to create their work in situ, as in the case of this house in Havana.

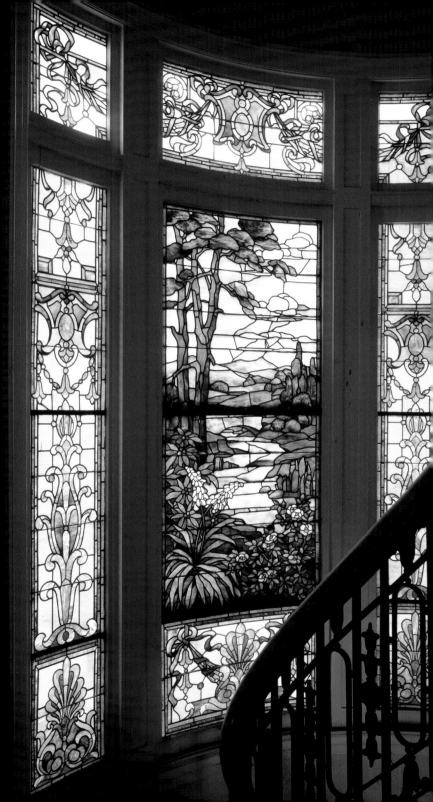

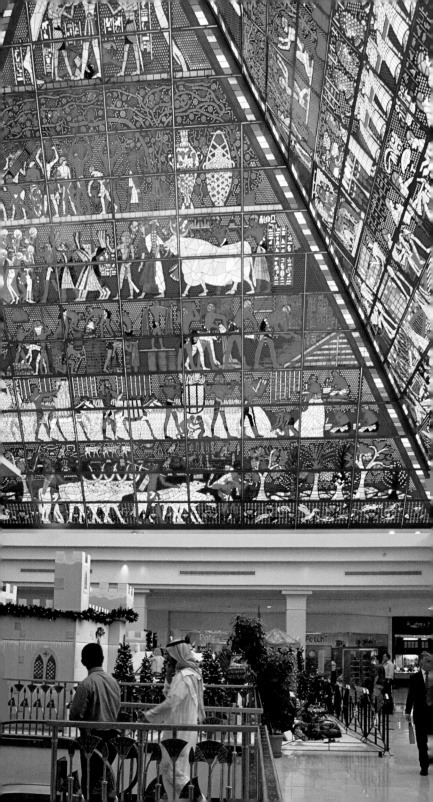

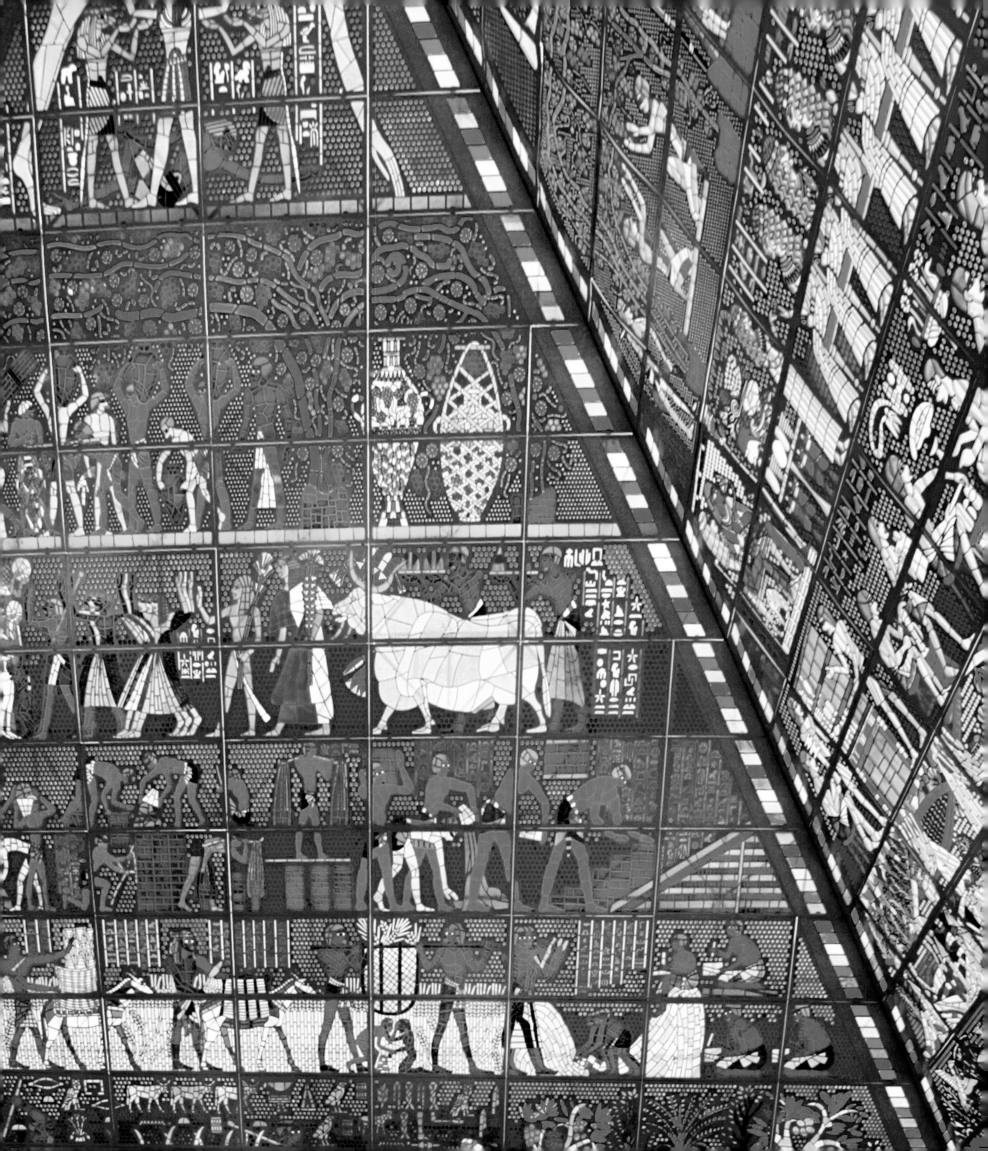

JVRI SIS

LAVSANNEN

✠ O ⋅ GERENTE ⋅ DE ⋅ FECIT ⋅ PARIS ⋅ ✠ D ⋅ O ⋅ M ⋅ DCCC ⋅ LXVI

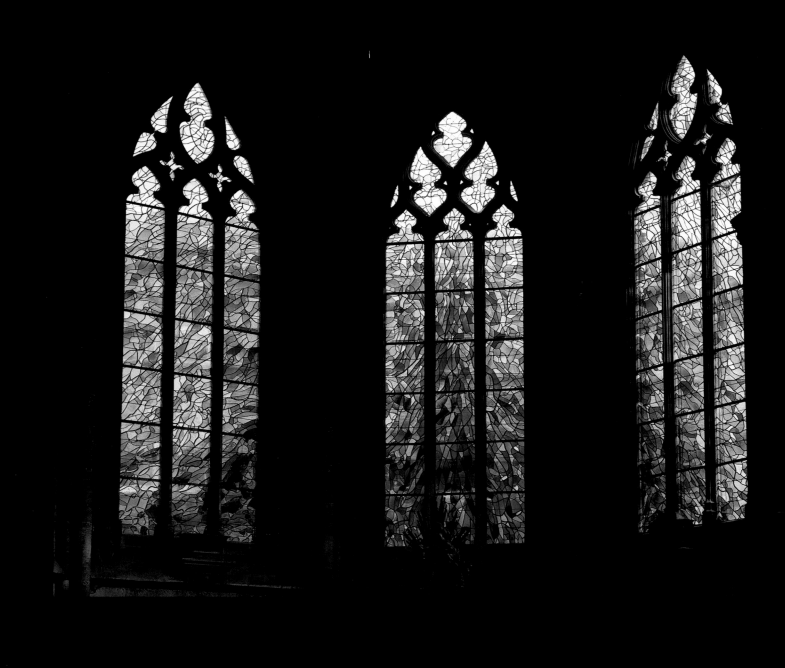

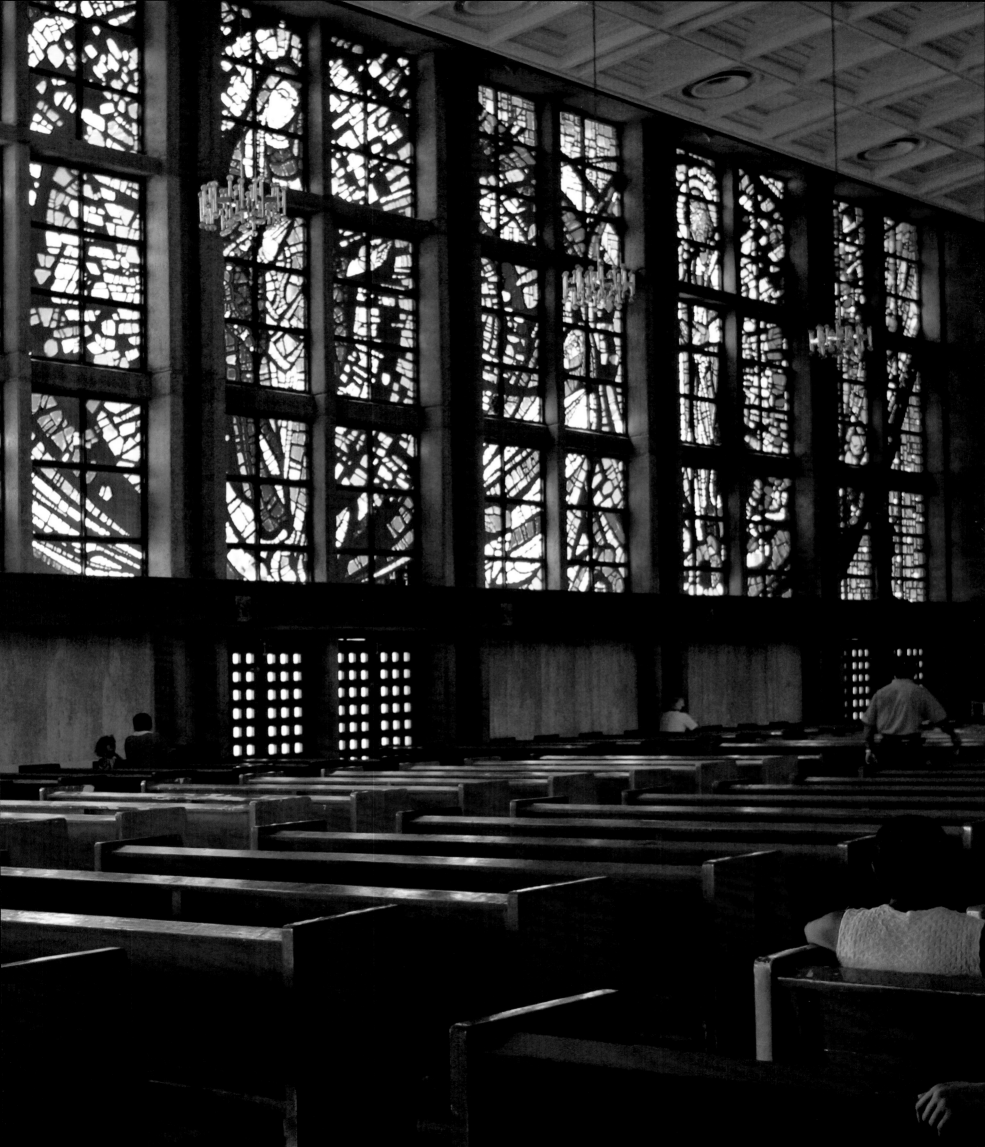

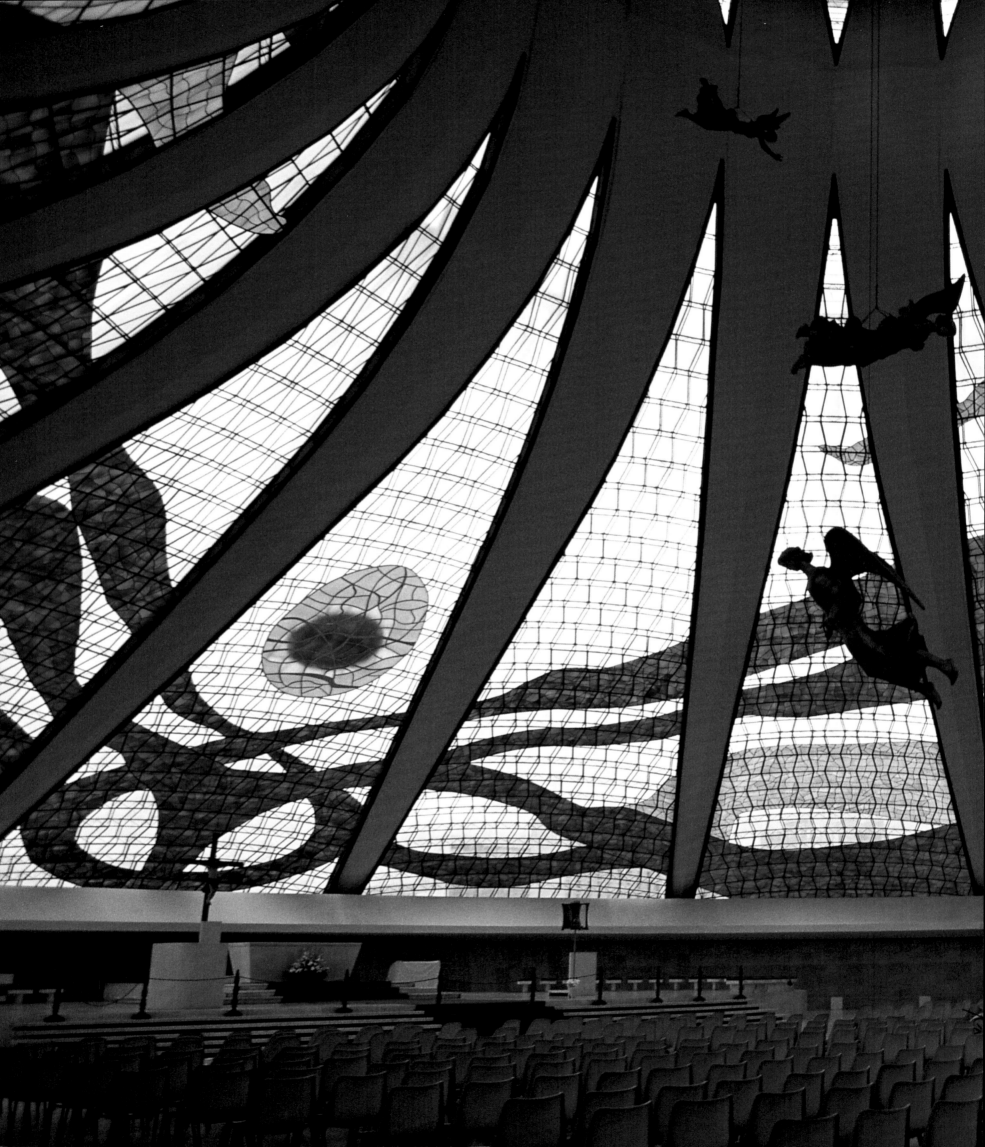

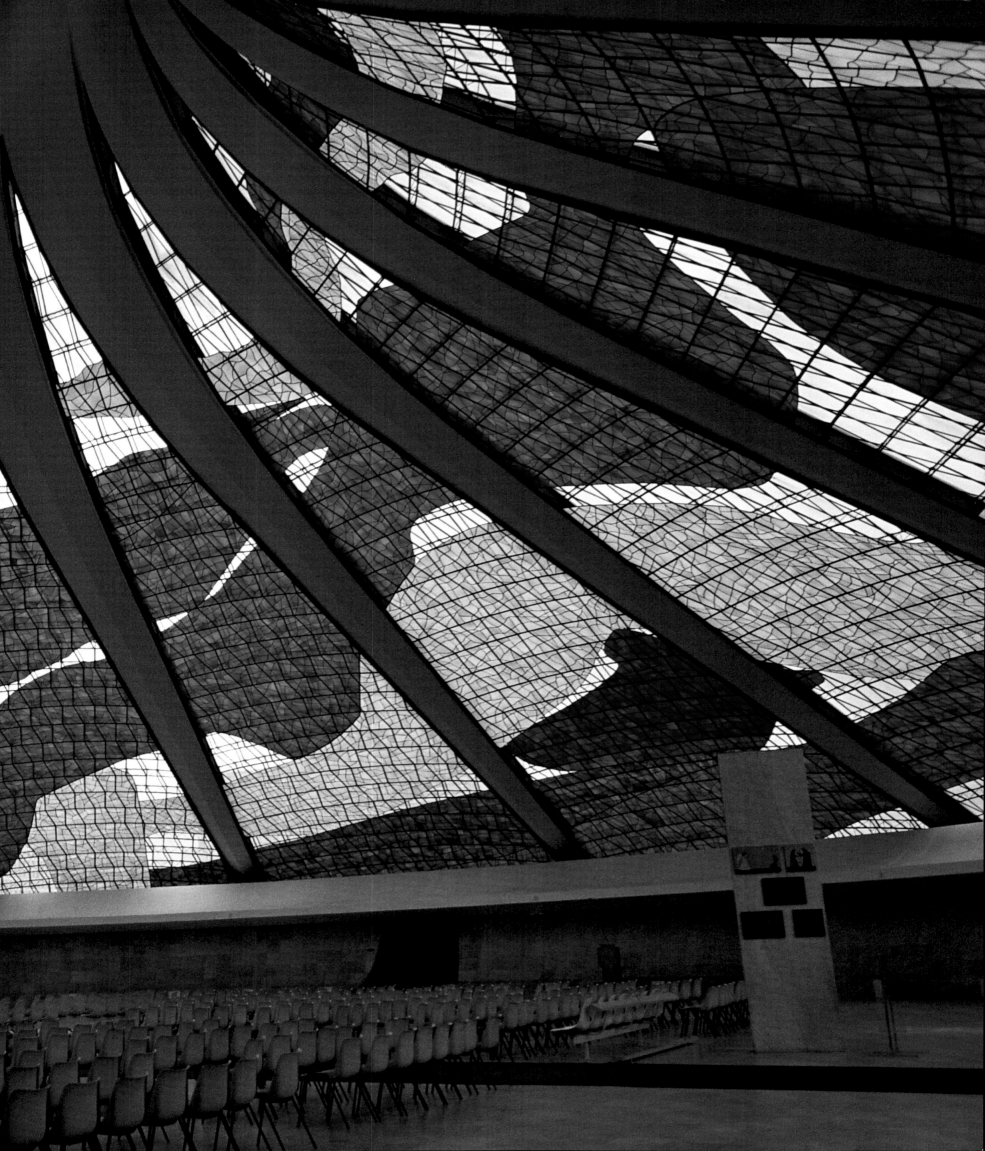

p. 62

pp. 76–77

pp. 78–79

p. 80

p. 81

p. 82

p. 83

p. 84

p. 85

p. 86

p. 87

p. 88

p. 89

pp. 90–91

pp. 92–93

p. 94

p. 95

pp. 96–97

pp. 98–99

p. 62

Stained-glass windows have been used on every continent to decorate both civil and religious buildings. Often the main aim is merely to provide variations of light in an interior, as with this hand-blown glass in Cape Town, South Africa.

pp. 76–77

A decorative stained-glass ceiling in the Wafi Shopping Mall in Dubai; in keeping with the pyramid shape, the glass portrays scenes from ancient Egypt.

pp. 78–79

The artist Domènec Fita has produced religious decorations in the form of both sculptures and stained-glass windows. This detail from the Dominican Church in Girona, Spain, illustrates how skilfully he combines figurative forms with a geometric composition.

p. 80

Several generations of craftsmen worked on Lausanne Cathedral, Switzerland, from the mid-19th century to the 1930s, turning it into a veritable museum of European stained glass in a religious setting. This heraldic window of 1866 was designed by Rodolphe Blanchet.

p. 81

Decorative stained glass in Kashan, Iran.

p. 82

This stained-glass window in Surakarta, Indonesia, depicts local musicians in traditional dress.

p. 83

The spiritual traditions and traditional iconography of Indian art are evident in this contemporary window from Jaipur.

p. 84

In Cartagena, Colombia, the colonial introduction of Christianity is reflected in these windows by the altar in the church of San Pedro Clavé.

p. 85

In the cathedral of Notre-Dame-de-Papeete, Tahiti, vivid colours and local iconography are integrated into a wider religious context.

p. 86

German neo-expressionism provides the inspiration for this image of Christ on the Cross, surrounded by his disciples, in the Church of the Holy Spirit, in Swabia, Germany.

p. 87

Majestas Domini, *a monumental figure of Christ designed by contemporary German glass artist Christian Oehler.*

p. 88

Religious stained glass in Italy has continued reproducing the traditional elements of Christian art throughout the 20th century, as in this window by Giuseppe Modolo showing the Madonna and Child, with St Catherine of Siena, and the Archangel Michael slaying a dragon.

p. 89

In the Casa do Douro in Peso da Régua, Portugal, the stained-glass windows illustrate religious themes in a realistic style.

pp. 90–91

This restrained combination of colour and geometric shapes enriches the interior of the yali (villa) of Said Halim Pasha, on the banks of the Bosporus in Istanbul, Turkey.

pp. 92–93

This decorative glass wall above the main entrance to Prague's Municipal House adds colour to the interior of this modernist setting and uses a combination of stained glass and metal framework to create an impressive exterior.

p. 94

The French artist Alfred Manessier produced these windows with geometric decorations from 1982 to 1993 in the Lorin workshops in Chartres for the presbytery of the church of Saint-Sépulcre in Abbeville, France.

p. 95

Decorative stained-glass windows in a church in Ciudad Juárez, Mexico.

pp. 96–97

The French artist André Dunoyer de Segonzac (1884–1974) designed the windows for the Basilica of Our Lady of Altagracia in the Dominican Republic; they were completed by the architect Pierre Dugré in 1972. Note the striking verticality of both the windows and the architecture.

pp. 98–99

Brasilia Cathedral, designed by the architect Oscar Niemeyer (born in Rio de Janeiro in 1907) is the setting for these stained-glass windows created by Marianne Peretti in 1970.

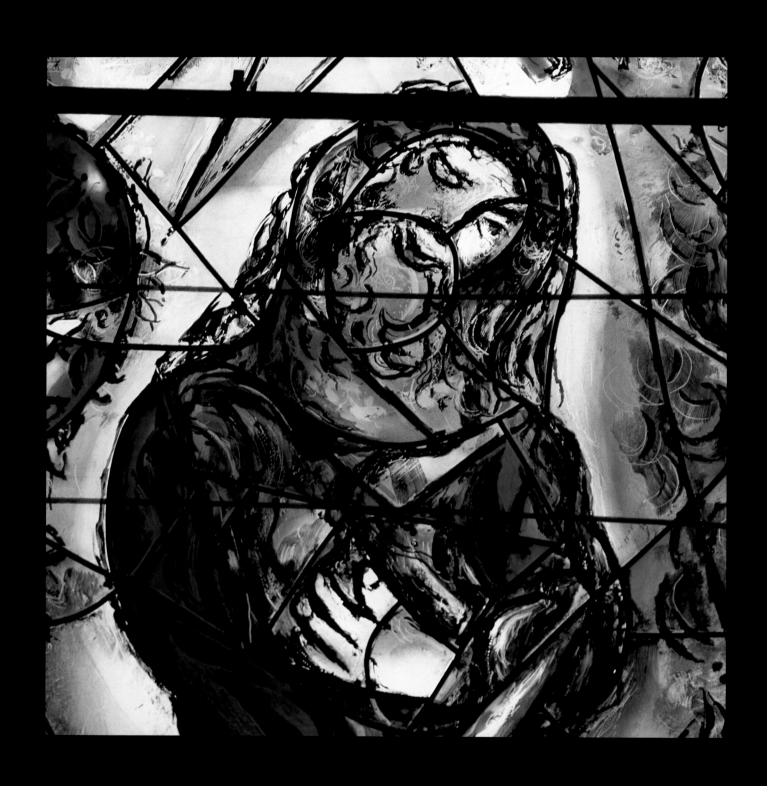

ARTISTS OF OUR TIME:
GEOMETRY, COLOUR AND SPIRITUALITY

The art of the stained-glass window has always depended on architecture – particularly religious architecture, as it first made its mark in medieval churches – so it has had to evolve in line with architectural developments. The 20th century witnessed great changes as a result of the widespread use of new materials like steel and concrete, and these were accompanied by the practices of incorporating thick sheets of glass directly into a building's structure and fusing pieces of glass to avoid inserting lead cames.

These technical advances have provided modern glass artists with richer means of expression and greater artistic freedom. The years following World War II were crucial in this respect, as both civil and religious architecture began to bestow increasing importance on stained glass. In France, for example, church authorities commissioned windows from major artists such as Henri Matisse, Georges Braque and Fernand Léger, who drew away from figurative representation and moved towards abstraction. Religious buildings in Britain also began to embrace abstraction, as seen in the depiction of the Holy Trinity in the Liverpool's Metropolitan Cathedral.

The post-war reconstruction of Germany involved the restoration of many churches that had been damaged in the conflict, thereby giving rise to close collaboration between architects and glaziers. A new generation of stained-glass artists, mostly based in Munich, experimented with colour combinations and used leading to place a new emphasis on line. The medium proved broad enough to embrace their individual concerns. Johannes Schreiter allowed his strong Japanese influences to shine through, while Ludwig Schaffrath and Dominikus Böhm (1880–1955) showed their predilection for soft colours, as in the latter's windows for the St Maria Königin church in Cologne, and Jochem Poensgen juxtaposed glass and concrete in the Christuskirche in Dinslaken. This pioneering group of artists has yet to be matched in Germany for its adventurous handling of stained glass.

As already mentioned, the French revival of stained glass attracted several famous artists. The process was kickstarted by the church of Notre-Dame-de-Toute-Grâce in Assy, even though its stained glass did not prove entirely successful, as the mixture of diverse styles did not always gel to form a harmonious whole. It was a fruitful initiative, however, as it plunged stained glass into the world of modern art.

In the forefront of the artists who contributed to this spirit of renovation stood Henri Matisse (1869–1954), whose work in this field moved away from figurative forms. Matisse designed not only the windows but also the murals and floor of the Dominican Chapel of the Rosary in Vence, near Nice (p. 135). He saw his stained-glass windows as an aid to meditation, a cue for onlookers to shed their worldly cares.

Georges Braque (1882–1963) and Fernand Léger (1881–1955) also adapted their artistic interests to the requirements of stained glass. Braque, for example, designed the windows for St Dominic's Chapel in Varangéville (1953–54), using luminous, sharply defined forms in keeping with contemporary trends in the field. One of the most powerful scenes shows the red-skinned figure of St Dominic, soaring upward from the top of a pedestal. This window is flanked by two others, portraying what seem to be snakes. The dominant colours are yellow and blue, marked out with bold black outlines. Léger, for his part, endowed the church of Sacré-Coeur in Audincourt with a spectacular frieze spanning three walls, made of one-inch thick sheets of glass embedded into the masonry (pp. 120–21, 160–61). Léger was an atheist but he created a work resonating with Christian symbolism, conveyed through brightly coloured firms with black edges, in the style of his paintings. He was also responsible for a window entitled *The Sacred Robe*, now part of the Vatican's collection of modern religious art (p. 119).

The painter Marc Chagall created many stained-glass windows, always in his distinctive style. He sought the luminosity typical of his paintings through the medium of glass, and he used leading to give his figures greater dynamism. In particular he won fame for his windows in

the Hadassah University Medical Centre in Jerusalem (pp. 186–189) and in Reims Cathedral (p. 109).

Chagall's first encounter with stained glass took place in 1948, in St Michael's Church in Bréseux, and it proved a turning point in the field, as it was the first time that non-figurative windows had been added to an old church. Another important project was St Peter's Church in Arles, with windows commissioned from Chagall by the architect Pierre Vago and made in François Lorin's workshop in Chartres. The two large and twenty-two small windows, which explore liturgical themes, were installed in 1975.

Georges Rouault was another painter fascinated by stained glass. The windows he contributed to Notre-Dame-de-Tout-Grâce in Assy echoed medieval styles but added expressionist touches such as anguished figures and intense, violent colours.

The art of the French stained-glass window gradually acquired a radically geometricized approach. One of the most representative examples of this trend was the work of Maria Helena Vieira da Silva in Reims (1966).

In recent years, contemporary stained glass has sparked a debate on the integration of contemporary art into our religious heritage, much of it dating back to the Middle Ages. Modern glass artists and designers are confronted by decisions about light and colour in churches that were built to fit the religious criteria of a different era; as attitudes to spirituality have changed, so has the architecture intended to embody its expression. Artists intervening in a Romanesque or Gothic church have to strike a balance between respect for the past and the expectations of the present by attempting to breathe new life into tradition.

In 2001, a French exhibition explored these dilemmas through an exhibition of modern stained-glass window designs, alongside texts by their creators discussing the challenge of representing the sacred in ancient monuments by means of modern devices such as geometric forms and monochrome colour schemes. These statements throw light on the process of reflection underlying many religious stained-glass windows.

One of the encounters between a major 20th-century artist and an important religious building that attracted most media attention was the work done by Pierre Soulages for the Romanesque abbey church of Sainte-

Foy in Conques (pp. 164–67). Soulages, who was born in Rodez in 1919, was one of the leading lights of the Parisian school that emerged after World War II. From the late 1970s, his paintings – often grouped in a series of panels – were distinguished by a paradoxical marriage of acute sensitivity to light and a predominance of black, combined with other dark colours and occasional patches of unpainted canvas. His application of black paint is so finely judged that his paintings seem to shimmer under light and even change colour.

This expertise informed his intervention in the medieval church of Conques, replete with a history that he took very seriously: 'Right from the start, I was moved solely by the desire to serve this architecture as it now survives, respecting the purity of the lines and proportions, the modulations in the colours of the stones, the organization of the light, the life of such a special space. The ultimate aim of my research was to make these elements visible.' In his attempt to cast light on the stone without destroying its subtle variations, Soulages meticulously chose glass that emphasized the formal distinction between luminosity and opacity, between openings and walls, and he opted to contrast the forthright vertical thrust of the church's vaults and semi-circular arches with fluid, oblique and slightly curved lines, imbued with a slight tension that also created upward movement: 'The view of the stained-glass windows from the interior is associated with that of the exterior, with one deriving from the other, according to whether the natural light is reflected or transmitted by the glass.'

Aurélie Nemours (1910–2005) was born in Paris and belonged to the generation of painters who experimented with geometrical abstraction after World War II. She studied art history at the Louvre School, before continuing her apprenticeship in Paul Colin's studio and then, in 1941, enrolling in André Lhote's academy, where she stayed throughout the war years. In 1948, she started working with Fernand Léger. Although Léger never made a total commitment to abstraction in his work, Nemours did take the plunge into this new idiom. It was not until 1953, however, that her mature style began to emerge, with its reduced vocabulary of essential geometric elements: horizontals, verticals, right angles, rectangles and squares (p. 107).

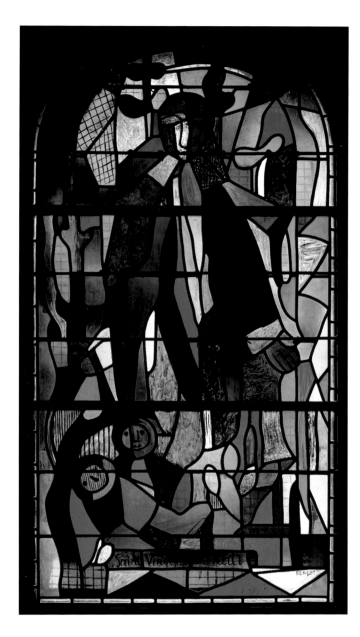

Between 1938 and 1949, the architect Maurice Novarina built a church in Assy, France, that is a veritable museum of religious art containing work by Matisse and Léger, among others. This illustration is Paul Berçot's depiction of St Vincent de Paul, founder of the order of the Daughters of Charity, the strong figurative details standing out against a purely abstract background.

The transposition of this bold and distinctive visual language to stained glass resulted in a pictorial poetry charged with sensuality, despite the austerity of the forms, and the rigour of the composition, calculated to painstaking perfection. Her highly personal handling of blocks of colour invites reflection by meditating on the order of the world, broken down into three fundamental aspects: rhythm, numbers and colour. The relationship between painting and life in Nemours's Constructivism gives rise to a spirituality that is a mark of freedom, going beyond the monotonous, almost obsessive appearance of the rhythmic relationships between horizontals and verticals. Rhythm is expressed by form, and in Nemours's work these stimulate silent contemplation by means of variations in lines and surfaces, right angles, crosses and squares. In Nemours's windows for the priory church of Notre-Dame-de-Salagon in Provence (1988), these technical devices are used to convey a sense of transcendence that has yet to be surpassed in stained glass. For this project she created five bright red stained-glass windows marked with black lines and crosses that simulate medieval leading and fit in with the purity of the Romanesque style. In Nemours's words: 'The silence and space of the stone lay down the essential rhythm for the stained-glass windows and the purple that inundates it.' The relationship between Nemours's spirituality and her work is especially intimate: 'The sacred is the meaning of art and even philosophy.'

Nemours is not alone among contemporary artists in experiencing this intense relationship between spirituality and the medium of stained glass. This is obviously particularly true of practising Christians like Alfred Manessier, who considered a church as a 'place of mystery, a mystery that is manifested through stained glass.... That is its true function. Architecture and glass must create the place of mystery together.' His first commission for windows was for St Michael's Church in the small town of Les Bréseux in eastern France. It was followed in 1953 by new windows for the church of St Pierre de Trinquetaille in Arles, which was rebuilt after World War II by the architect Pierre Vago (1910–2002). For these, Manessier worked in the Lorin studio in Chartres to create geometrical designs inspired, in the presbytery, by matins and, in the gallery, by vespers. Manessier explained his approach as follows: 'I like

joining up my simple pieces of pure glass with the mesh of lead that gives them meaning, using their transparency to make them fit with the exterior light in a kind of exchange and enhancing their projection in unity with the interior of the sanctuary.'

Another artist responsible for many religious windows was Léon Zack (1892–1980), a Jew who converted to Catholicism. He was born in Russia but in 1923 he settled in France. The windows he produced for churches in Urschenheim and Kirchberg in Alsace were marked by their geometrical abstraction, but two years later he was placing greater emphasis on colour in the Romanesque church of Notre-Dame-de-Nazareth in Valréas, Provence. Zack summed up his philosophy thus: 'Underlying non-figurative art and all its reflection there is a sense of man's spiritual and physical unity, which he strives to express through artistic means...this path seems to me to be the only one that is currently capable of penetrating the mystery of mankind and the world.'

Brittany is distinguished by the work of Jean Le Moal (1909–2007), who contributed windows to many churches in the region from 1956 onwards. He also collaborated with Manessier on the windows in Les Bréseux and was involved with the magazine Art Sacré. Le Moal created an expanse of stained glass covering some 300 m² in Saint-Malo Cathedral, and another covering over 500 m² in Nancy, ensuring himself a permanent place in the history of the medium. At the age of 92, he declared: 'For me, stained glass must, above all, create a light in a given space in which one is bowled over by the atmosphere – of prayer, for those who want to pray, of silence and dignity for those who do not pray.'

In 1994, Marc Couturier (born 1946), working in conjunction with the Fleury studios in Toulouse, designed windows for the church of Saint-Léger in the town of Oisilly near Dijon, coinciding with the restoration of the 12th-century building. The theme, inspired by the third and fourth days of creation in the Book of Genesis, was conveyed by evoking a landscape through photographic imitations of bluish greens and golden oranges suggestive of plant forms, along with points of light symbolizing stars: 'When images of nature appear in stained-glass windows, they are more of a matter of a representation of creation, the creation of the Creator and the creation of the artist, in other words the man who

The American painter Shirley Jaffe made a series of highly expressive, decorative stained-glass windows for La Funeraria, a 14th-century chapel attached to Perpignan Cathedral.

with his tools, grisaille and printing tries to transcribe the infinity of creation.' Couturier believed that the leaf that sparked off the inspiration for this project had been brought directly from heaven by an angel. A few years later, in 2001, Louis-René Pitt collaborated with the Loire studio in Chartres on windows for the old repertory of Sénanque Abbey, reflecting that: 'Light penetrates into the Abbey's church while shade escapes into the oratory.' An artist's relationship with the sacred is always expressed on a very intimate, personal level.

Just as Soulages intervened in a historic site in Conques with substitutes for older windows that were still remembered by some of the townspeople, in 1990 Jean-Pierre Bertrand replaced, with the help of Florent Chaboissier's workshop, the 19th-century windows of the collegiate church of Bourg-Saint-Andéol, Ardèche, that had been destroyed by bombardments in 1944. This was the first venture into stained glass by this French artist, born in Paris in 1937. He sought to organize the new light that was to pour into this 12th-century Romanesque building around unchanging mathematical modules. Other artists have chosen different paths. In 1994, François Rouan (born 1943), who had already made windows for Nevers Cathedral, teamed up with Jacques Simon's studio in Reims to create a series of windows decorated with crosses and bars for the fortified

In 1997, the painter Aurélie Nemours created a set of windows in a minimalist geometric style for the priory church of Notre-Dame de Salagon in Provence.

Romanesque church of St John the Baptist in Castelnau-Le-Lez. In contrast, the German artist Georg Ettl (born 1940), chose a colourful and unconventional figurative style to illustrate chapters 21 and 22 of the Book of Revelations on six windows on the western façade of the collegiate church of St Barnard in Romans, Isère, manufactured in collaboration with Thomas de Valence's studio in 2000. For this atheist artist, 'Art is perhaps almost always sacred, but it is not sacred just because it is displayed in a religious site.' A comparison with Jean-Marc Cerino's unused designs on the same theme for the same church proves interesting, as Cerino approached this Biblical text through ascending and descending movements that represented such concepts as grace and the victory over evil.

In 1994, Claude Viallat (born 1936) designed windows for Nevers Cathedral, having already won acclaim in the field for his contribution to Notre-Dame-des-Sablons in Aigues-Mortes. His red patches against a blue background have become a classic of contemporary stained glass owing to the relationship they establish between colour and spiritual symbolism: 'My work is very marked by materialism. However, I have investigated the symbolism of colours and I have found that it is often contradictory. In choosing the colours, I have opted for common sense and intuition more than any canoni-

cal symbolism. The iconographical theme for Nevers Cathedral was the Heavenly City. The axial window is devoted to the Virgin, hence the presence of the red circle.... In Aigues-Mortes the theme of the presbytery is the Trinity. The colours approximate the traditional symbolism: the Father is golden pink and blue, the Son is red and blue and the Holy Spirit is red and blue.'

This overview of notable religious windows created in modern France is by no means exhaustive. Special mention should go, however, to Nevers Cathedral, where a diverse range of artists was brought together to produce more than 1,000 m^2 of stained glass. One of these artists, the Belgian Raoul Ubac (1910–85) made austere windows with striking wavy patterns of colour for the presbytery: 'I believe, certainly, that all valid work is ultimately a religious work or has religious roots: these may not be immediately visible, but their influence will eventually be perceived, despite everything else.' Ubac's windows were completed in 1977, with the collaboration of Jacques Simon's studio in Reims. One of the artists who subsequently contributed work to the cathedral was Jean-Michel Alberola (born 1935), who added windows from 1992 to 2001 with strongly figurative elements and colour schemes recalling medieval stained glass. This medium has a special attraction for Alberola: 'I do not work for myself but for others. Stained-glass windows are for the people, in this case the faithful.'

We cannot complete this discussion about the relationship between art and religion, particularly in France, without mentioning Sarkis and David Rabinowitch. The former was born in 1938 into an Armenian family in Istanbul but now lives in France. In 2001, he collaborated with the Duchemin studio in Paris to create windows for the refectory in the Abbaye de Silvacane in Provence, France. For Sarkis, artistic creation revolves around the idea of memory and stained glass serves as its embodiment. Rabinowitch, born in Canada in 1943 but now resident in New York, provided both nine windows and various furnishings, also in conjunction with Duchemin, for the Romanesque cathedral of Notre-Dame-du-Bourg in Digne in 1996. It is unusual for a project of such magnitude to be entrusted to a single artist, and the results were distinguished by their minimalist conceptualism. Rabinowitch considered that stained-glass windows define the volume – and indeed the very purpose – of a

cathedral, and he sought a contrast between the immateriality of the light passing through the windows and the solidity of the furnishings, thereby creating a veritable synthesis of different artforms.

Whereas some artists feel that the introduction of stained glass into religious buildings should be minimalist, others are convinced that its true function is to tell stories and convey information. The abstraction that once overthrew figurative expression has become a tradition in its turn, and some new talents are emerging to challenge its supremacy. Whatever the artistic approach, however, a stained-glass window cannot be brought to fruition without the assistance of a master glass artist and a specialist team. Such experts can provide fascinating insight into the creative process. Gilles Rousvoal (born 1948), a glass artist working at the Duchemin studio, remembers, for example, that Aurélie Nemours was able to effortlessly integrate lead cames into her work, while they posed a problem for David Rabinowitch, as they hindered the positioning of glass discs in the centre of his windows. When Robert Morris (born 1931) worked on St-Pierre-de-Maguelone in 2002, he arrived at the studio, like Rabinowitch, without preparatory sketches, preferring to remain open to the possibilities of improvisation. In contrast, the artist Carole Benzaken (born 1964) turned up at the Duchemin studio in 2001 with extremely detailed designs, allowing little room for variation, for the windows of the Saint-Sulpice church in Varennes-Jarcy; so Rousvoal's task was to find the technical means most suited to enlarging these designs up to scale. The intervention in St Martin's church in Lognes in 1999 by Christophe Cuzin (born 1956) embraced not only the windows but also the furnishings and walls, requiring a dialogue, as in medieval times, between wall paintings and stained glass. His collaboration with the studio led him to invert the traditional system of glass supported by a metal structure, taking advantage of the mechanical qualities of modern glass to enable it to stay in place unaided. These few examples are sufficient to illustrate how the responsibility for a stained-glass window does not exclusively rest in the hands of the artists who design it but also depends on the creative input of craftspeople.

Above:
The painter Marc Chagall designed a series of stained-glass windows for St Etienne Cathedral in Metz, France; they were made in Jacques Simon's studio in Reims, where Chagall is shown at work in this photo dating from 1962.

Opposite:
Famed for his intense colours and great expressivity, Chagall interpreted Biblical themes in the stained-glass windows he made from 1965 to 1974 for Reims Cathedral; he used vivid reds and, above all, blues, filling the Gothic windows with colour, just as they were in the Middle Ages.

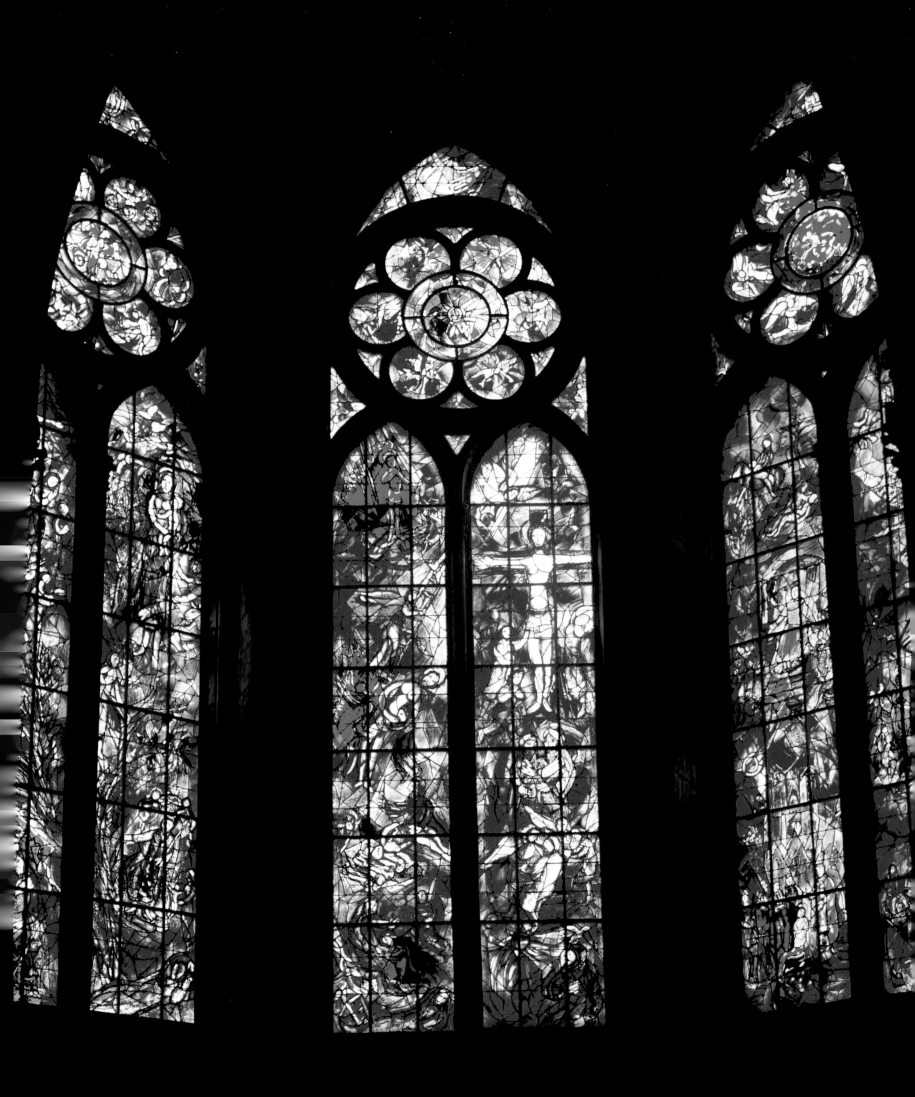

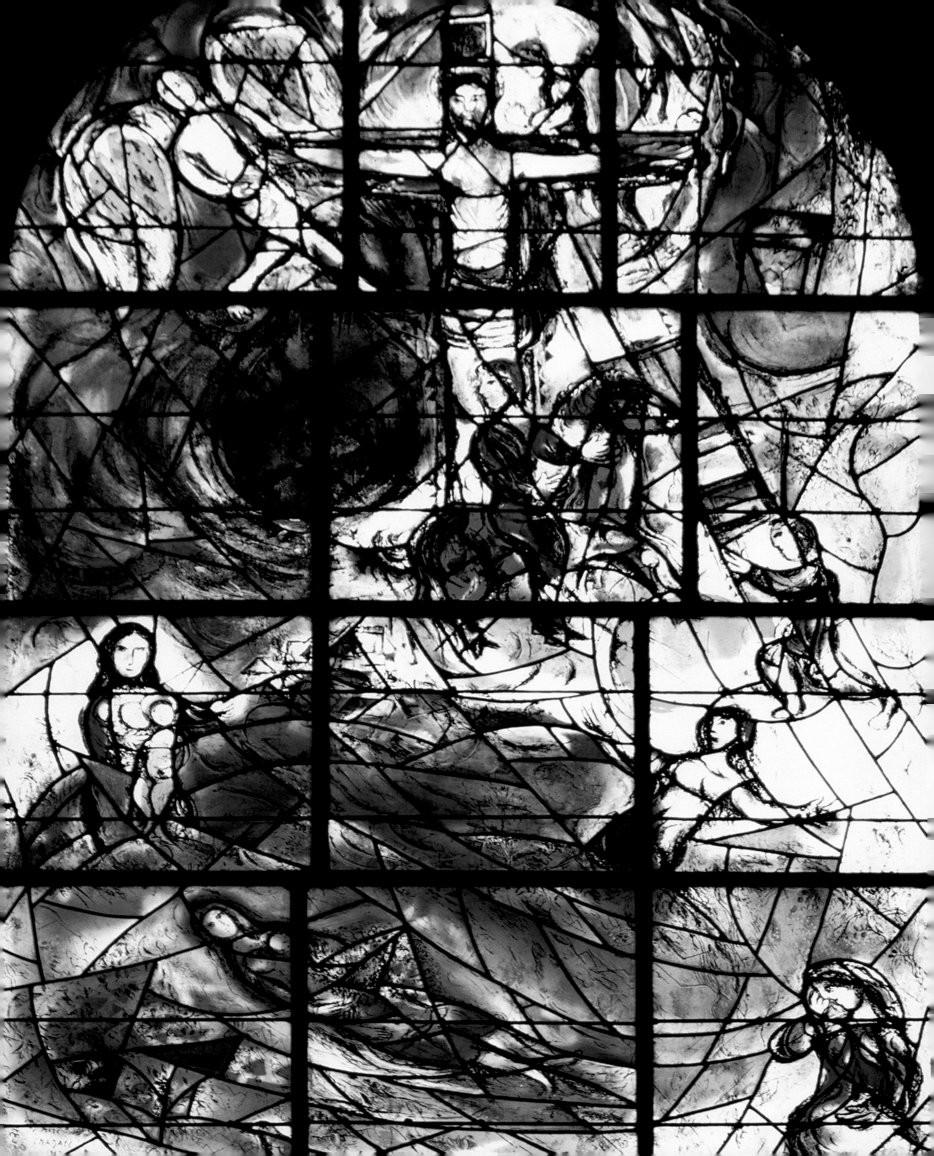

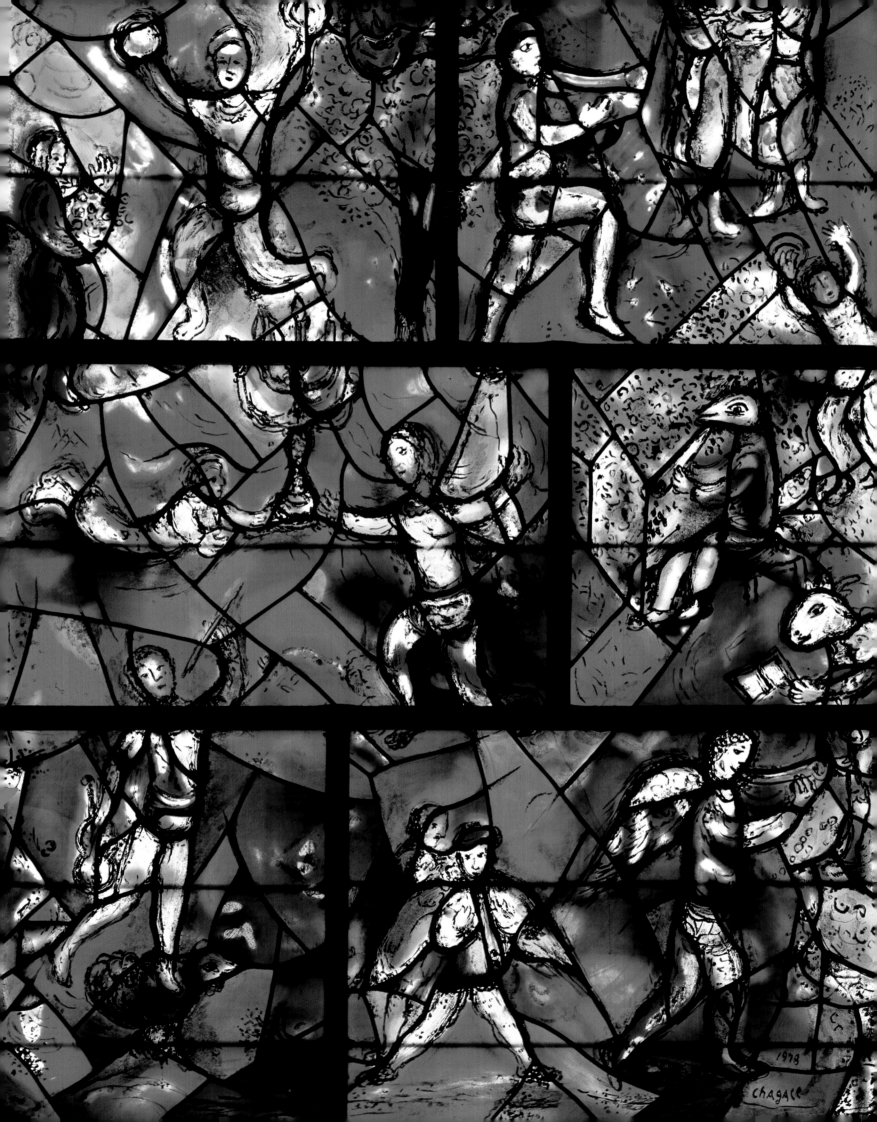

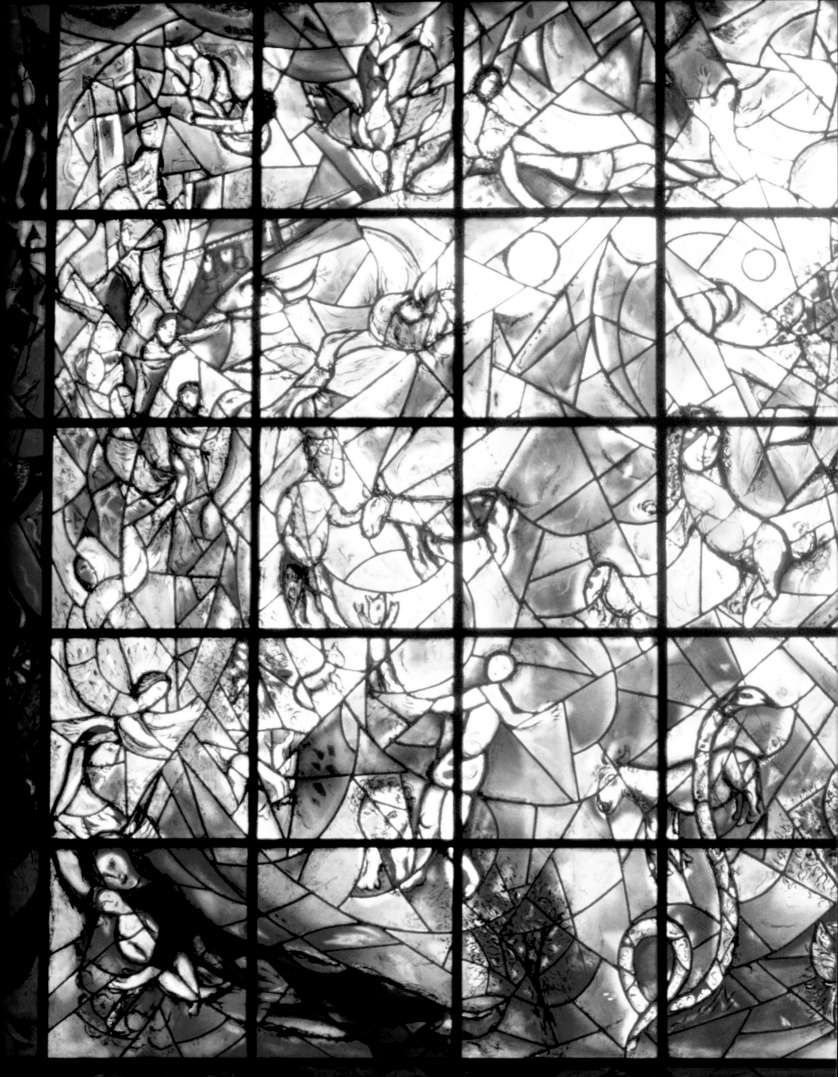

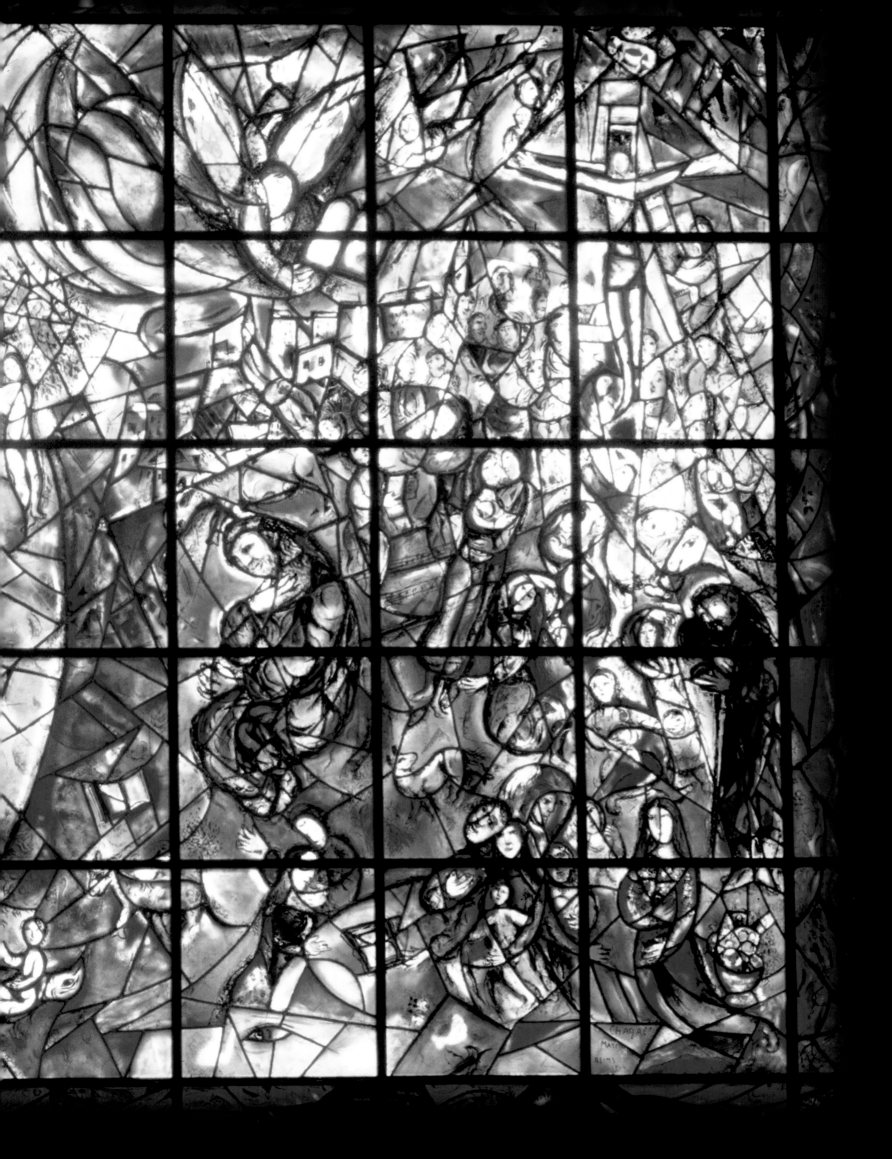

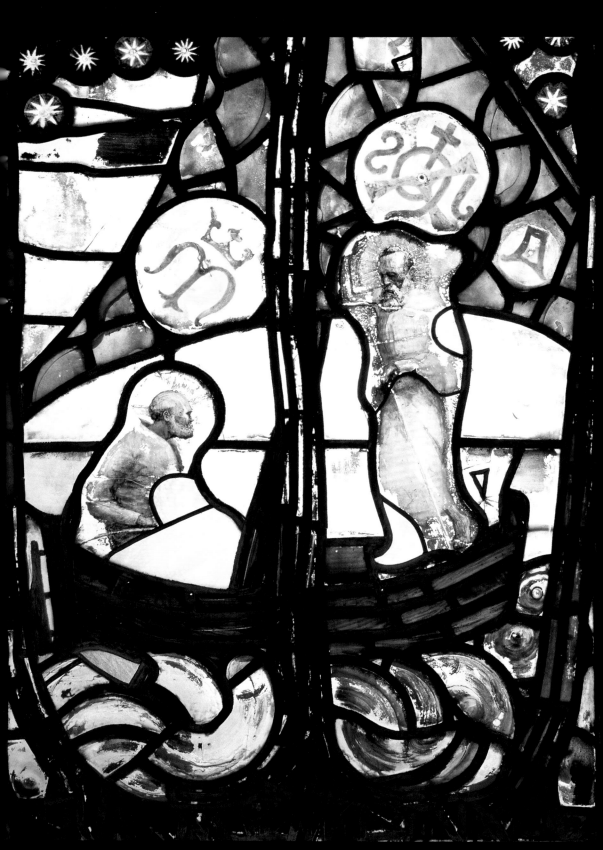

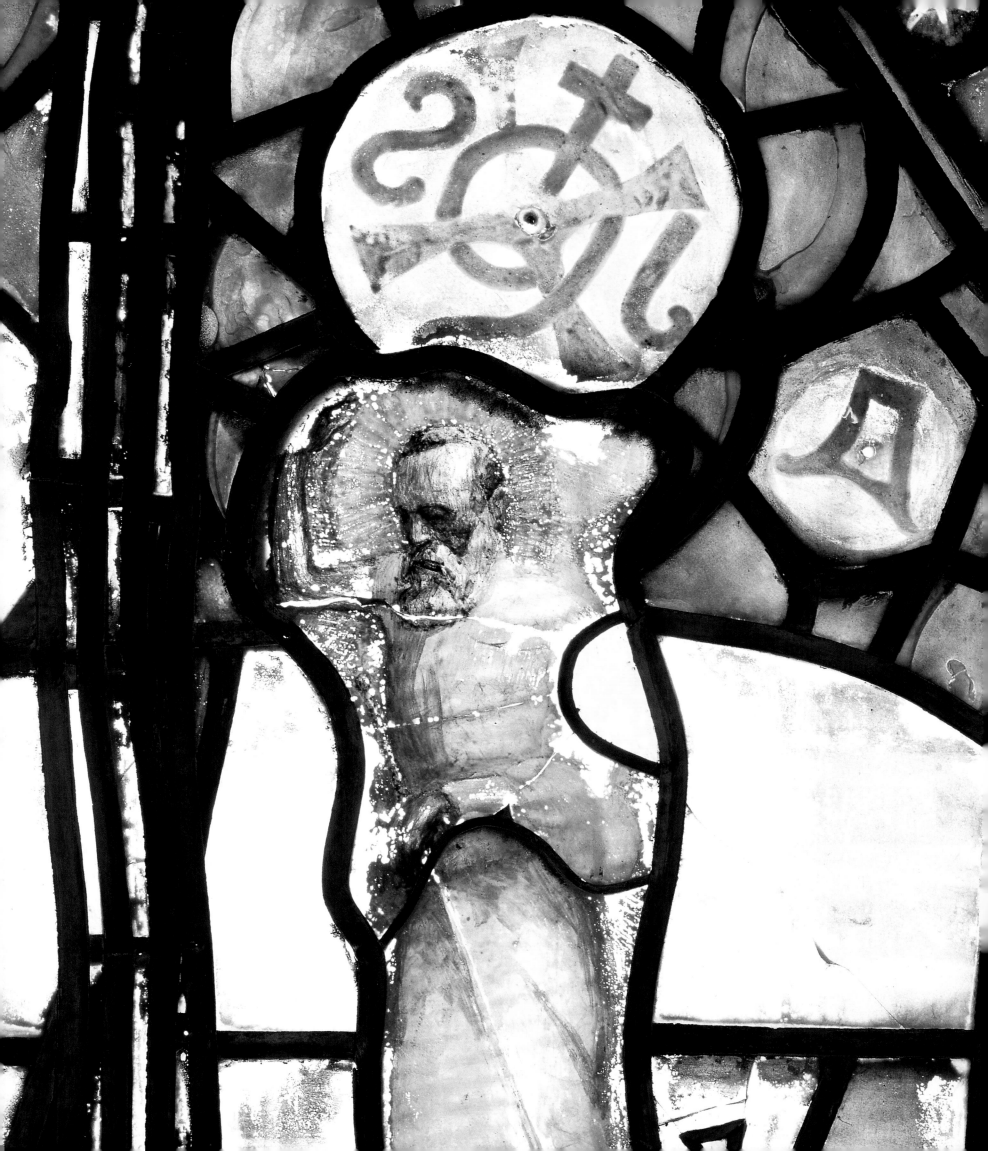

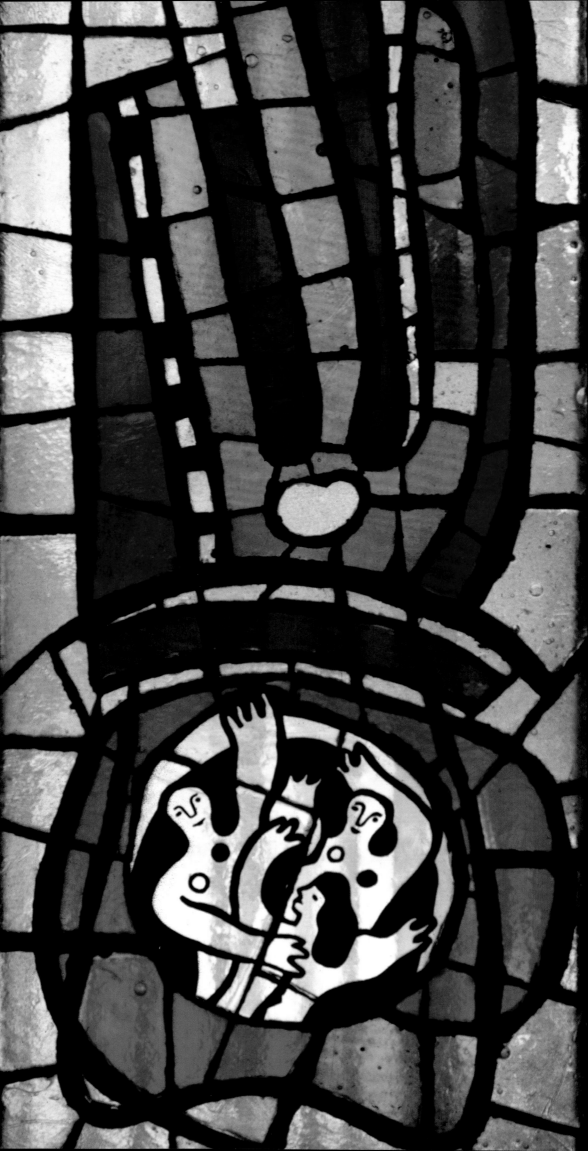

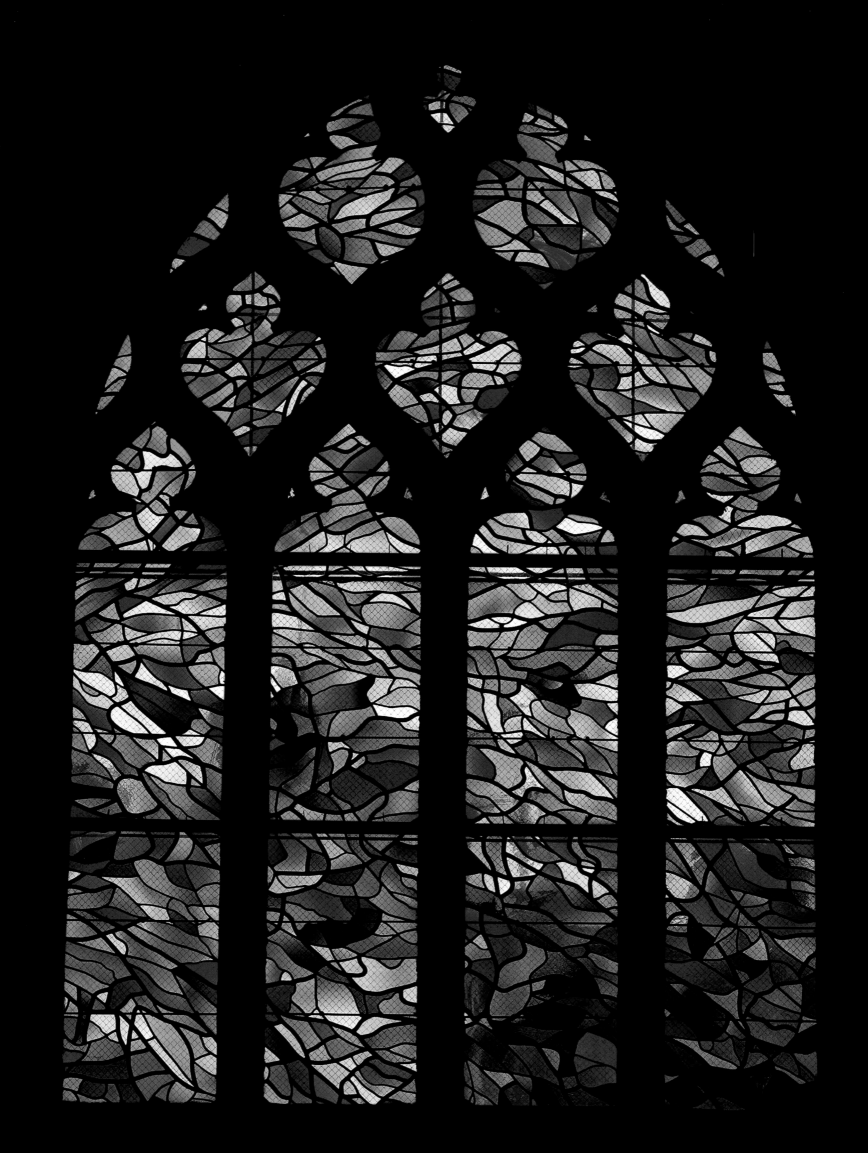

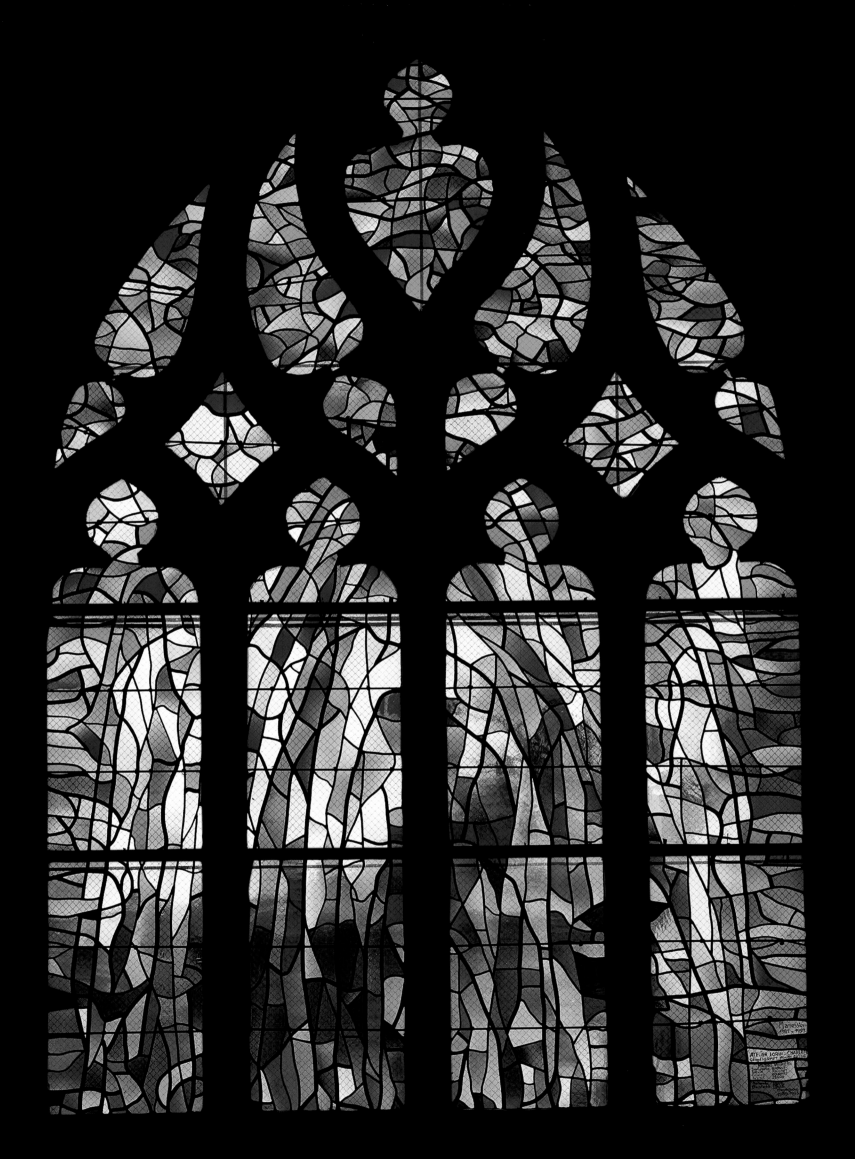

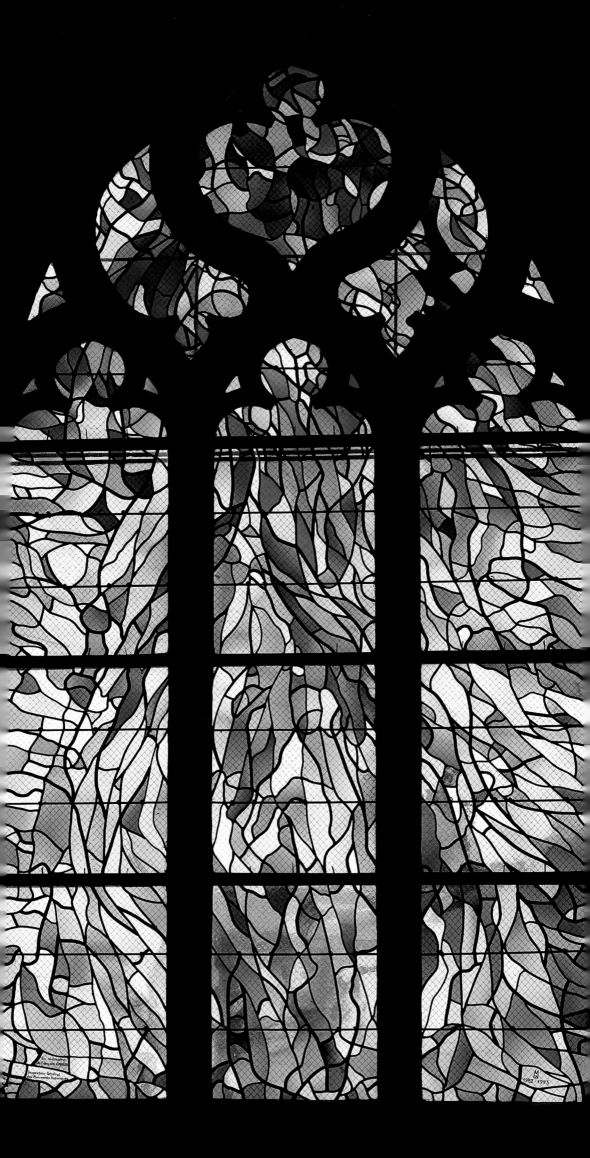

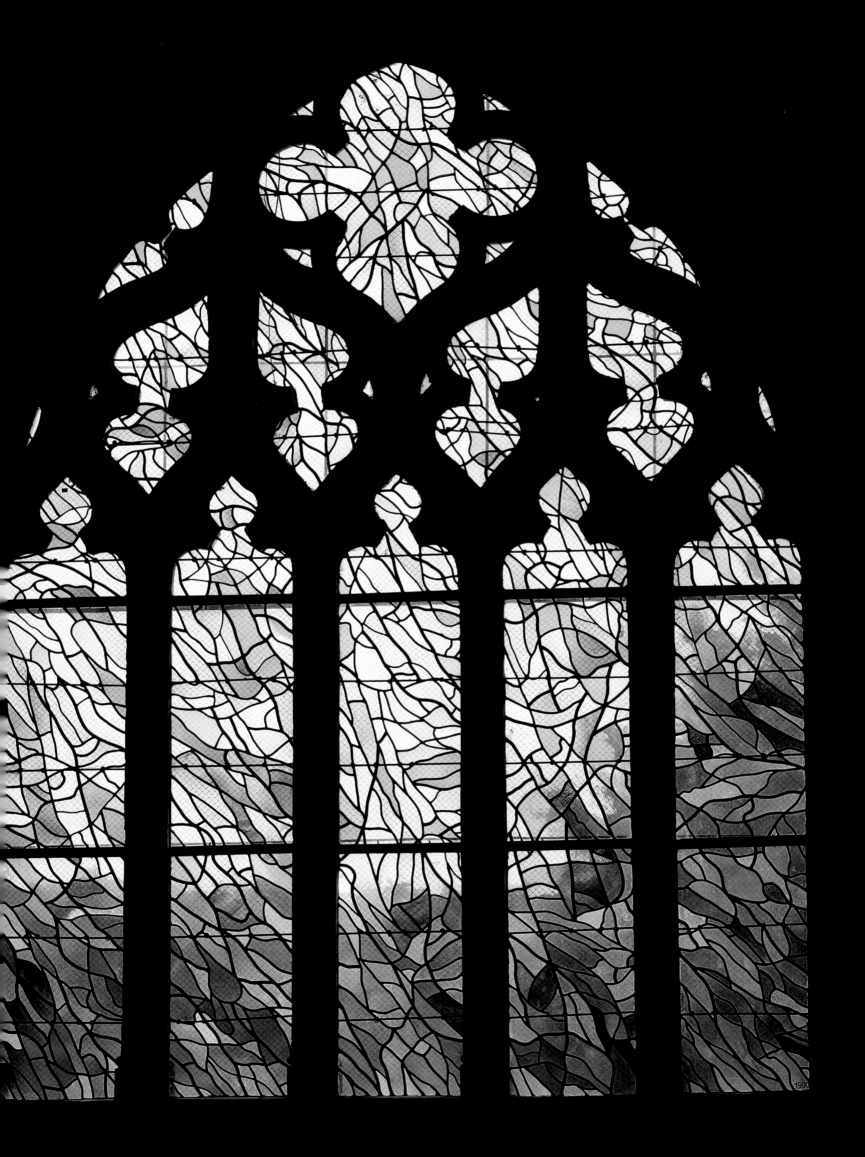

p. 102

p. 110

p. 111

pp. 112–13

p. 114

p. 115

p. 116

p. 117

p. 118

p. 119

pp. 120–21

p. 122

p. 123

p. 124

p. 125

p. 126

p. 127

p. 128

p. 129

p. 102
Detail of a stained-glass window by Marc Chagall in St Etienne Cathedral in Metz, France.

p. 110
Large composition dominated by the Crucifixion, designed by Chagall for the west window in All Saints' Church in Tudeley, Kent.

p. 111
Chagall's window for Chichester Cathedral (1978), England.

pp. 112–13
Chagall's fame and the high quality of his work with stained glass (mainly on religious subjects) led to a wide range of commissions; this window is installed in the public lobby of the UN Headquarters building in New York and contains many images symbolizing peace and love.

pp. 114–15
The modernist architect Antoni Gaudí created a set of stained-glass windows for the restored Gothic cathedral in Palma, Majorca. Pictured is a detail of the window St Peter's Boat *(1903).*

p. 116
This window from 1907 portraying a nude with a mirror is typical of the modernist style of Maurice Denis.

p. 117
The Priory Museum in Saint-Germain-en-Laye, France, has preserved this example of stained glass, entitled Dawn in Fiesole, *designed by the Symbolist painter Maurice Denis in 1898.*

p. 118
Fernand Léger succeeded in translating the distinctive style of his paintings and sculptures, with their vivid colours, schematic forms and simplified images, to stained glass.

p. 119
Stained-glass window by Fernard Léger showing his personal vision of the Sacred Robe of Christ, preserved in the Vatican's Museum of Modern Religious Art.

pp. 120–21
The Sacré-Coeur church in Audincourt, built by the architect Maurice Novarina, is a milestone in the history of modern religious stained glass in Europe, in its divergence from purely figurative representation. Fernand Léger used the technique known as dalle de verre (faceted glass) to create this large window in 1950.

pp. 122–25
Alfred Manessier produced several decorative stained-glass windows in the Lorin studio in Chartres for the church of Saint-Sépulcre in Abbeville, France, between 1982 and 1993.

He achieved a powerful vertical thrust to symbolize prayers rising upwards and the congregation's relationship with divinity.

p. 126
The former dormitory of Fontfroide Abbey in France is a robust example of Romanesque architecture. In medieval times, all the light came from the small windows, which have since been replaced by stained glass designs by Richard Burgsthal. The addition of electric light has completely transformed the atmosphere in the interior.

p. 127
Frank Lloyd Wright created this monumental metal and glass lobby for the Rookery Building in Chicago, Illinois. Its design was highly innovative, owing to the lack of supports and the spatial unity established by the expanses of glass on the roof.

p. 128
In the early 20th century, Frank Lloyd Wright crowned the Unity Temple in Oak Park, Illinois with a geometrically structured roof that creates a striking monochrome effect.

p. 129
The famous spiral staircase in the Guggenheim Museum in New York, conceived by Frank Lloyd Wright between 1943 and 1946 but not built until 1956 to 1959, is illuminated by a glass skylight.

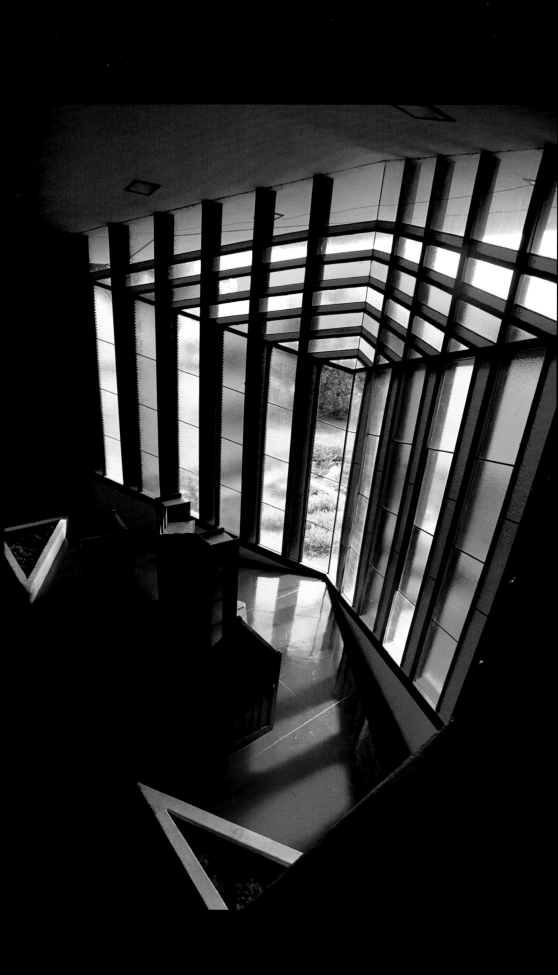

PLACES OF WORSHIP:
THE REBIRTH OF STAINED GLASS

When we discuss contemporary stained glass, we cannot speak in terms of the great production centres that existed in the Middle Ages. This is partly because the revival of the medium has been so recent that such centres have not had the time to develop, but the main reason is that recent production has centred around individual buildings rather than any particular artistic school or studio. A series of building projects have pushed back the boundaries of innovation and become landmarks for future creators in this field. These emblematic buildings, dating from the late 19th century onwards, are mostly religious and result from renovation required after war damage, or merely the passing of time. Contemporary artists were called upon, particularly in France, for the challenging task of finding a perfect balance between the ancient and the modern, between religion and a secular society.

One of these groundbreaking buildings was the church of Notre-Dame in Raincy, near Paris. Its reconstruction in 1920 was supervised by the architect Auguste Perret, in collaboration with the celebrated artist Maurice Denis (1870–1943), who participated in the creation of the stained-glass windows (p. 147). Denis studied at the Lycée Condorcet in Paris and went on to become a painter. He was one of the founders of the Nabis group in 1888. At that time he was heavily influenced by the ideas of Paul Gauguin, then based in Pont-Aven in Brittany. Denis was a devout Christian who decorated many churches and produced many works exalting the Holy Family. Together with Rouault and Desvallières, he founded the Sacred Art Studio in 1919. Four years later, he produced the designs for the Raincy windows, which were made by Marguerite Huré (1895–1967). When Denis created stained-glass windows, he tried to ensure that the light pouring through them revealed the construction materials inside in all their starkness, in order to transform them.

Lausanne Cathedral is a key building for any study of stained glass, as it contains major work from medieval times, as well as from the 19th and 20th centuries. The cathedral itself was predominantly built between 1190 and 1235. Stained glass played an important role right from the start, as in the rose window, installed prior to 1220. The wear and tear caused by the weather called for regular repairs, until it was decided, in 1817, to reinforce the windows to avoid any further damage. Coloured geometric forms were added to the windows in the north and south transepts, and this timid experiment sparked a change in taste, as seen in the mid-19th-century heraldic windows designed by the historian Rodolphe Blanchet (p. 80). Blanchet came up with a striking iconographical format for the five windows in the nave; these were financed by public subscription and manufactured in the Parisian studio of the master glazier Alfred Gerente. The resulting lighting effects were reminiscent of the earlier fashion for shields painted in enamel on white glass.

At the end of the 19th century, the master glass artist Eduard Hosch (1843–1908) was entrusted with the restoration of various windows in the cathedral, including the rose window. In 1892, Hosch had been responsible for realizing a design by the painter Paul Robert (1851–1923), on the theme of *The Law and the Grace of God*. It was originally intended for the church of St Blaise, but in 1896 it was finally installed in the chapel of St Maurice and the Theban Martyrs. In all, Hosch made some thirty pieces of glass for the cathedral to complete the oculus in the south transept (1895–99), as well as three lower windows (1899–1900) that featured old roundels taken from the original oculus windows, along with other archaic images, albeit surrounded by a frame that departed from the medieval style. (These windows were removed in 1933.) In 1878, Eugène Viollet-le-Duc proposed the idea of non-figurative windows for the cathedral, but it was not until 1915 that Eugène Grasset came up with a complete project along these lines. Grasset's death prevented it from being brought to fruition, however.

In 1918 the Stained Glass Commission organized a competition, which resulted in Marcel Poncet (1894–1953) winning the opportunity to design ten

windows for the cathedral's west façade, as well as one for St Michael's Chapel. Poncet signed the contract in 1919 and chose the theme of the four Evangelists, using them as illustrations of the Christian obligation to spread the word of God. The stylized figures were depicted with an almost sculptural solidity in a setting dominated by ochres, blue and a purplish pink. The windows were fitted and unveiled to the public on 14 April 1922, immediately unleashing a torrent of criticism: the composition was too modern, the designs strayed too far from academicism, the colour scheme was too lively, the glass lacked the quality of Gothic glass... The Canton of Vaud's Fine Art Society enlisted the support of various celebrities to mount a campaign in defence of Poncet, who, unperturbed, went on to produce a second window in St Michael's Chapel portraying the Crucifixion.

In 1928, the Commission organized a second competition, and this time the winners were Alexandre Cingria (1879–1945), Charles Clément (1879–1945), François de Ribaupierre (1886–1981), Edmond Bille (1878–1959) and Louis Rivier (1885–1963), who between them contributed fifty windows to various parts of the cathedral, following an iconographic scheme devised by a local pastor. Rivier and Ribaupierre were assigned scenes from the Old and New Testaments for the high windows in the choir, as well as the cycle of the Eucharist for six windows facing the rose window. These were all made in the Guignard and Schmidt studio in Lausanne, the former from 1930 to 1932, the latter from 1932 to 1933.

Bille was allocated the windows in the ambulatory, with seven narrating a cycle starting with the Incarnation and culminating with the Crucifixion, six relating the Passion of Christ and ten with scenes from the Old Testament. These were all created between 1932 and 1934 in the Renggli studio in Lucerne. Bille later produced four more designs for the high windows at the start of the nave, illustrating events from the Book of Revelations with suitably apocalyptic imagery.

Clement was responsible for fifteen windows running from the lower part of the nave to the south transept. These were made up of small figures and decorative elements intended to merge unobtrusively with the architecture. Cingria designed the two stained-glass windows in the lantern, depicting the two great patriarchs, Abraham and Noah, monumental figures set against abstract backgrounds who dominate the compositions. These windows were produced in the Chiara studio in Lausanne.

As we have already seen, Notre-Dame-de-Toute-Grâce in Assy was one of the first 20th-century churches to boast stained-glass windows by famous artists – in this case, Léger, Matisse, Chagall and Rouault, to name but a few. The origins of this adventure lie in the days when Assy was an isolated town with no religious institutions of its own. A priest, Father Devémy, was charged with building a church in the town to cater for the needs of the sick. Devémy hired the services of a young architect, Maurice Novarina, who completed the building between 1937 and 1946. Visitors to the church were immediately confronted with a mosaic by Léger illustrating the Litanies of the Virgin. The baptistery was decorated in 1957 with stained-glass windows designed by Chagall and made by Paul Bony that portray a landscape representing the parting of the Red Sea. The windows in the crypt were created in 1938 by Marguerite Huré. Devémy was meanwhile anxious to find an artist to decorate the Chapel of Our Lady, and his prayers were answered when he visited an exhibition in the Petit Palais in Paris in 1939, where he was impressed by the work of Rouault, whom he persuaded to contribute five designs, which were converted into windows by Paul Bony. Matisse was also commissioned to design the panel representing St Dominic in 1948, while Léger was responsible for the façade.

Léger played a particularly important role in the field of stained glass, largely through his involvement with the Sacré Coeur church in Audincourt. Five years after his return to France in 1945, after spending the war years in the US, Léger was commissioned to design windows for this church. His sketches were transformed by the glass artists Jean René Bazaine (in the baptistery), Jean Le Moal (the crypt) and Louis Barillet into an abstract frieze – albeit with the strong presence of Christian symbols evoking the Passion – that floods the interior with light and spans three walls. Léger used sheets of glass one inch thick, directly embedded in concrete, and sharply defined his colours by using thick black outlines that simulate leading. This was one of the first stained-glass windows to use this technique and became instrumental in popularizing it.

*The painter Henri Matisse, who designed windows for churches
in Assy and Vence, is seen here in his house in Nice in 1949, in
front of one of his stained glass designs for Vence.*

Matisse struck up a friendship in the later years of his life with the nun Sister Jacques-Marie, who suggested that he should decorate the small Dominican Chapel of the Rosary in Vence, near Cannes. Matisse took on this task between 1947 and 1951, seeking a balance between line and colour in the whitewashed setting, topped with a blue-and-white bell tower. The interior contains three large windows running from floor to ceiling. Matisse chose the theme of the Heavenly City, but he found his initial designs too austere and produced a more colourful version. This had failed to take into account the metal structure supporting the glass, however, and his third and final effort revolved around the Tree of Life, based on a combination of translucent yellow, navy blue and bottle green. Matisse considered that the ideal time to observe the windows was at 11 am in winter. The chapel was consecrated by the Bishop of Nice on 25 July 1951. Along with the windows in Assy and Audincourt, Matisse's work in Vence played a crucial role in boosting the status of stained glass in contemporary art.

The chapel of Notre-Dame-du-Haut in Ronchamp, in the diocese of Besançon in eastern France, was one of the key buildings of the architect Le Corbusier (1887–1965), who was born in La Chaux-de-Fonds, Switzerland, where he studied art. He worked for two years in the Paris studio of Auguste Perret and later travelled to Germany, where he worked sporadically with Peter Behrens and met Josef Hoffmann and the Deutscher Werkbund. In 1922 he opened a studio in Paris with his cousin, the engineer Pierre Jeanneret. Although architecture was his primary career, Le Corbusier was also an accomplished painter and pioneering art theorist. He saw architecture as the interplay of volumes under light, enhanced by the use of technical developments like reinforced concrete and large sheets of glass.

The chapel in Ronchamp had been a frustrated project for years, as designs by various architects had been rejected before the commission was finally given to Le Corbusier – who insisted that he be allowed to complete the building as he saw fit and have sole responsibility for every detail. The chapel was eventually finished in 1955. As in all his buildings, Le Corbusier carefully controlled the light, and sunshine only enters through small openings irregularly scattered across the south-facing wall. (This type of opening was not new but was in fact inher-

ited from Mzab architecture in central Algeria, which manipulates sunlight to enhance interior spaces.) Some of these openings were fitted with transparent panes, and others with stained glass, sometimes containing references to the Virgin Mary (pp. 150–53). In all cases, they were designed according to the effects of light and shade on the interior, and the colours were selected on this basis as well.

In Barcelona, the architect Manuel Baldrich Tibau (1911–66) was commissioned in 1953 to build a housing estate, the Hogares Mundet (pp. 154, 163), complete with its own church; the construction started the following year and was completed in 1957. Baldrich drew inspiration from Nordic architecture, particularly the work of Alvar Aalto, for the design of the church. He followed a simple, classical floor plan, with a single nave, a wide, protruding transept and a polygonal apse. Baldrich called on various artists for the decoration: sculptures from Josep Maria Subirachs (born 1927) and Eudald Serra (born 1911), paintings from Joan Josep Tharrats (1918–2001) and stained-glass windows from Jordi Pla Domènech (1917–92) and Will Faber (1901–87). The latter opted for geometric designs and an array of colours, and the rectangular forms of the windows gave the naves a regular rhythm, as in medieval times, by breaking up the wall in upward slashes. It was one of the first examples of abstract art used in stained glass to create rhythm rather than to evoke specific forms.

Albert Ràfols Casamada, born into a famous family of Catalan artists in 1923, has earned an international reputation, primarily as a painter, although he has also continued to experiment with other artforms: collage, objects, stage sets, graphic design and stained glass. In 1959, he was commissioned to design windows for the church of the Virgen del Camino near León, which were manufactured by Gabriel Loire in Chartres. Further windows were designed by Father Domingo Iturgáiz, for the Virgin's shrine and the hall of ex-votos.

The artist Georg Meistermann made stained-glass windows for the churches of St Gereon in Cologne (shown opposite), and St Elizabeth's church in Marburg, adapting his personal vision to fit the two great medieval styles, the Romanesque and the Gothic.

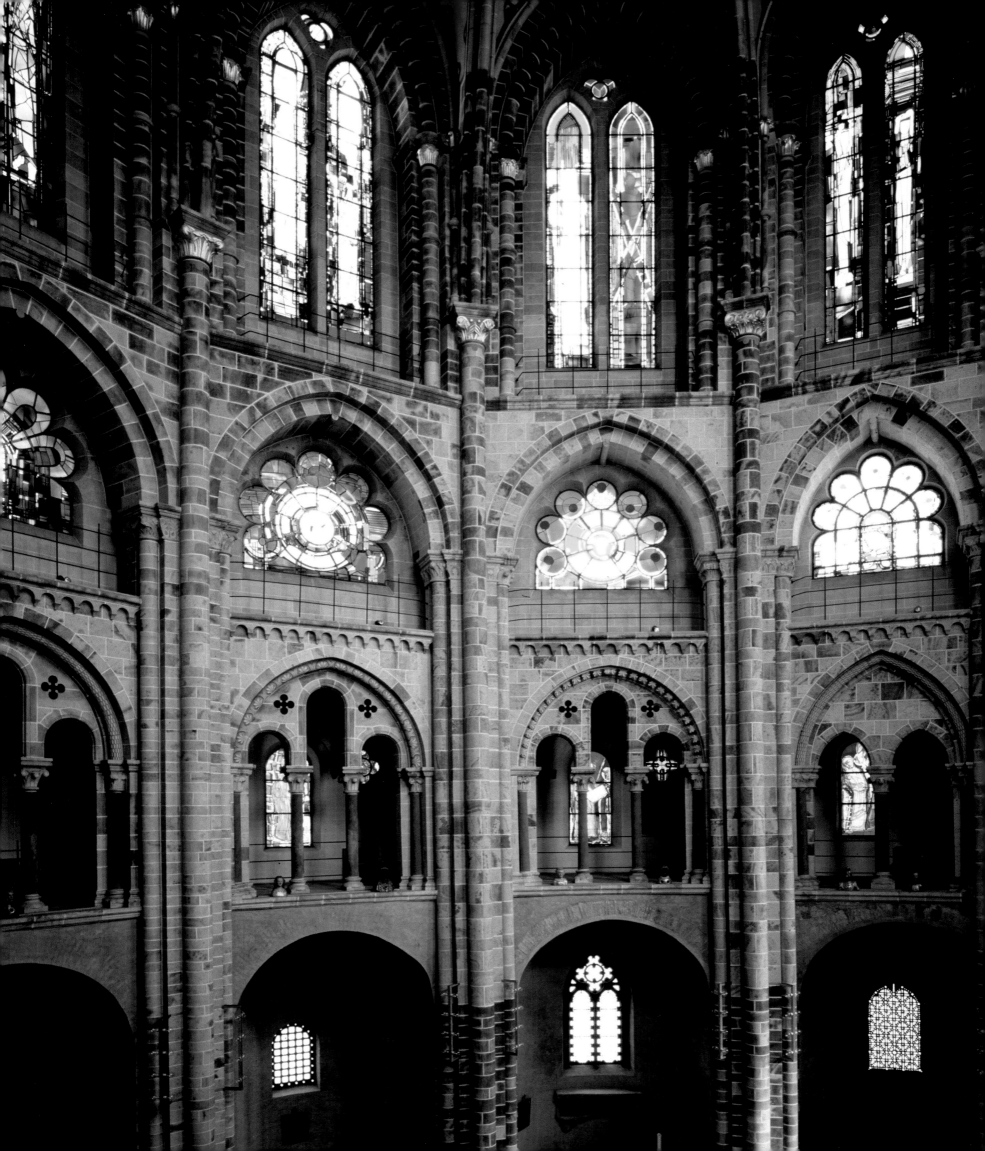

In England, meanwhile, a major project led by the architect Sir Basil Spence was underway to rebuild Coventry Cathedral, which had been largely destroyed by German bombardments in 1940. The new cathedral was consecrated in 1962, amid great controversy about its architectural style, including its stained-glass windows, which had been designed and positioned in a way that radically departed from established tradition. The ten windows in the nave are set in recesses and can only be viewed in their entirety from the altar. In all, they stretch over 21 metres and explore the relationship between God and mankind over the course of a human lifespan; those on the south side of the nave portray the natural order, while those to the north illustrate the divine order.

The cathedral's most striking window, however, is situated in the Baptistry (pp. 148–49). Designed by the artist John Piper (1903–92) and made by Patrick Reyntiens (born 1925), it symbolizes the light of the Holy Spirit being cast on the world, with a resplendent yellow and white sun in the centre, surrounded by blues, reds, purples, greens, greys, ochres and browns. Over the course of time, the controversy over these windows has abated and they are now recognized as landmarks of British decorative art.

In Switzerland, the Fraumünster church in Zurich is outstanding for its stained-glass windows by Marc Chagall (pp. 168–69) in the presbytery and the south transept (installed in 1970) and those by Alberto Giacometti (1901–66) in the north transept. Chagall's work took on a monumental dimension around 1956 and his restless curiosity led him to explore new artistic disciplines, such as sculpture, pottery and stained glass, including the blue windows for the ambulatory in Reims Cathedral, made from 1965 to 1974 (pp. 109).

In 1975, Jean-Pierre Raynaud (born 1939) was asked to design windows for the church and refectory of Noirlac Abbey, which is an austere stone building with a stark interior. Raynaud approached the commission with great humility and concern that the stone walls should not be disrupted by his additions. He confronted the monotony of the space by making openings of unequal sizes to create a thrilling interplay of lines and squares that seem to glide across the walls. In the church's choir, the light becomes increasingly bright, as it pours through white windows full of subtle details.

In 1987, the French government commissioned the abstract painter Pierre Soulages (born 1919), to create stained-glass windows for the abbey church of Sainte-Foy, Conques (pp. 164–67). Soulages was particularly enthusiastic about this project as he had grown up in the area. Soulages worked in collaboration with the glass artist Jean-Dominique Fleury (born 1946), who would go on to work with many major modern artists. Soulages devoted himself almost exclusively to this ambitious attempt to adapt an 11th-century church to contemporary requirements, and by 1994 he had produced 104 windows. He wanted his windows to become part of the pre-existing space and provide the light it needed. Although the church was endowed with many windows – 104 in a building 56 metres long – the congregation had frequently complained about the gloom in the interior. Soulages saw Conques as a heavenly city illuminated by the grace of God and so flooded the church with light, while leaving the interior walls free of any frescoes or decorations. The starkness of the walls in fact constituted Soulages's starting point, as he adjusted the incidence of light to heighten the contrasts in the stone – a process that involved painstaking technical experimentation. Soulages recorded all the various production phases in notebooks. To obtain the most appropriate glass, he enlisted the help of glass workers from the Saint-Gobain research centre, and they visited the church together on several occasions to observe the fall of sunlight. They then searched for a type of glass that would modify the translucency and make the light more diffuse; Soulages tested some three hundred samples before finding a material that satisfied him. The results are extremely striking, with windows that are translucent but not transparent, owing to their physical composition, incorporating white glass beads of varying thickness spread unevenly over the surface. Soulages was distinguished by his quest for pure materials that did not pretend to be anything other than what they were but that embodied the characteristics he was seeking in their natural state. These criteria inspired his choice of 'white' glass. Although the light may not appear white at first, it immediately conveys great warmth and clarity, while emanating a mystical quality with its subtle variations.

The traditional technique for stained glass – namely lead cames holding together separate pieces of glass –

Henri Matisse's stained-glass window above a Romanesque crucifix is a good example of the meeting of ancient and modern in the Maeght Foundation chapel in Saint-Paul-de-Vence, in the French region of Provence.

would have given the windows a heavy, rigid appearance. To achieve greater dynamism, Soulages opted for wrought-iron bars placed at regular intervals to form a solid framework into which panes of glass could be fitted, while being resistant to inclement weather. The gentle, sinuous curves of the lines crossing the windows also contribute an effect of great fluidity. Soulages conceived the windows as ornamental forms that convey a sense of upward movement. To come up with the designs, he worked in his Paris studio with Jean-Dominique Fleury, sticking pieces of black tape onto white surfaces to find the most suitable configuration for the iron bars.

The Catalan artist Joan Vila-Grau (born 1923), is particularly known for his windows in the Sagrada Família in his home city (see below; pp. 156–59). He is a painter who trained as a glass worker in 1955 and has restored several ancient stained-glass windows. He sees the medium as simply another way of painting. In 1995, he created windows for the upper part of the church of St Gregori Taumaturg in Barcelona, which was started by the architect Bartomeu Llongueras Galí (who worked on it from 1954 to 1963) and completed by Jordi Bonet i Armengol. It stands in the middle of a major roundabout, causing the influential architect Oriol Bohigas to publicly complain about the disastrous city planning occasioned by the Church after the Spanish Civil War.

In Provence, the Priory of Salagon was declared a listed building in 1921, forming part of the region's ethnological heritage and coming under the protection of the General Council of the Alpes de Haute-Provence. When the priory was restored in 1997, with funding from the General Council, the Ministry of Culture and private sponsors, five stained-glass windows were commissioned from the French painter Aurélie Nemours (profiled in the previous chapter).

Nevers Cathedral is the site of one of the most ambitious stained-glass projects of the second half of the 20th century, as it contains 32 windows with a total surface are of 1,052 m^2. The cathedral's structure was heavily damaged by German bombing in July 1944; although this was subsequently repaired in 1950, no decisions were made at the time with respect to the replacement of stained-glass windows. Eventually, however, commissions were given to Jean René Bazaine (1904–2001), Alfred Manessier and Raoul Ubac, who made four windows, including an oculus in the Romanesque apse in 1977. Four years later, the Ministry of Culture called on the services of three more artists – Simon Hantaï, Pierre Soulages and Sam Francis – but the offer was promptly withdrawn. In 1986, a group of artists was finally assembled: Jean-Michel Alberola, Gottfried Honneger, Nelly Rudin, Markus Lüpertz, Brice Marden, Joan Mitchell, François Rouan, Frank Stella and Claude Viallat. One of the inherent risks of dividing a project among such a diverse range of artists from different countries was a lack of unity, so the selection caused controversy and triggered appeals to the Ministry for close supervision.

The National Committee of Sacred Art staunchly defended this adventurous approach, however, in the conviction that it would stand the test of time – as indeed it has. The works by all these artists come together to form a kind of collage, unified not by submission to the architecture but by the denaturalization of the space.

This pot-pourri of stained-glass windows was unveiled in 1992. They range from the geometrical curves of the conceptual artist Honneger, flooding the interior with purple, to the fragments of coloured glass assembled by Rouan, who is considered by many the heir to Matisse. In his abstract windows, Rouan breathed new life into the concept of collage, much as Matisse's deceptively simple paper cut-outs had done not long before. Rouan considered the form of the windows to be their attraction and so based his stained-glass design on that very form, thereby creating, with the help of the master glass worker Benoît Marq, windows within windows. Viallat, a founder of the contemporary art group Supports/Surfaces, contributed windows to the choir, while Alberola made thirteen windows for the Romanesque transept that combined abstraction, conceptualism and figurative representation, as well as also playing with the idea of windows within windows. Interpreting the theme of the Book of Revelations, Alberola drew heavily on medieval sources, so that, for example, his depiction of Christ recalls that of a 13th-century window in the church of St Cunibert in Cologne. Later on, Alberola was also commissioned to create more windows for the ambulatory, on specified themes from the Bible and apocryphal texts. These windows use different techniques from those in the transept and show a greater mastery of the medium.

One of the most ambitious projects currently in progress in the field of religious stained glass is that of the Sagrada Familia in Barcelona (pp. 52–53, 156–59), which seeks to combine the light demanded by its architect, Antoni Gaudí, in the early 20th century with the additions made to the building since his death.

The Sagrada Familia was not intended to receive unfiltered sunlight or be gloomy inside. The decision to incorporate stained-glass windows was therefore logical, and it did not arouse the same controversy as the continuation of the building works or the addition of sculptures by Josep Maria Subirachs. Architecture is based on the control of light and space, and deciding on the characteristics of openings is an essential part of that process.

Gaudí, according to his disciple and collaborator Isidre Puig Boada, considered stained glass vital to the project and sought to achieve effects similar to those of the pair of windows he restored in the presbytery of Palma Cathedral in Majorca (pp. 114–15), which used four layers of glass, in yellow, blue, red and white, to distribute light. Gaudí himself described what he was looking for as 'an extraordinary definition in the composition, obtained solely through the contrast of colours, without any type of line: the transparency and purity of coloured light, and the possibility of an infinity of subtle touches without having to resort to painting the glass.'

In 2001, stained-glass windows were installed in the west façade of the Sagrada Familia, above Subirachs's sculpture of the Passion. This made an important contribution to the building, as it captures most of the afternoon light and, along with two side windows, provides almost ten per cent of its total area of stained glass. The windows on the transept façade depict the Resurrection, in the form of eight panels 3.5 m high, six oculus windows and an ellipsoid measuring 6 x 3 m, set 40 m above ground level; all these elements are unified to such an extent that they appear to be components of the same window.

Gaudí put great thought into this window, as he explained to Puig Boada: 'The stained-glass windows will be of a diverse nature: the lower ones will all be brightly coloured; the high ones – the eye of which is a large ellipsis that will contain a representation of Jesus of the Parables (the Sower, the Good Shepherd, etc.) – will be polychrome only in the figures, and in clear tones elsewhere; and finally, the highest windows of all, which are those of the central nave, will be of white light, as they serve to illuminate the vaults decorated with mosaics.'

The current phase of the windows in the Sagrada Familia is in the hands of Joan Vila-Grau. In unpublished notes, he ponders the difference between the genius of Gaudí's architectural conception and the limitations of his iconography. The former is distinguished by its timelessness: 'Very few architects, over the course of history, have been capable of creating an atmosphere, a space that is special and distinctive. Most architects build

houses, factories, religious buildings, but they do not create spaces where something inexplicable transports us to a dimension beyond time, style, the historical moment and its technical, cultural and religious conditioning factors: they are not transcendental. I do not mean that Gaudí's religious and mystical sentiments were not the impulse behind his work in the case of the Sagrada Familia, but this religiosity is found within his architectural forms. For me, this fact is essential to understand or justify how I see the second aspect of his work, as it is in the symbolic elements and the images and ornaments where Gaudí is anachronistic, where he lapses into the sensibility proper to his age, where the iconography is dated by the passing of time. Gaudí's greatness lies in the materials, in the forms, the proportions, the colour and the light. His deepest religiosity is in the delicacy of a vault, the elegance of a column and the space that all these elements create.'

Vila-Grau established the pre-condition that any conventional and traditional portrayal of the Resurrection was out of the question, and in fact he entirely rejected figurative representation in favour of abstraction. This option was justified by architect Jordi Bonet i Armengol on the grounds that the window had to be based on the Gospels, but from reading them it was obvious that nobody witnessed the precise moment of the Resurrection (Matthew 27: 50–54). The group of fifteen panels was treated as a single unit, 'as if it were a Gothic stained-glass window in which each component is conceived as a single unit, regardless of whether it is made up of two, three or more panels separated by mullions.'

The Middle Ages had their own language of light and colour which enriched, guided and explained the iconography of stained-glass windows. Vila-Grau worked along similar lines: 'For the colour scheme of the window of the Resurrection, I have not searched for the meaning of each colour (as these are sometimes somewhat conventional concepts) but rather for the reaction that colours produce in people, a reaction that corresponds with ancestral phenomena that have marked humankind, without going into the controversial subject of the collective subconscious. This is why the glass on the lower part of the big window displays a range of dense, darkened, almost opaque colours, in pursuit of the idea of death, burial and the earth, and at the same time tries to

convey the sense of a buried seed of new life, suggested by some shades of green as well as some white glass, which (aside from its lighting function) acts like a crack through which it is possible to breathe. In stained glass, white provides relief and makes the light shimmer: it is essential in these windows, both aesthetically and for its power of suggestion.'

Outside the temple, the windows of the Resurrection can be seen from afar, although they do not shine, as a result of a matt treatment, invented by Antoni Vila Delclós, that highlights the configuration of the leading. From the inside, onlookers can fully appreciate the idiom of the colours and, above all, the essence of stained glass – light: 'The colour scheme of this windows starts in the lower part with dark colours – ochres, earth colours, reds – and lightens as it goes up to the middle or upper level. At the top, the large ellipsoid is almost completely resolved with paler glass, so that the light shines, and with whites of different and varied textures – snow, roots, marble, stars – all framed by others.'

It was the historian Georges Duby (1919–96) who suggested that stained glass was the medieval art form that best expressed the concept of God as light. Even today, many of the windows we have mentioned are still inspired by this notion and attempt to embody it in a modern context.

No discussion of religious stained glass can be complete without a mention of synagogues. Although stained glass has been used for centuries in synagogues, in some periods it has met opposition from some religious authorities who maintained that the presence of images contravened the second commandment of the Jewish law, and that it could distract worshippers from their prayers. In the 20th century, however, stained glass became more common in synagogues. As Judaism has no standard visual iconography, it was often abstract and seen as a complement to functional modern architecture, although figures and faces increasingly began to appear in Reformist synagogues.

One of the most famous synagogues in this respect is that of the medical centre in the Hadassah Hebrew University, Jerusalem, which was opened in 1962 to coincide with the institution's golden anniversary. The building's structure was made with Jerusalem stone and the synagogue is illuminated by stained-glass windows designed

by Marc Chagall (pp. 186–89), who saw the project as a gift to the Jewish people. He worked on the windows for two years, alongside his assistant Charles Marq, who developed a special technique for applying pigment that allowed Chagall to use three colours on a single piece of glass. To ensure that the glass would emit the appropriate light, Marq travelled to Jerusalem to test the light in each of the sites for the twelve windows, which were then manufactured in Reims by the Simon studio. They were then exhibited in New York, before finally being put in place. These windows depict the twelve sons of the patriarch Jacob, who founded the twelve tribes of Israel, although they are also dotted with animals, fish and Jewish symbols, seemingly floating in space. The colours are inspired by Jacob's Biblical blessings of his twelve sons (Genesis 49), Moses' blessing of the twelve tribes (Deuteronomy 33) and a description of priestly ornaments (Exodus 28, 15). The colour combinations, which are set off by patches of white, set up striking modulations, while the leading follows curved lines that frame the figures perfectly.

The United States is one of the leading producers of stained-glass windows for synagogues, and these are characterized by a bold exploration of new motifs (albeit often based on ancient tradition). Examples of this trend include the ten abstract windows designed by William Saltzman (1916–2006) for the B'nai Aaron synagogue in Saint Paul, Minnesota, and the four created by Helen Carew and Nick Parrendo for the Tree of Life Synagogue in Pittsburgh, Pennsylvania. Although synagogues traditionally had few openings, it is now possible to find them with huge windows, as in the one measuring 12 x 9 m in the Chicago Loop Synagogue, made in 1960 by Abraham Rattner (1893–1978), or the impressive glass façade of the Milton Steinberg Center in New York, designed in the 1950s by Adolph Gottlieb (1903–74).

Another important artist involved in the creation of stained glass for synagogues is David Wilson (born 1941), who is a member of a group of craftspeople based in New York that is responsible for windows in both civil and religious buildings. Outstanding work by Wilson can be seen in the Hebrew Congregation Synagogue in Washington DC (1988), the chapel in Moyne College, Syracuse, New York (1994) and the Beth David Synagogue in Gladwyne, Pennsylvania (1996). One of his most recent projects was the *Glassboro Kaleidoscope* window, completed in 2005 for the College of Education at Rowan University, Glassboro, New Jersey.

The church of St Elizabeth in Marburg, with stained-glass windows by the artist Georg Meistermann.

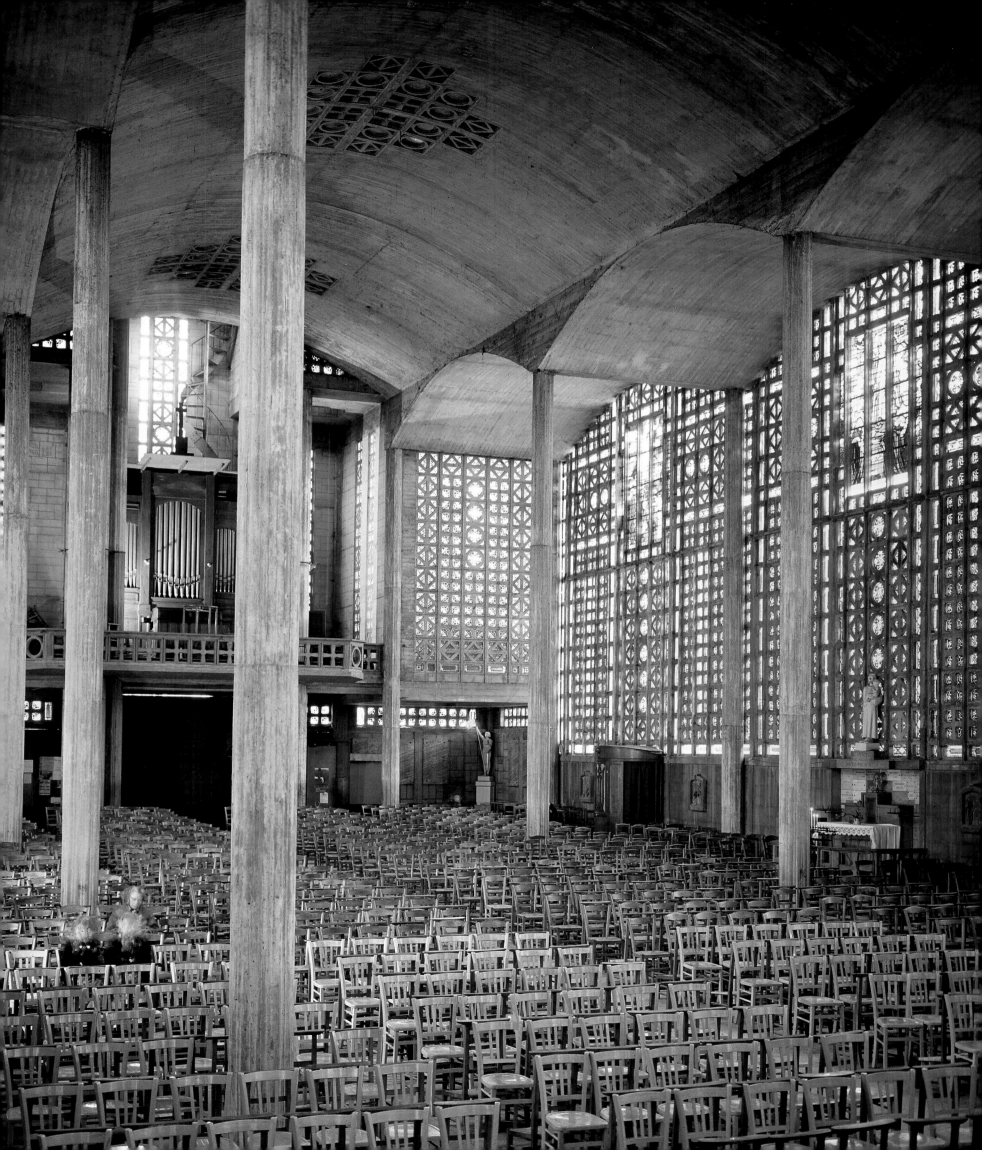

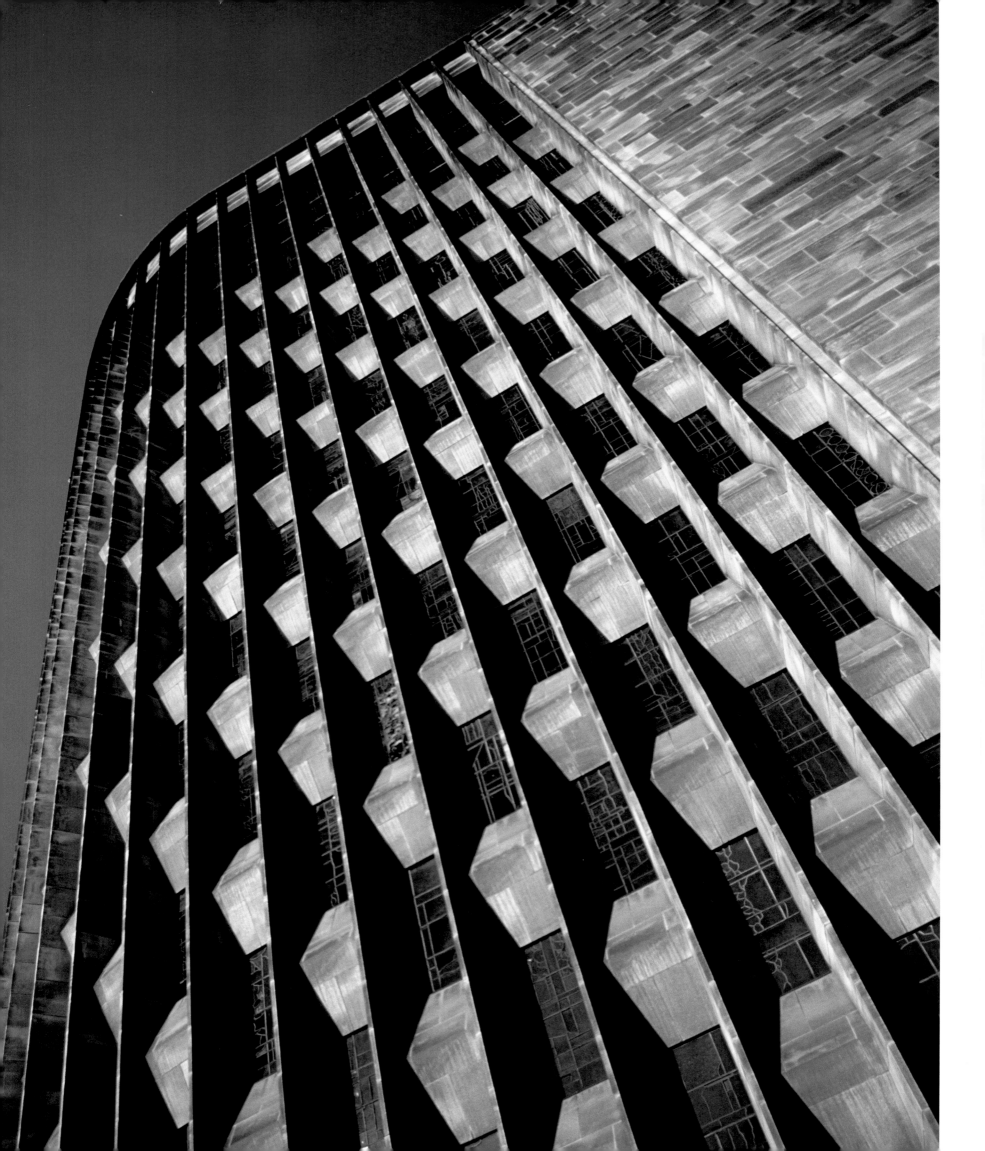

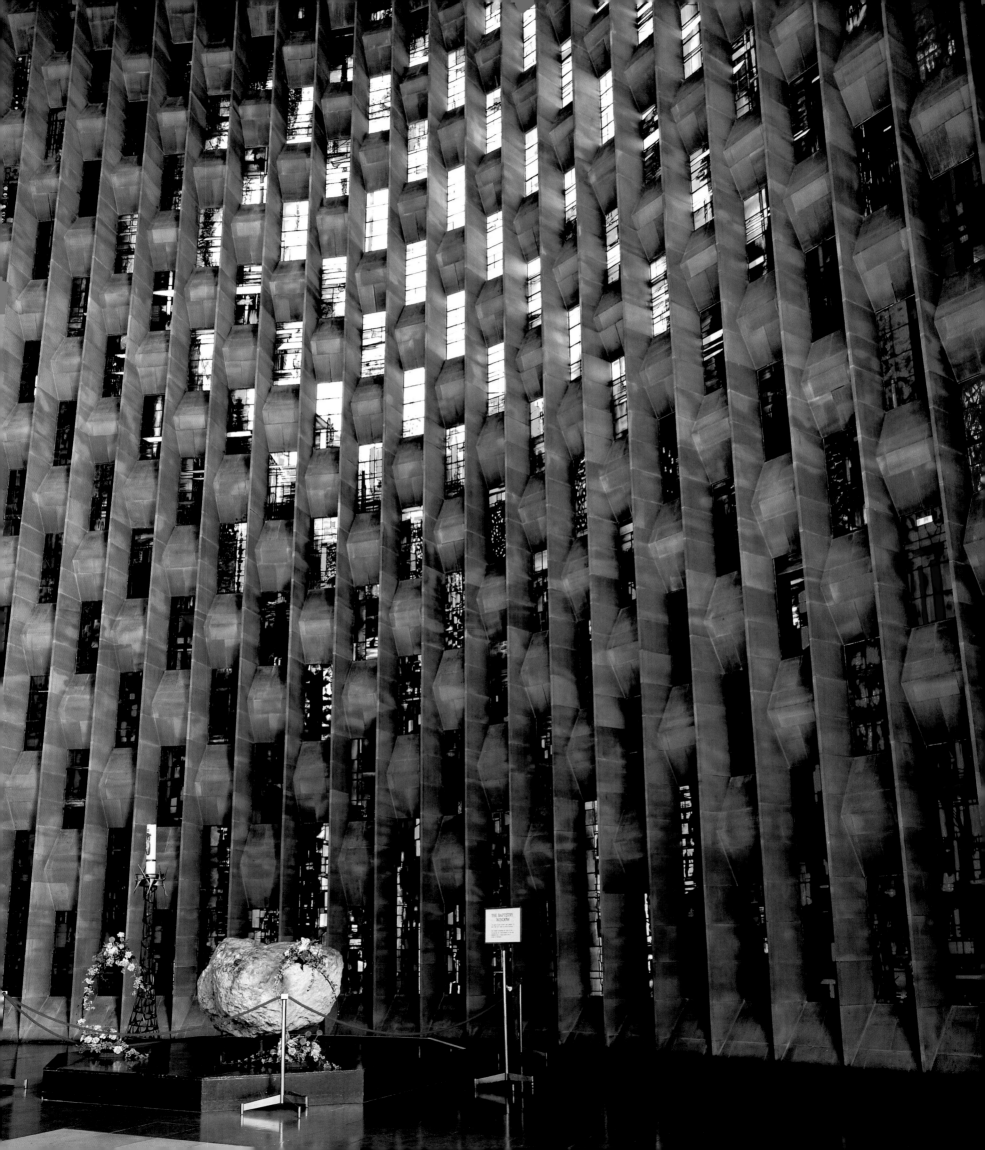

THE BAPTISTRY
WINDOW

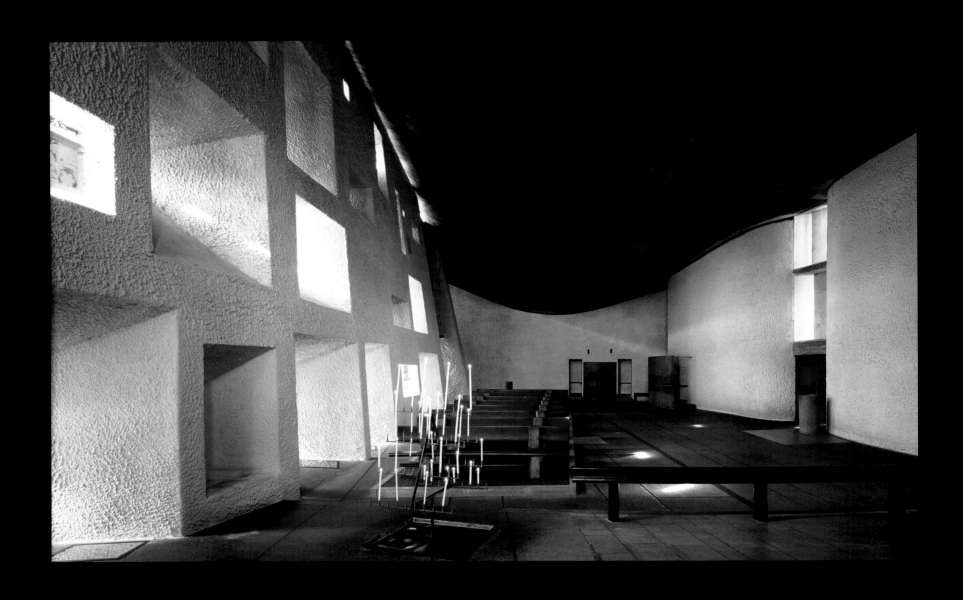

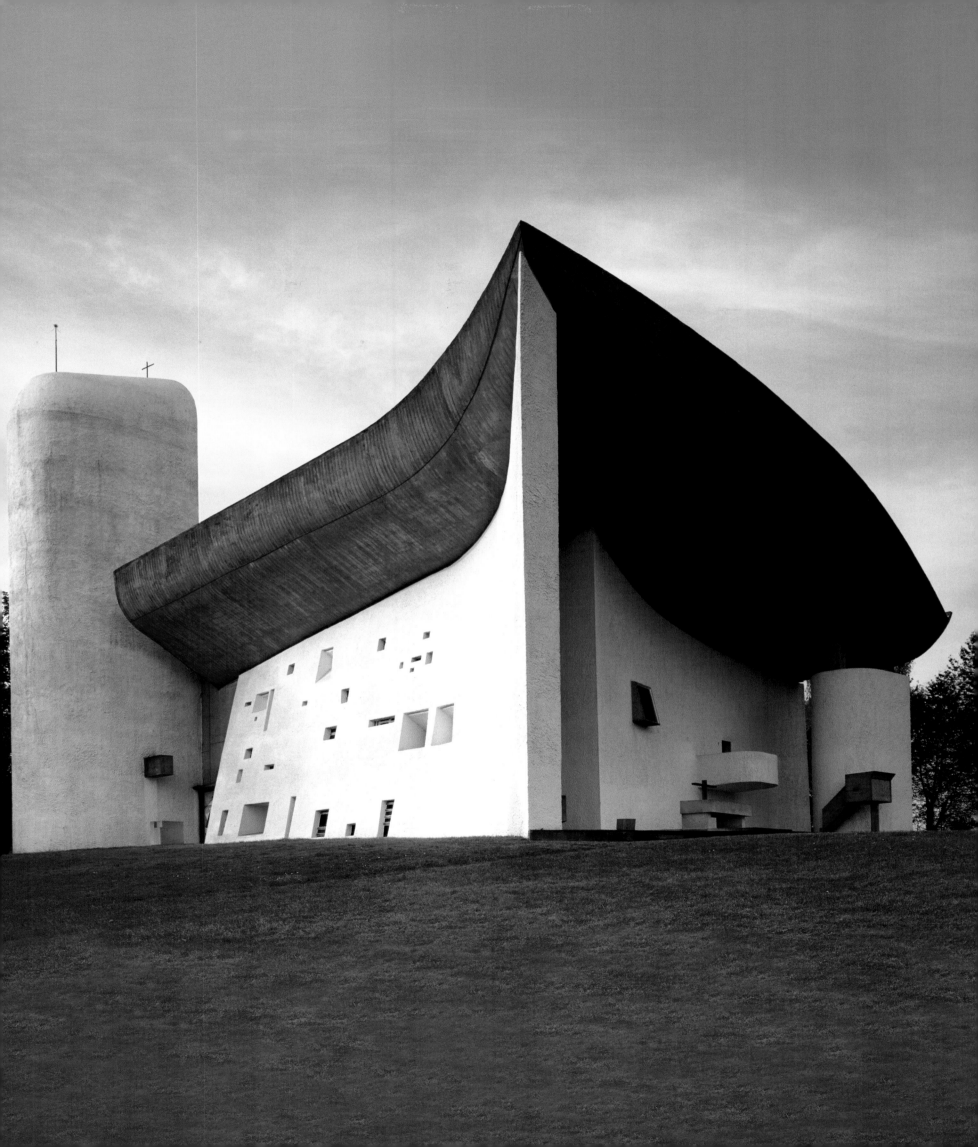

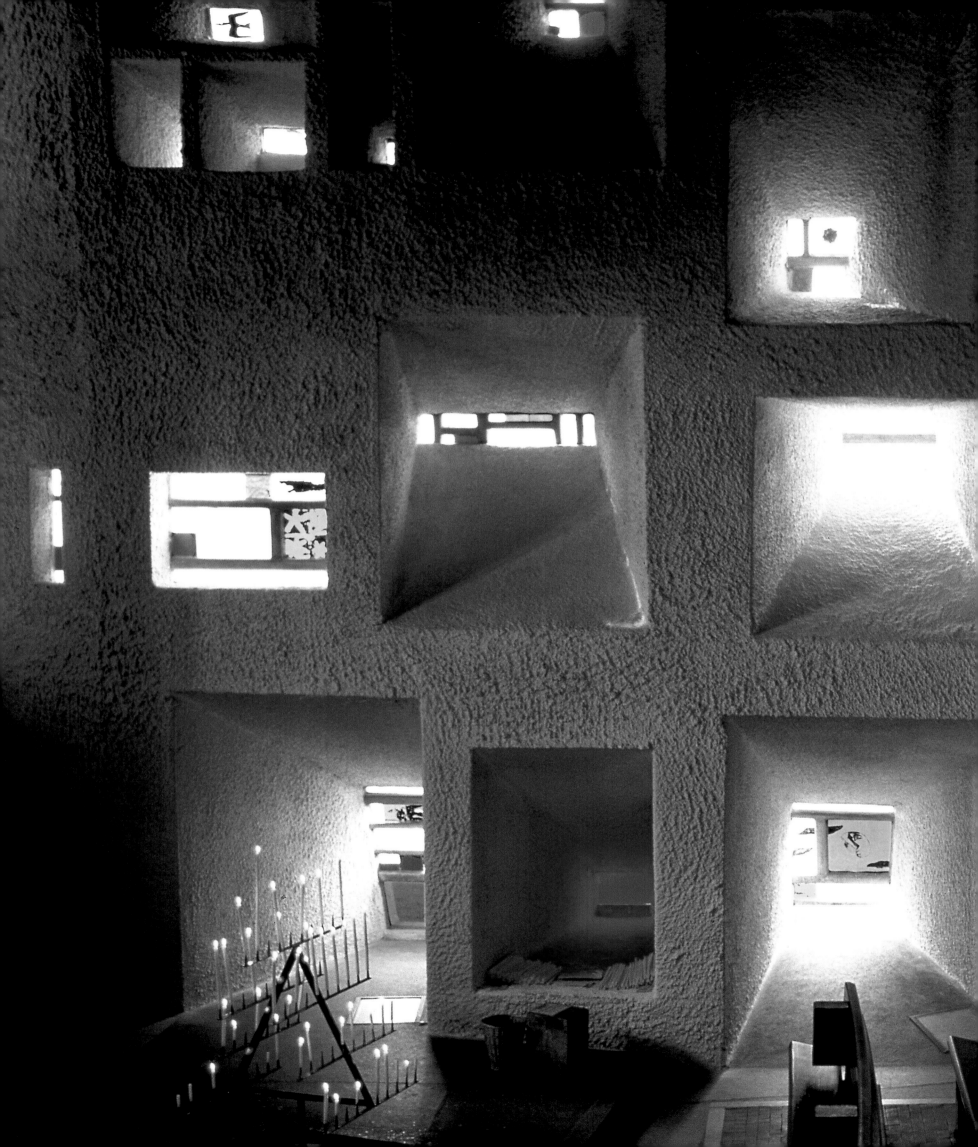

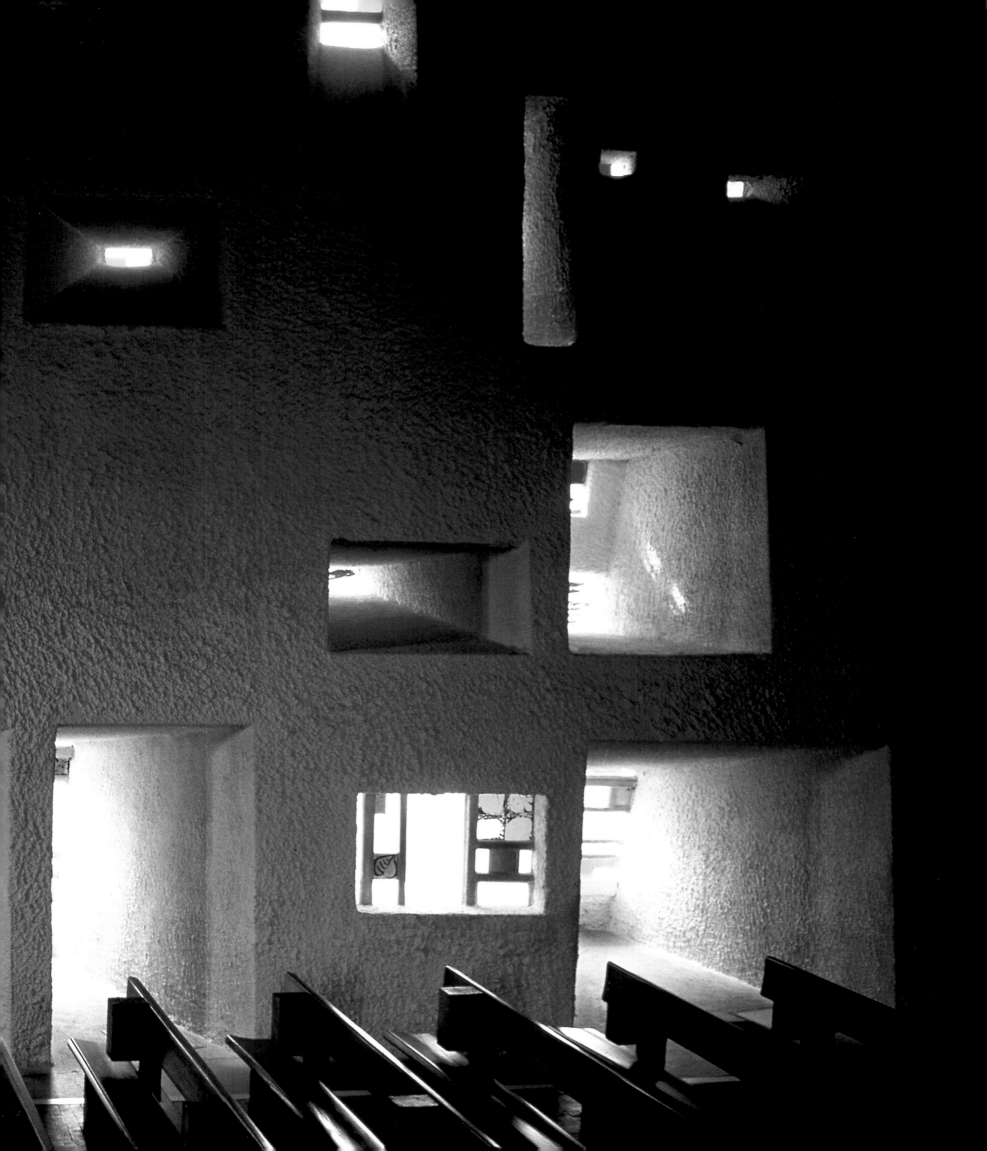

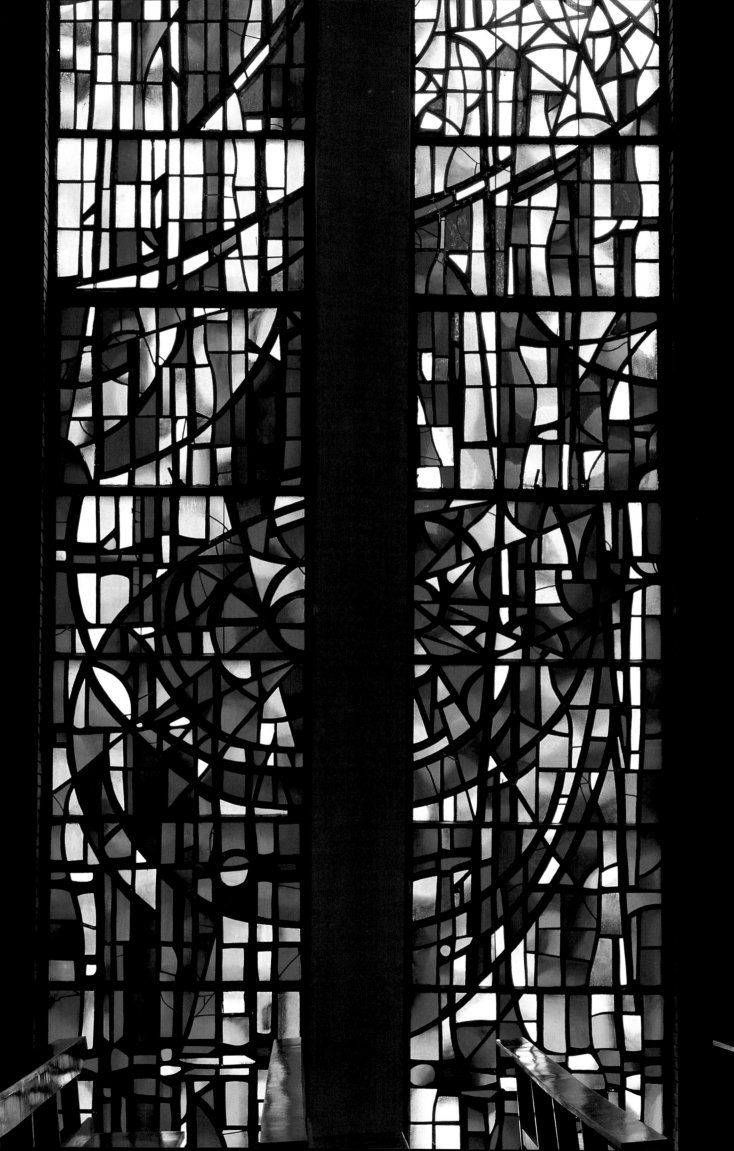

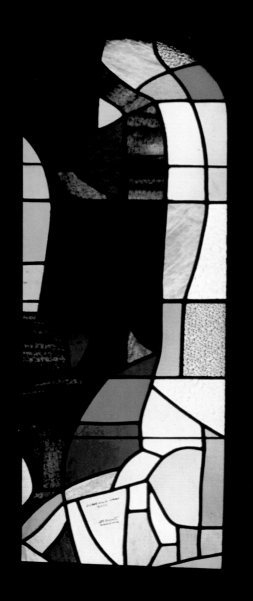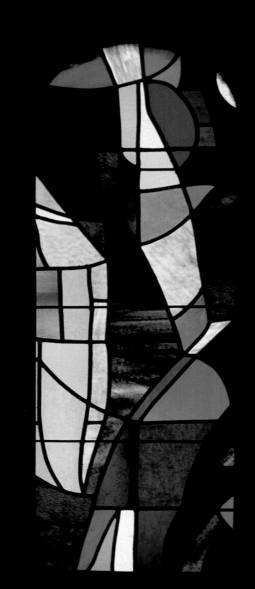

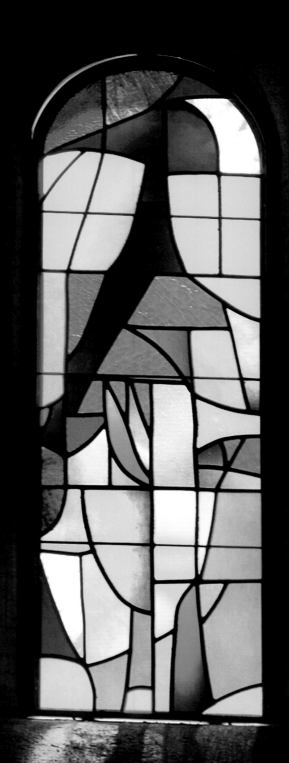

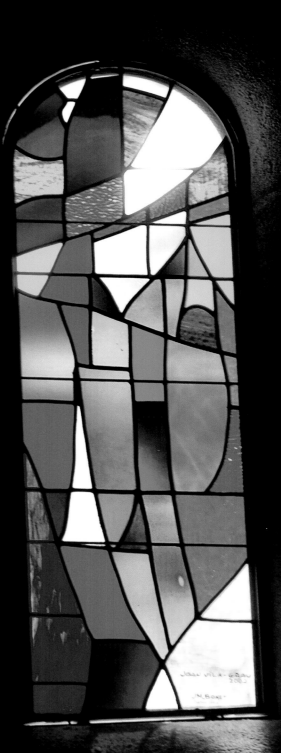

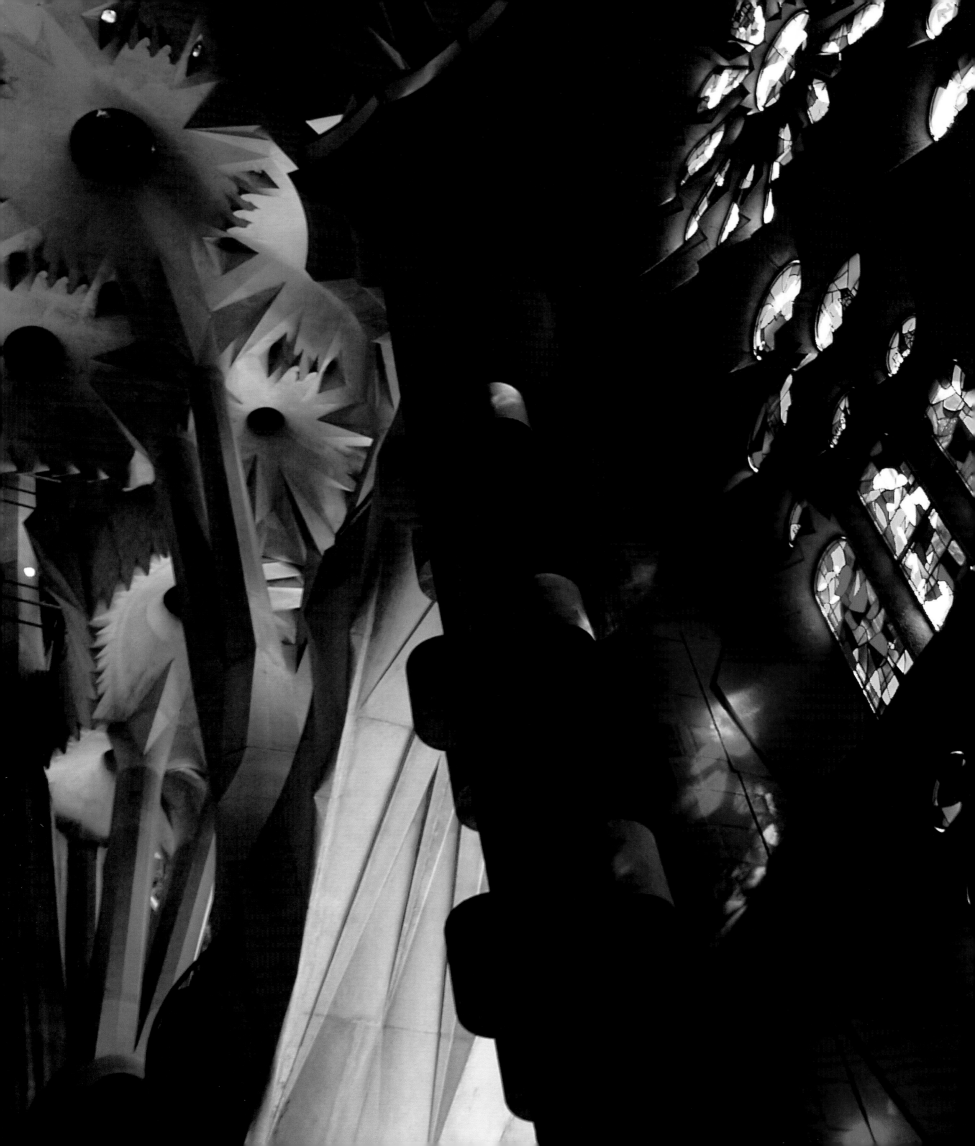

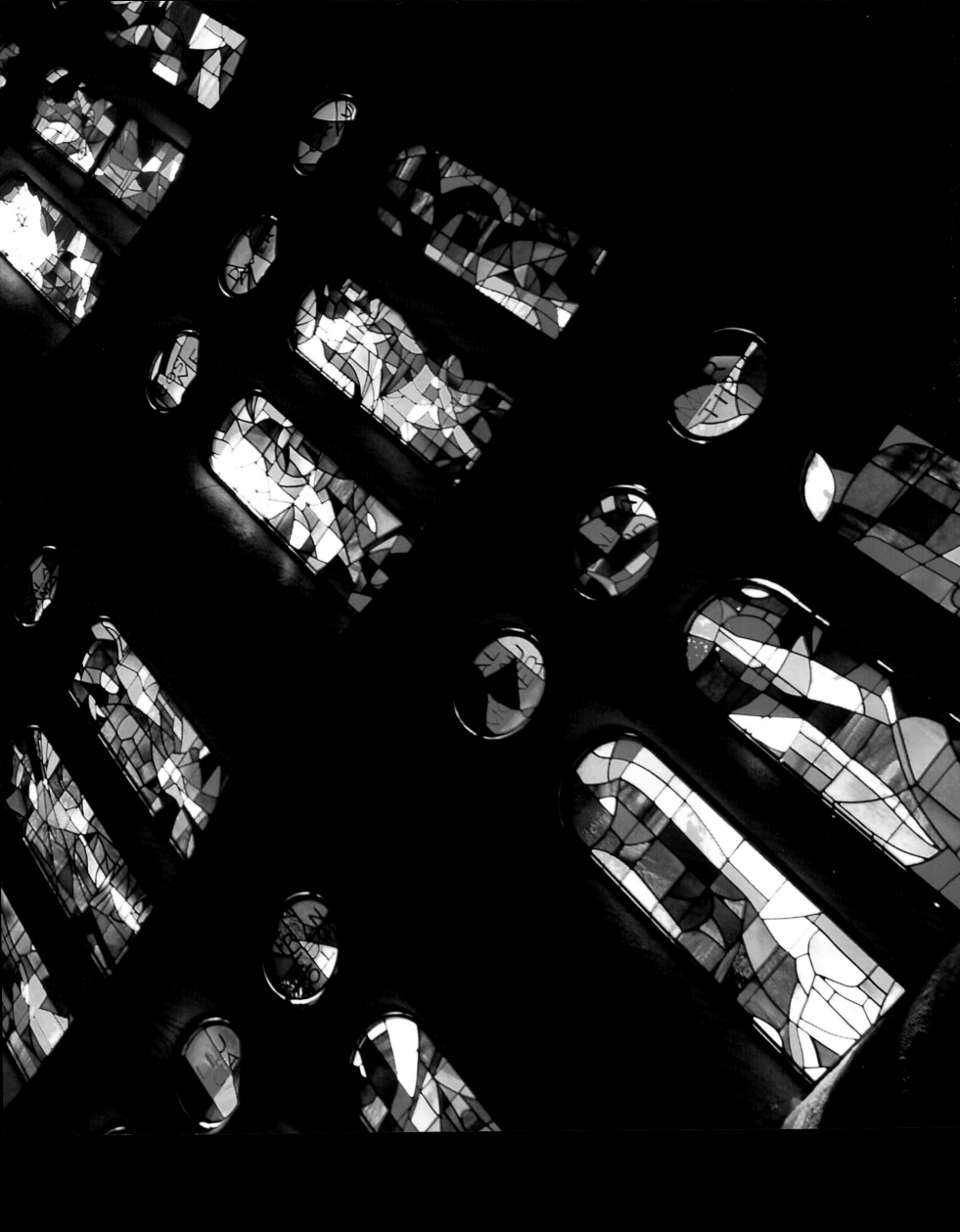

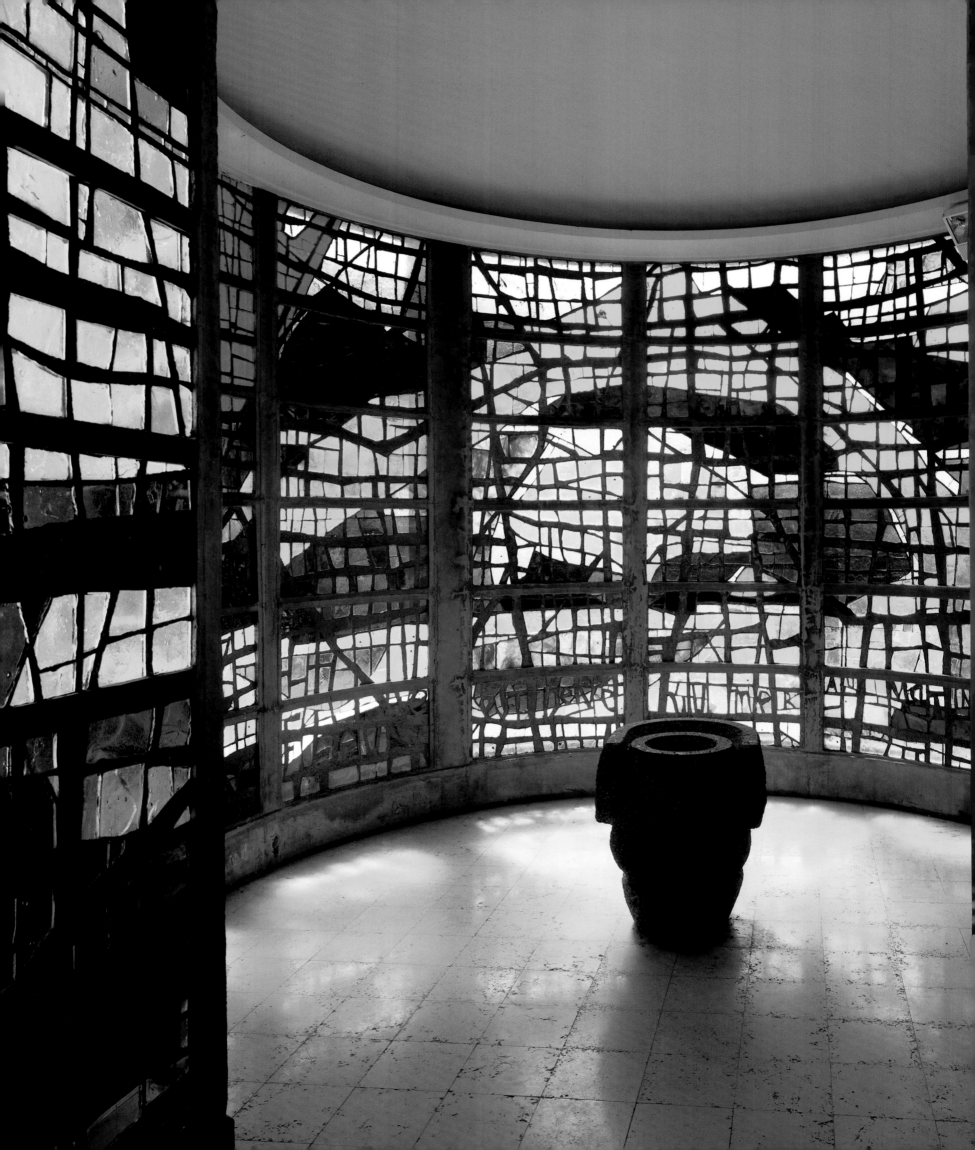

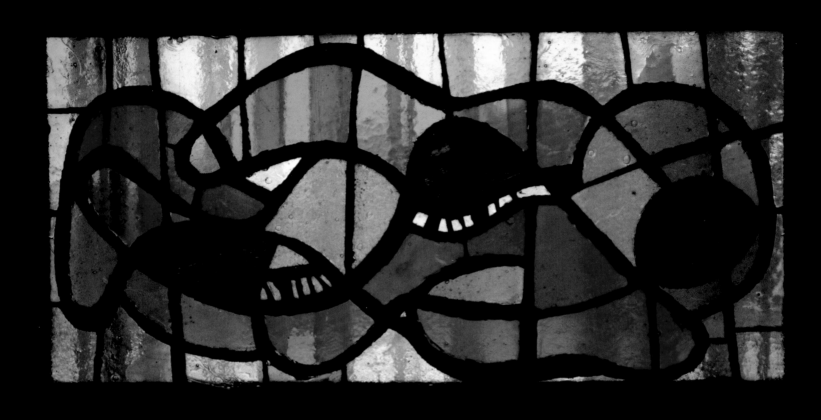

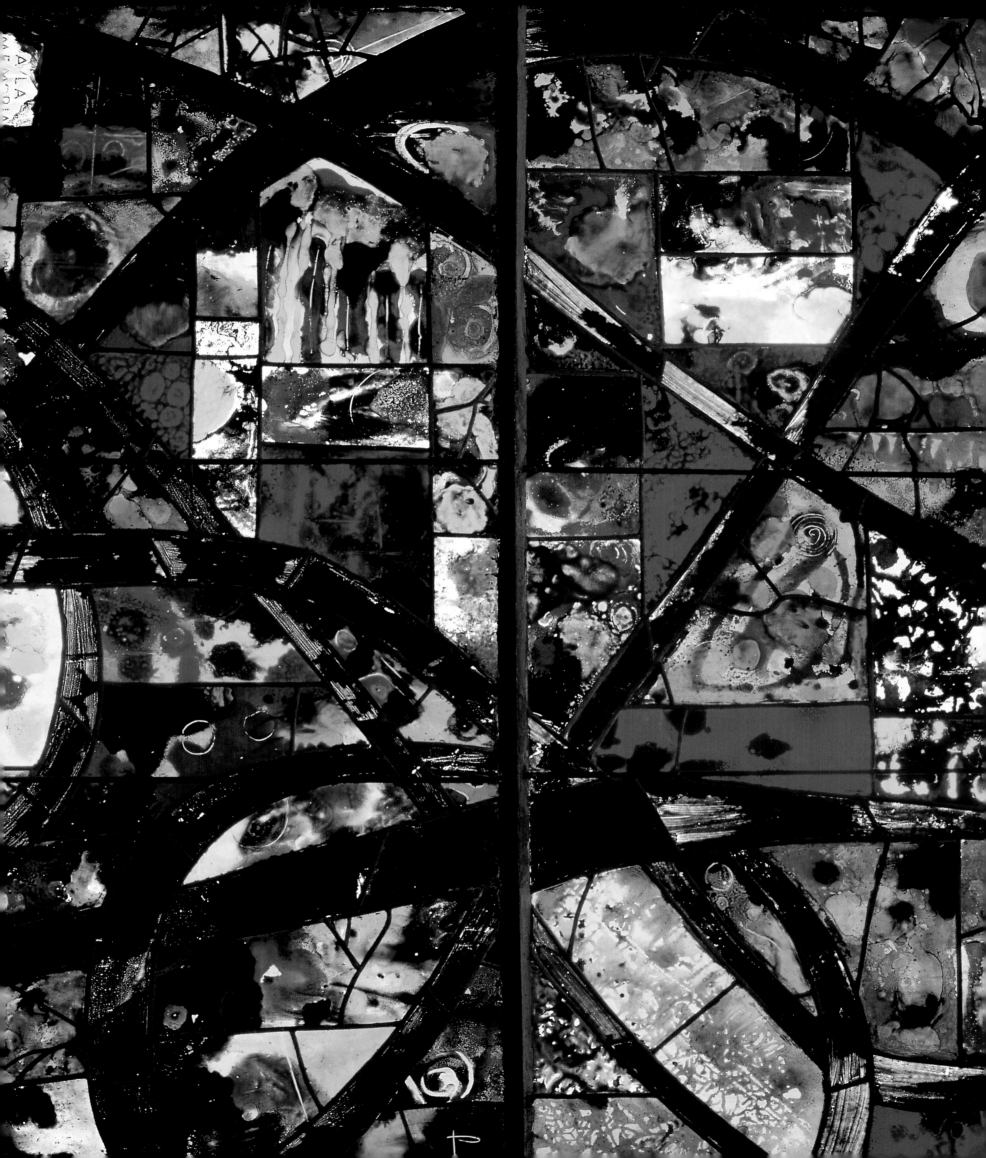

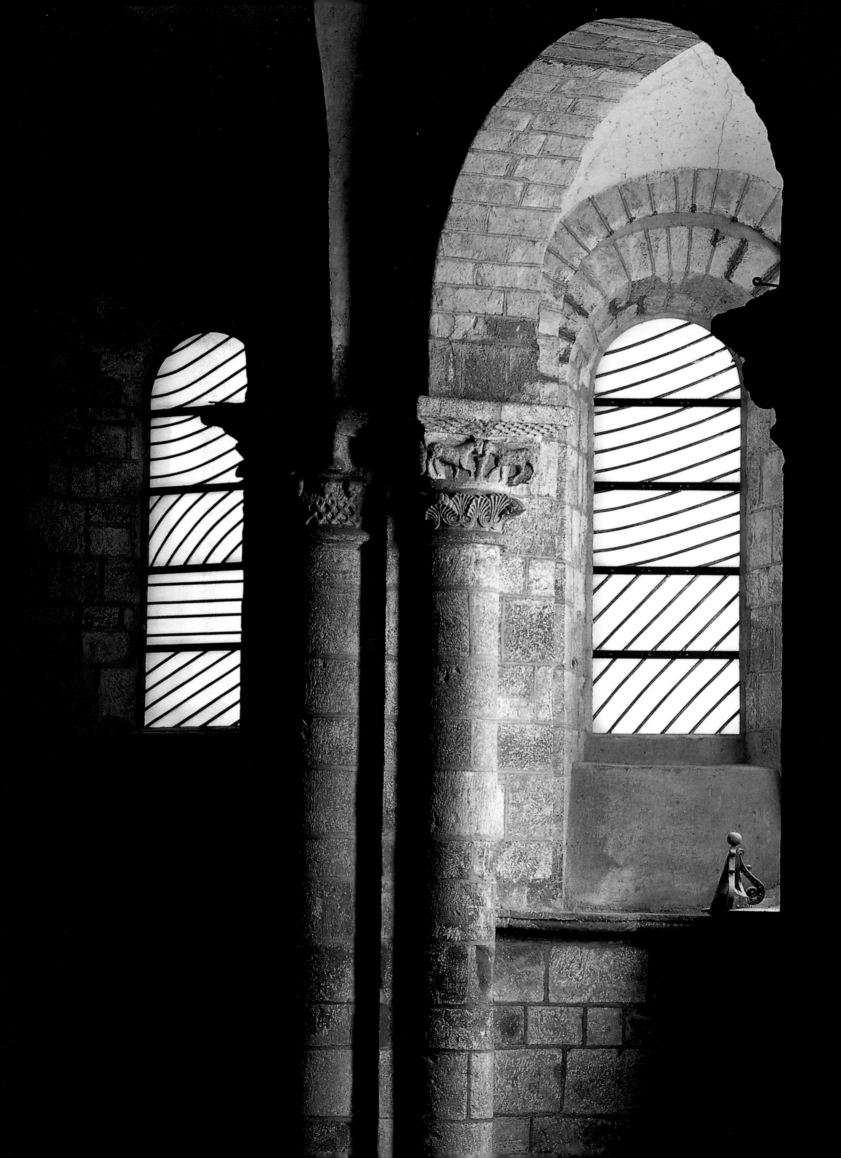

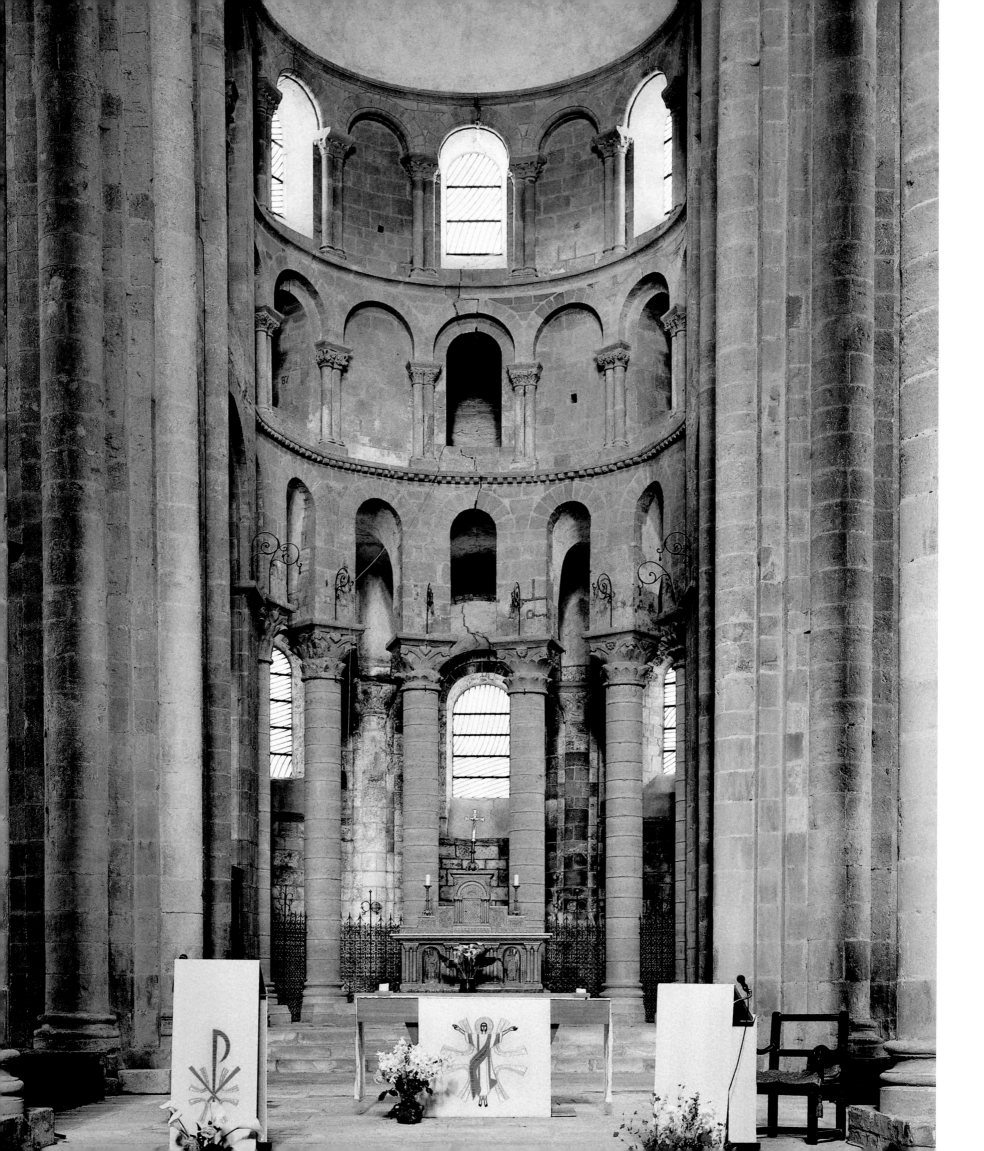

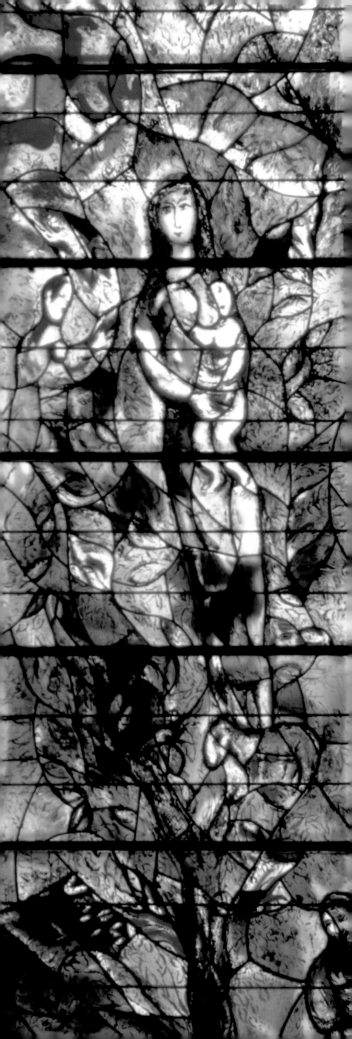

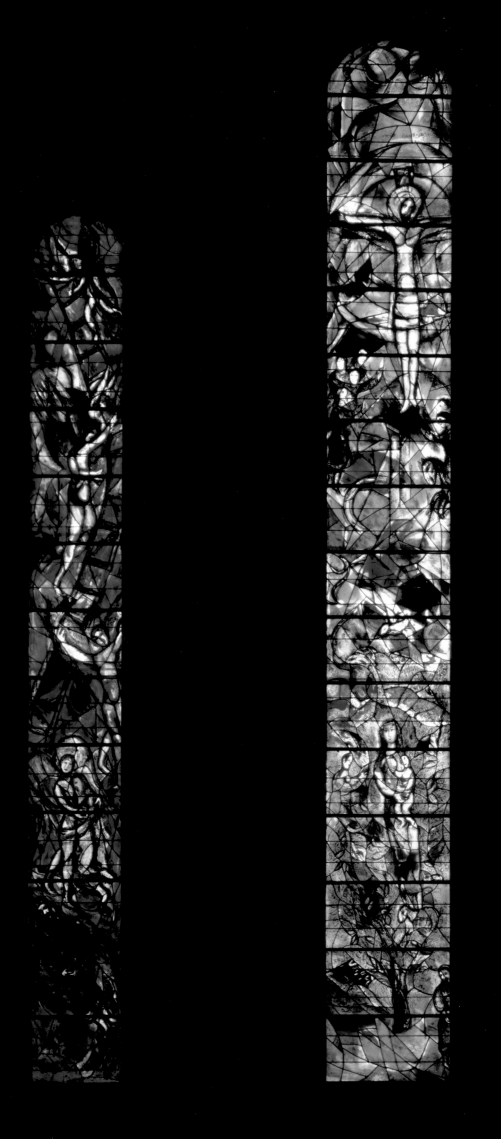

p. 132

pp. 144–45

p. 147

p. 148

p. 149

p. 150

p. 151

pp. 152–53

p. 154

p. 155

p. 156

p. 157

pp. 158–59

p. 160

p. 161

p. 162

p. 163

p. 164

p. 165

p. 166

p. 167

p. 168

p. 169

p. 132

The modernity of Frank Lloyd Wright's architecture and the austerity of his pure, rational lines are expressed in stained glass in the Danforth Chapel (1955) at Florida Southern College, Lakeland.

pp. 144–45

Installed in 1992, these imposing windows by Tom Denny in Gloucester Cathedral are reminiscent of the work of Marc Chagall.

p. 147

The church of Notre-Dame in Raincy, on the outskirts of Paris, built by the architect Auguste Perret in 1922–23, is distinguished by its vaulted ceilings and supports, its inner spaciousness and the light that pours in through the stained-glass windows, some of which were designed by Maurice Denis.

pp. 148–49

The new Coventry Cathedral, built after the destruction of the original building in World War II, is a solid structure lightened both inside and outside by the interplay of rectangular stained-glass windows set into the stone, and by variations in colour.

pp. 150–53

The chapel of Notre Dame du Haut, Ronchamp (1950–55), is one of Le Corbusier's most original works. His characteristic curving forms incorporate deep, narrow, strictly geometric openings, echoing the medieval notion of heightening the luminous effect from the exterior to the interior by isolating beams of light.

p. 154

The church of Hogares Mundet in Barcelona (1954–57) was one of the first attempts to create modern religious art in the Franco era. The windows by Will Faber and Jordi Pla Domènech were some of the first abstract, geometric stained glass to be produced in Spain.

p. 155

Stained glass by Gerdur Helgadóttir (1928–75) in the church of Skálholt, Iceland. This expanse of red and blue helps to trap the Nordic light inside a building that is naturally dark.

pp. 156–59

The continuing construction of the Sagrada Familia in Barcelona has aroused fierce debate in recent decades between those who wish to leave Gaudí's building unfinished and those who want it to be completed. The geometric designs of these windows by Joan Vila-Grau are full of religious symbolism.

pp. 160–61

The church of Sacré-Coeur in Audincourt, France, built by the architect Maurice Novarina, is famed for its faceted glass windows, created in 1950 by Fernand Léger.

p. 162

Stained-glass window designed by Fernand Léger, in the Maeght Foundation chapel in Saint-Paul-de-Vence, France.

p. 163

Stained glass in the church of Hogares Mundet in Barcelona, by Will Faber and Jordi Pal Domènech

pp. 164–67

One of the most renowned French glass projects in recent years was Pierre Soulages's contribution to the Romanesque church of Sainte-Foy in Conques. Commissioned in 1987 and completed seven years later, these 104 windows ambitiously sought to transform the light and geometry within the stark building. Parallel lines – horizontal, vertical and curving –and subtle variations of shade give these abstract designs a strong impact. The windows produce a striking effect from both inside and outside the church.

pp. 168–69

The elongated shape of the presbytery windows in the Fraumünster church, Zurich, was ideally suited to the style of the painter Marc Chagall, who produced them in 1970 in his customary palette of blues and reds.

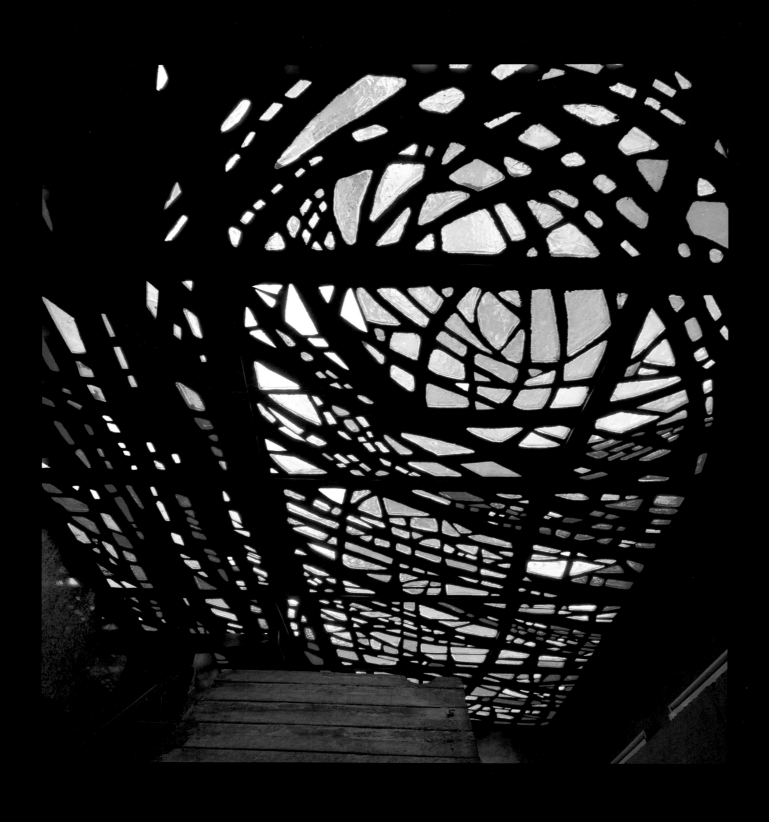

EMBLEMS OF THE EVERYDAY:
NEW SPACES, NEW PROJECTS

Two elements encouraged the use of secular subjects in stained glass during the Renaissance: a growing interest in classical literature and a gradual weakening of the influence of the Catholic Church in northern Europe as a result of the Reformation. The new trend was further intensified by the emergence of a new middle class that started to build houses with private chapels and spacious halls ideally suited to decoration with large stained-glass windows. These houses set fresh challenges for glass workers as, unlike churches, they required a maximum of light and so strong colours were out of the question; transparent glass with heraldic adornments was usually considered most appropriate. The impact of domestic stained glass was thus generally more discreet than that of its religious counterpart, as it operated on a smaller scale.

Other subjects liable to be found on the windows of mansion houses included portraits and figures from Greek and Roman mythology – often imitating fashionable Italian paintings or popular stories, as in Rendcomb College (1867) in Gloucestershire, with its windows based on Aesop's fables. There were also cases of stained-glass windows that inspired artists working in other media – those in Rouen Cathedral, for example, prompted Gustave Flaubert to write *The Legend of St Julian the Hospitaller*.

Once stained glass fully broke free of its religious confines in the late 19th century, it began to find a place in communal leisure areas, such as cafés, concert halls and restaurants – and in the latter case it would continue to be popular well into the 20th century. This eruption of stained glass into everyday life was propitiated by the increasing incorporation of iron and glass into architecture. These two materials were combined to make buildings that demanded bright interiors – greenhouses, markets, warehouses, factories – as well as new structures that would greatly expand the repertoire of modern architecture – department stores, railway stations, kiosks, entrances to underground stations. An early example of this process was the Gare d'Orsay railway station in Paris, opened on 4 July 1900 and designed by the architect Victor Laloux in a combination of stone, glass and metal. It formed part of the plan to spruce up the city for the 1900 Universal Exhibition; in 1986 it was reopened as the Musée d'Orsay. Its monumental structure contains 12,000 tonnes of metal, over 110,000 m^2 of supporting structure and 35,000 m^2 of glass. Another imposing structure from the same period is the Alando station in Bilbao (also known as the Estación del Norte), where the central foyer leading on to the platforms is embellished by a huge stained-glass window showing various aspects of the economy in the Basque Country. The Netherlands, in its turn, can boast Amersfoort station, where the main façade is a stained-glass window with decorative abstract motifs. Stained glass also featured in the underground railway systems of Moscow and Montreal.

In London, the Michelin Building (1909) also included stained glass as an integral part of its decoration; it is a significant example of Art Nouveau, with elements anticipating Art Deco thrown into the mix. In 1985 it was bought by Sir Terence Conran and Paul Hamlyn, who converted it into the restaurant Bibendum. The restoration project sought to restore many of the building's original features, while adapting it to its new use.

The early 20th century saw the development of the new architectural form of the shopping arcade, covered by metal and glass roofs that took advantage of natural light. Pioneers in this field included the Galeries Lafayette in Paris, topped by an enormous skylight (p. 180), and the Victoria Quarter in Leeds, designed by Frank Matcham. A century later, stained glass still finds a place in modern shopping malls, as evidenced by the Victoria Quarter's new roof (1989; pp. 192–93), designed by Brian Clarke, or the glass pyramids covered with Egyptian motifs at the Wafi Shopping Mall in Dubai (pp. 76–77). Market buildings may also feature stained glass – as in the municipal market of São Paulo in Brazil, with a window on its façade showing farmers working in the fields.

Stained glass is sometimes used to add a distinctive touch to hotels. It plays a key role, for example, in the decoration of the hotels on the Hawaiian island of Maui, while the Gellert Hotel in Budapest sports a large rose window in pure Gothic style that creates attractive combinations of light and colour (p. 181).

In the late 19th century, botanical gardens and greenhouses began to become fashionable, as their presence in a city indicated its mastery of the technical innovations involved in building glass structures. The Botanical Gardens in Toluca, Mexico, boast magnificent stained-glass windows completed in 1990 by Leopoldo Flores Valdés (born 1934); one stunning panel shows flames swathing a man's body in an array of reds, whites, oranges and yellows.

In 1964, the United Nations Building in New York installed a stained-glass window designed by Marc Chagall in its visitors' reception area (pp. 112–13). This window had a particular poignancy, as it was a monument to Dag Hammarskjöld, the second Secretary-General of the UN, who was killed in a plane crash in 1961, along with fifteen others. The window contains many symbols of love and peace, such as a maternal figure and a young man in the centre being kissed by an angelic face emerging from flowers. The composition is dotted with musical notes from Hammarskjöld's favourite symphony, Beethoven's Ninth. Again in 1964, stained glass was used in another commemorative monument, this time in honour of the slain in Vietnam and Korea, in the National Memorial Cemetery of the Pacific in Honolulu, Hawaii. Years later, in 1998, an illuminated stained-glass plaque was unveiled at the Diana Princess of Wales Children's Hospital in Birmingham in tribute to the late princess. It depicts the silhouettes of both children and adults grouped around a red balloon marked with a white cross.

In 1989, the Louvre Museum in Paris opened, amid enormous controversy, its glass pyramid extension (pp. 208–9), designed by the Chinese-American architect I. M. Pei. The structure consists of 666 diamond-shaped pieces of glass, spanning a total area of 1,250 m². The glass here serves a functional purpose that moves it away from the decorative approach of stained glass, but it represented a landmark in the control of light and transparency in modern architecture.

Many contemporary European artists have sought to break away from the religious subject matter traditionally associated with stained glass in order to further its possibilities, and American artists have not been slow to follow suit. Technical advances and the notion of glass as an integral component of a building's structure have led artists to innovations in both the composition of glass and its role in architecture. For example, Ed Carpenter (born 1946) has brought glass into three dimensions and imbued it with a new expressive language, creating a powerful visual impact that is enhanced by his striking colour schemes. His lobby window for the Justice Center in Portland, Oregon, dating from 1983, reflects the blue of the sky and captures sunshine throughout the day. The large window that he created in 1993 for the School Of Business Administration of Wisconsin University in Madison is comprised of some 75,000 wafers of blue glass, arranged in a pattern recalling a computer circuit. In the same year, Carpenter endowed the Federal Building in Oakland, California, with a glazed rotunda consisting of 128 panels that set up infinite nuances of light. In 1997, Carpenter reinterpreted the idea of the rose window in St Mark's Cathedral in Seattle, Washington, by masking it with a structure composed of glass sheets that refracted the light passing through the window in an attractive display of colours.

The US currently leads the way in the field of secular stained glass. Another pioneering figure is James Carpenter, who takes the concept of tridimensionality even further than his namesake, into the realm of architectural glass sculptures. He specializes in the use of dichroic glass, which is treated with a coating to create different colours and reflections according to the light. This quality draws in onlookers, who are able to 'change' the colour of the glass as they move around the installation. From 1985 to 1987, he created *Structural Glass Prisms* for the chapel of the Christian Theological Seminary in Indianapolis. Another of his major works is the *Dichroic Light Field*, made in 1994–95, which is now displayed on the façade of the Millennium Tower in Columbus Avenues, New York. It is comprised of a grid of laminated glass panels, supported by a simple steel substructure, and studded with more than 200 dichroic glass fins, which split and reflect the sunlight, creating colours that range from gold and green to indigo and magenta.

Covered shopping arcades were one of the 19th century's most notable architectural innovations. Their structure combined stone and metal, while they often used stained glass for their internal lighting, as in the County Arcade (1898–1904) in Leeds, built by Frank Matcham.

The innovations undertaken in stained glass in the United States have embraced many different fields. Some artists, for example, have focused their attention on colour. This is the foremost preoccupation of Narcissus Quagliata (born 1942), an Italian who studied under Giorgio de Chirico but has long been resident in the US. Quagliata came up with a new technique for fusing glass that enhances its colour and therefore its expressive power. These effects can be seen in his window for the library in the Engineering Department of the National University of Mexico City (1989) and his monumental glass wall entitled *Gateway into Night* (1995), made up of 108 panels. Quagliata's recent work has been undertaken in conjunction with the architect Ricardo Legorreta. Their collaborations include a window panel for the Hotel Reforma in Mexico City, which incorporates 800 m^2 of stained glass. In 2000, as part of the millennium celebrations, Quagliata replaced the old rotunda of the Basilica of Santa Maria degli Angeli in Rome with a new glass dome called *Divinity in Light*. This includes three astronomical lenses, designed and calibrated in the National Autonomous University of Mexico, which are crowned by a yellow sphere. The lenses are intended to project the image of the sun on the centre of the dome during equinoxes and solstices.

Another leading figure on today's American scene is Stephen Knapp (born 1947), who combines various types of glass in his work. He also subjects his glass panels to fissures, marks and incisions in order to obtain different light effects.

In Barcelona, the recently completed Torre Agbar (2000–2005), designed by the architect Jean Nouvel (born 1945), uses an original combination of light and glass to create a polychrome exterior and interior in various shades, with a predominance of blue at night.

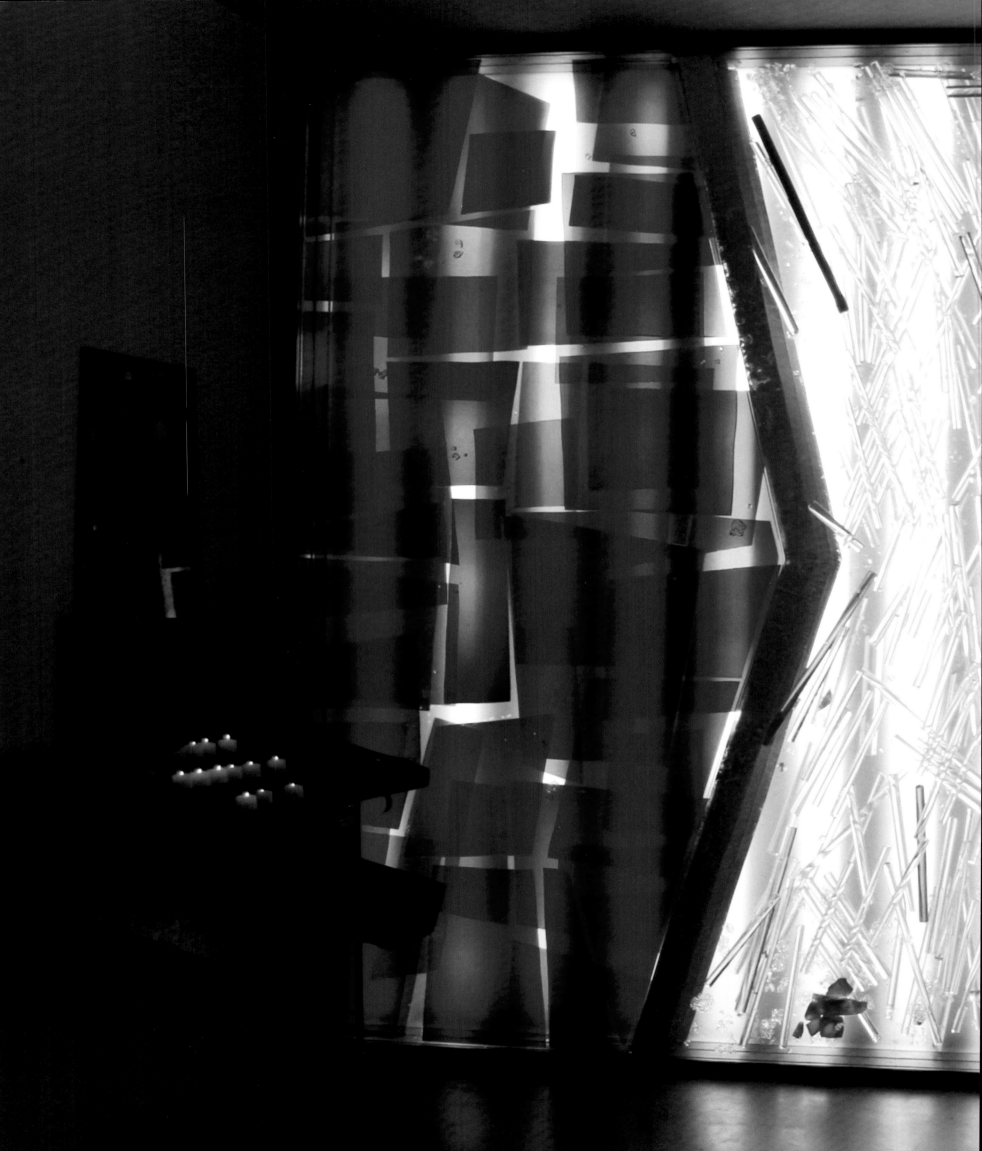

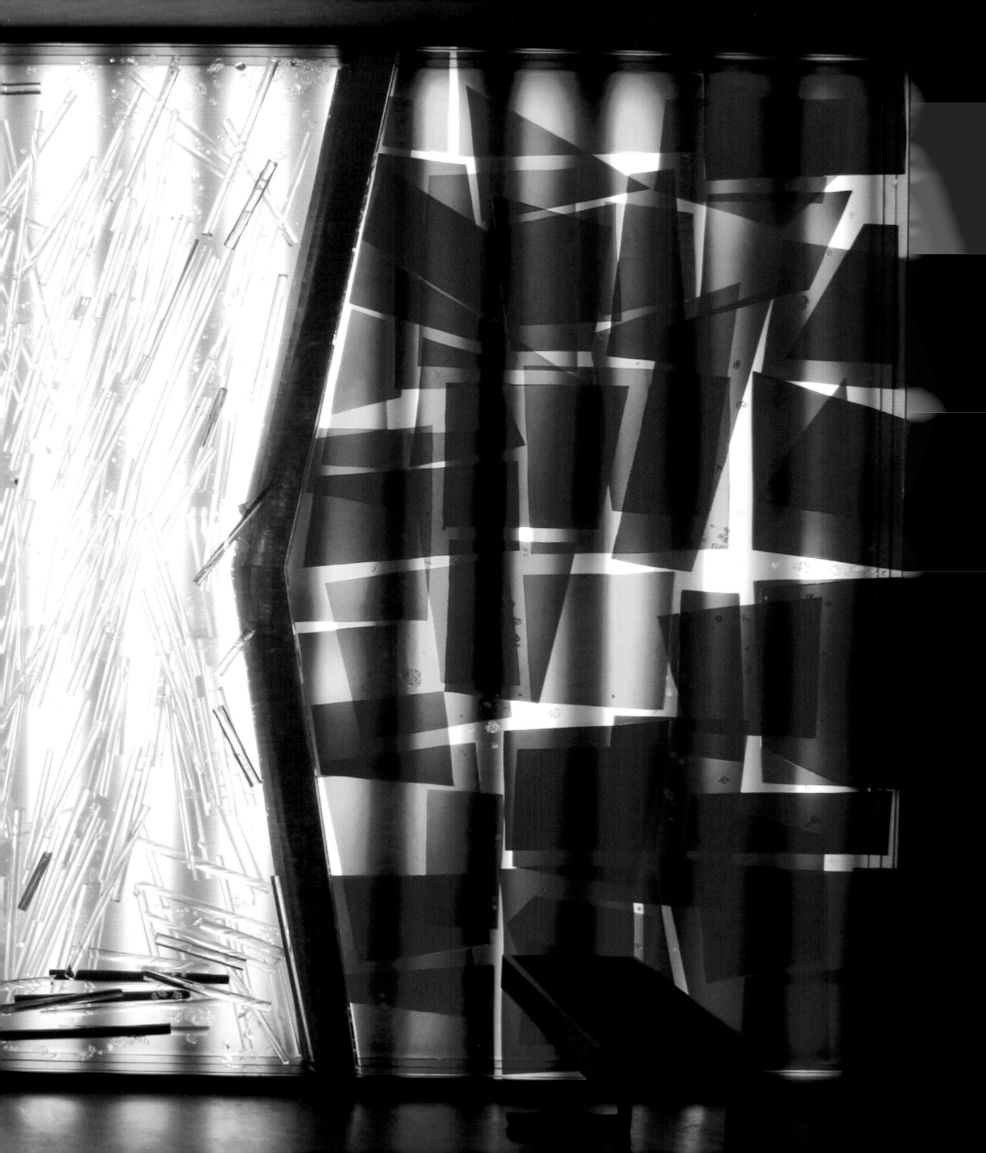

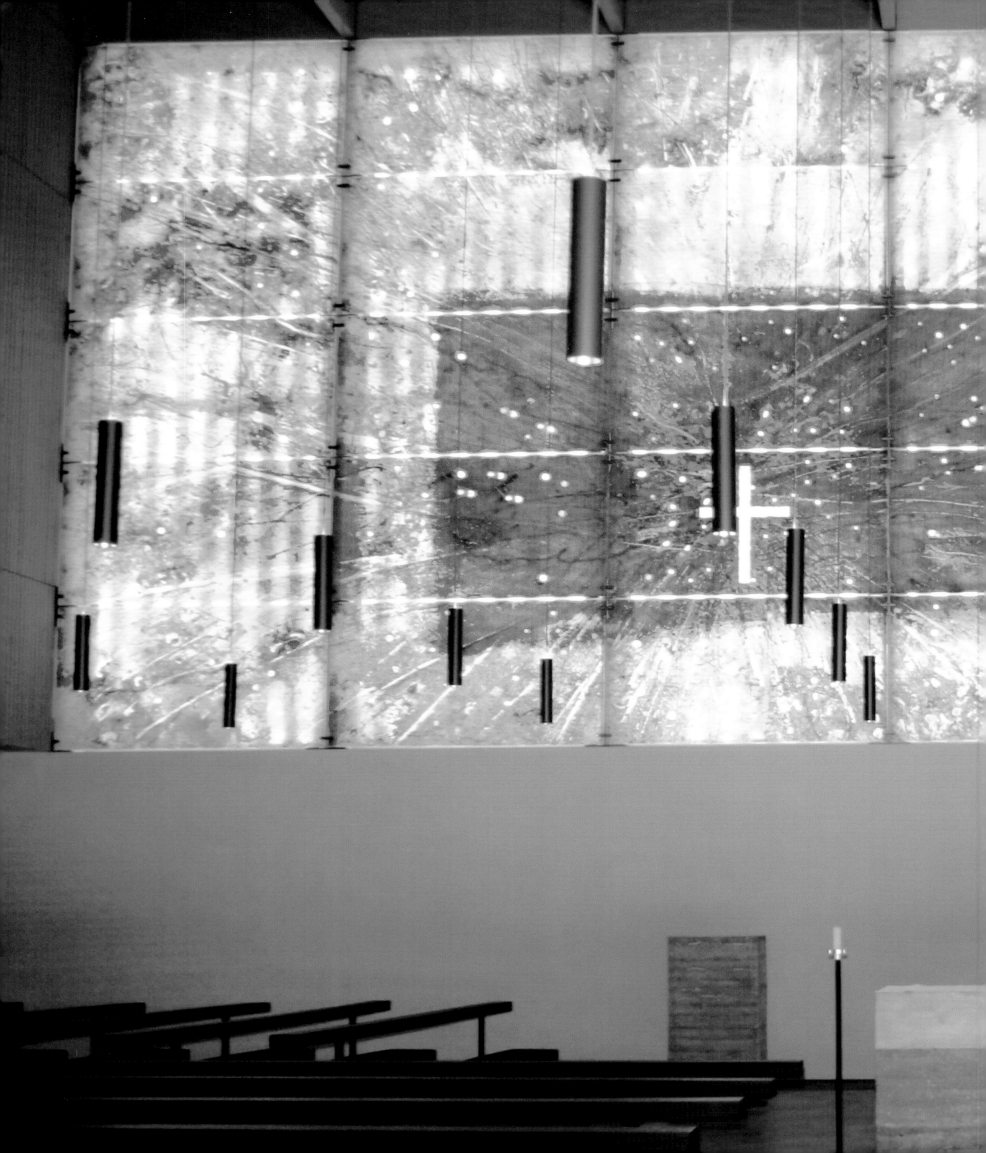

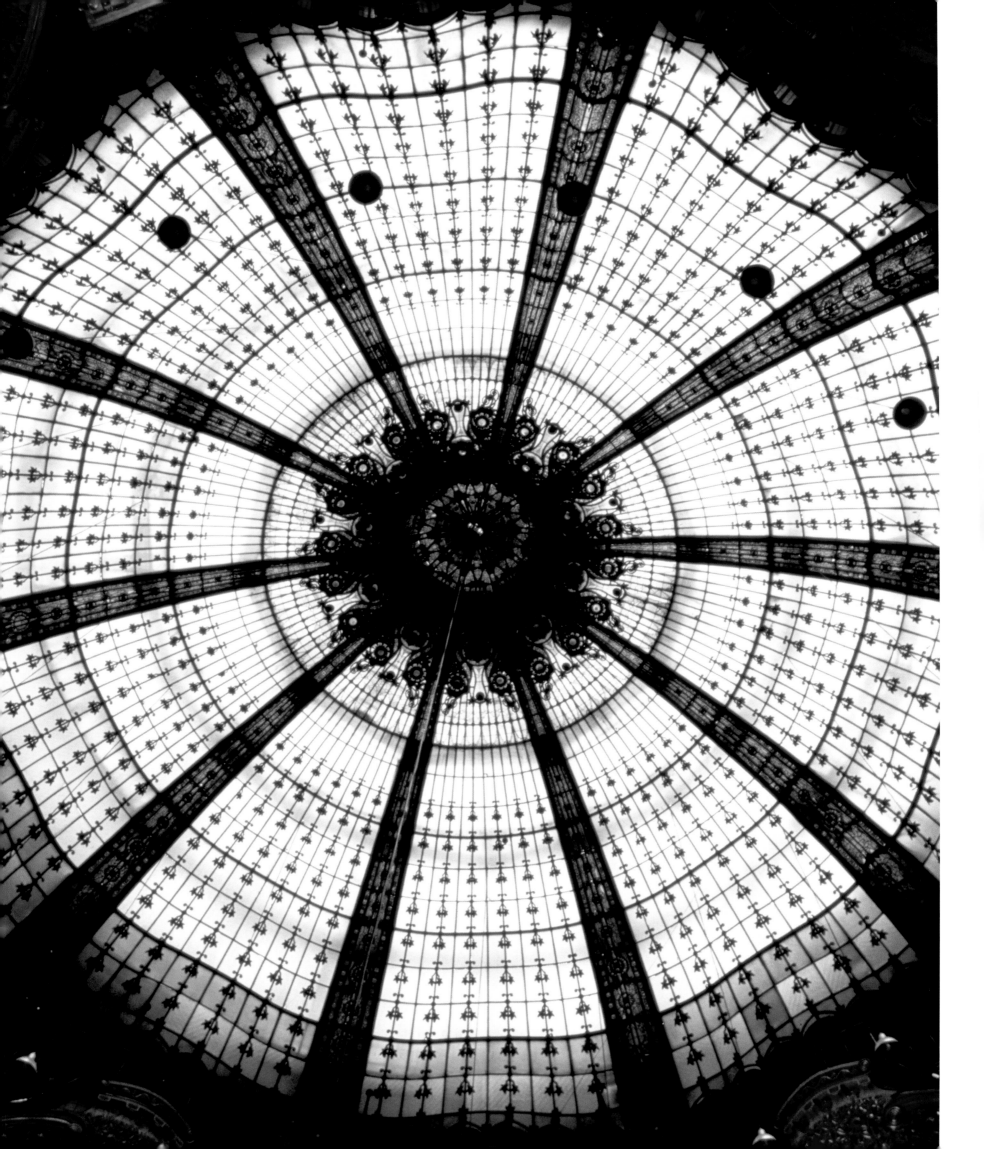

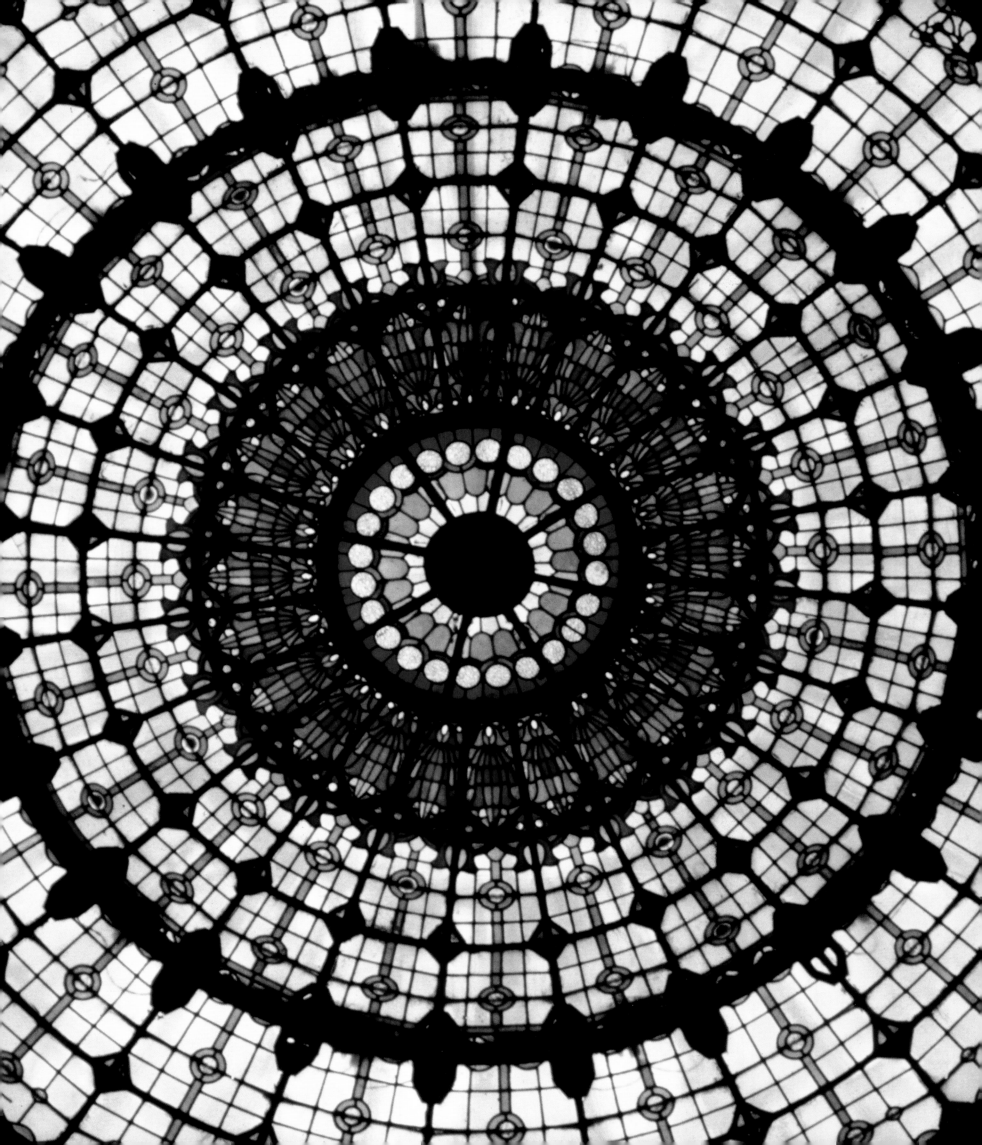

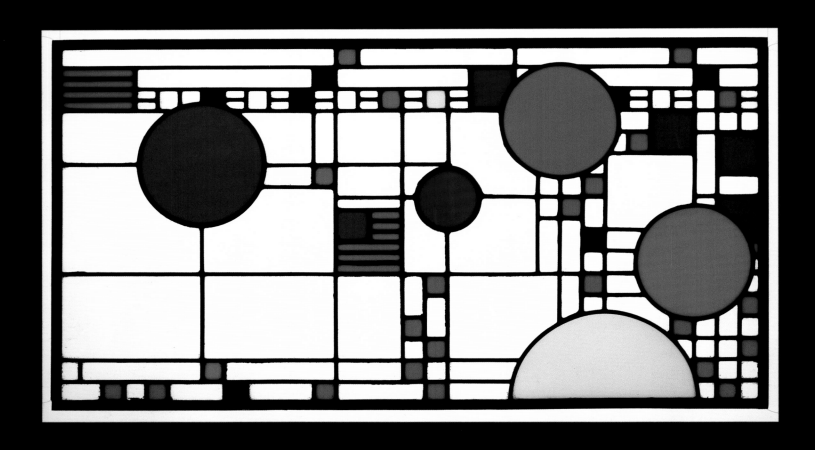

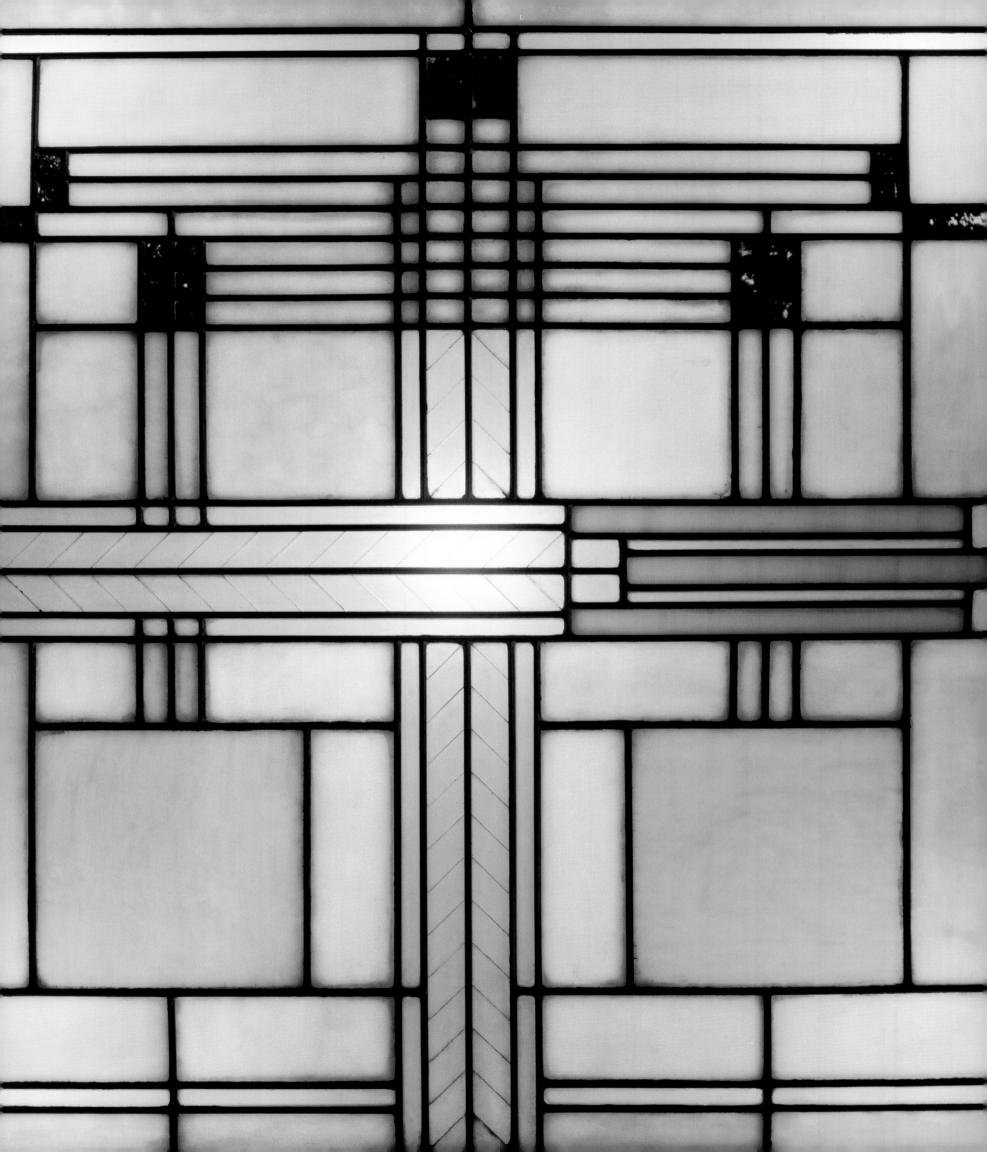

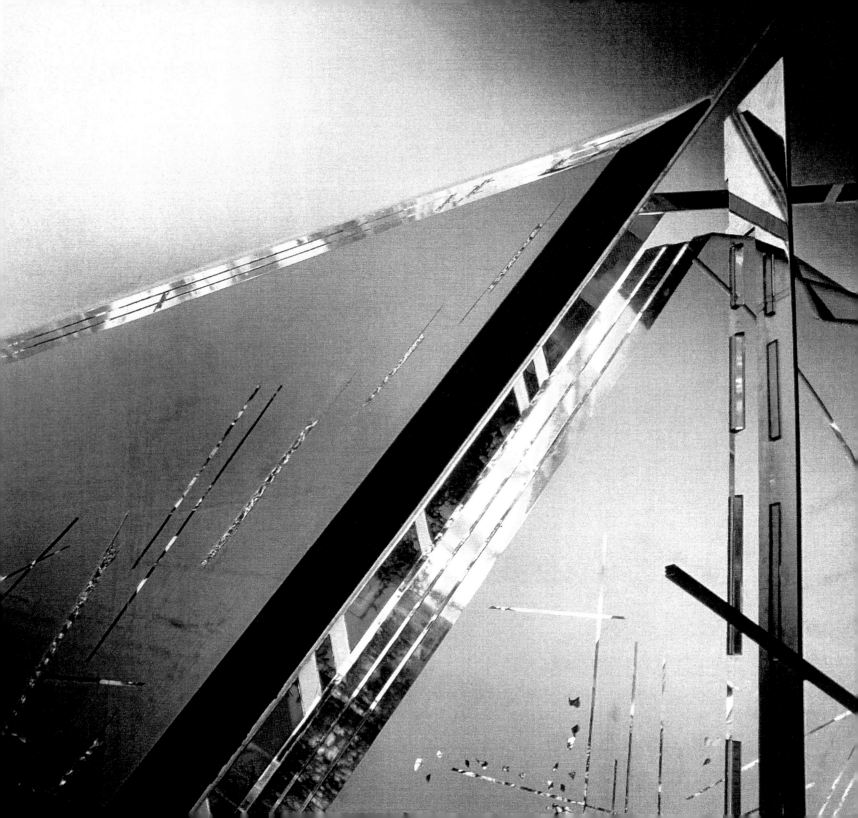

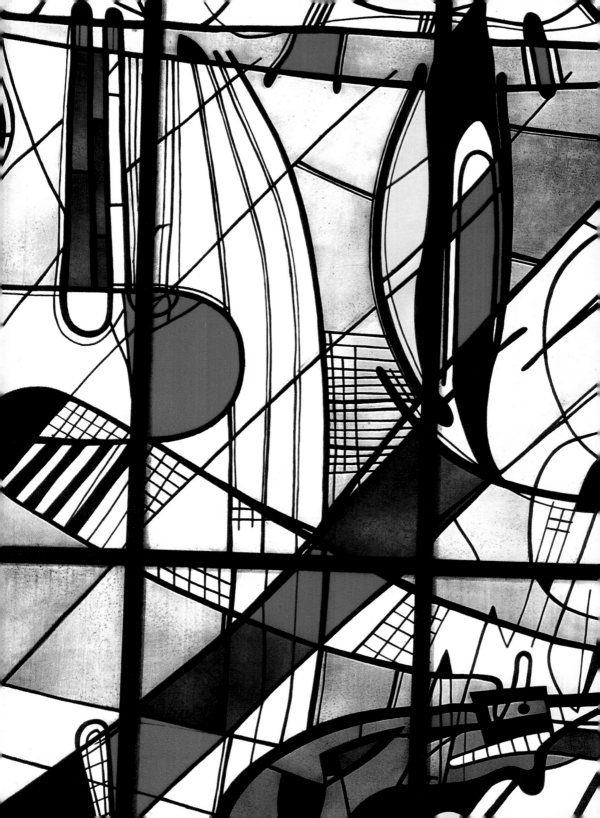

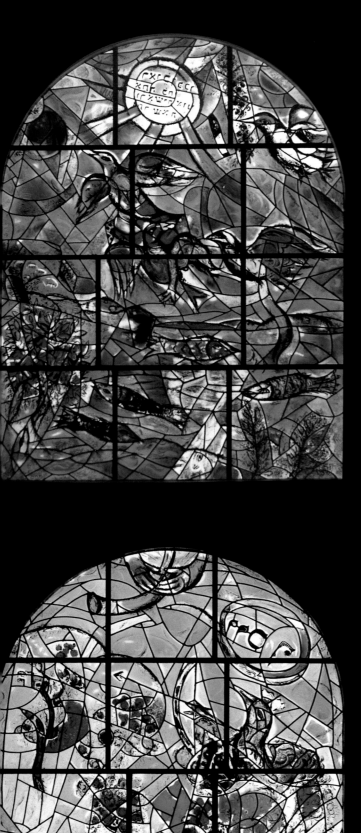
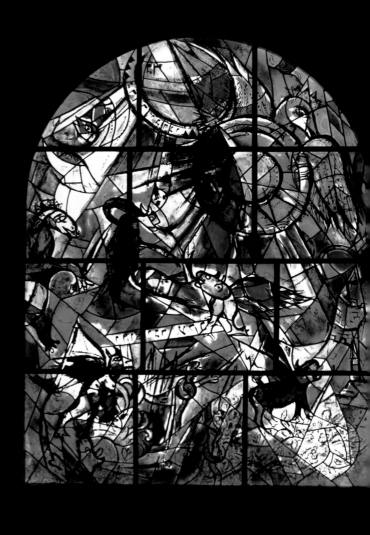
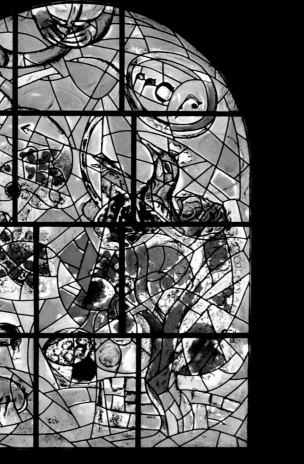
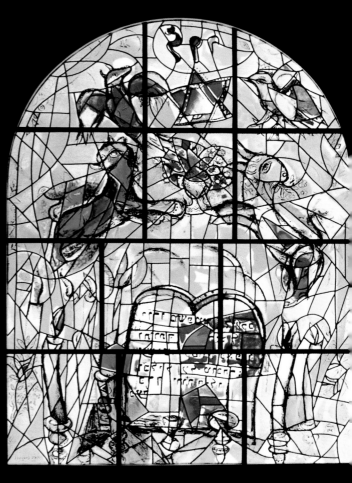

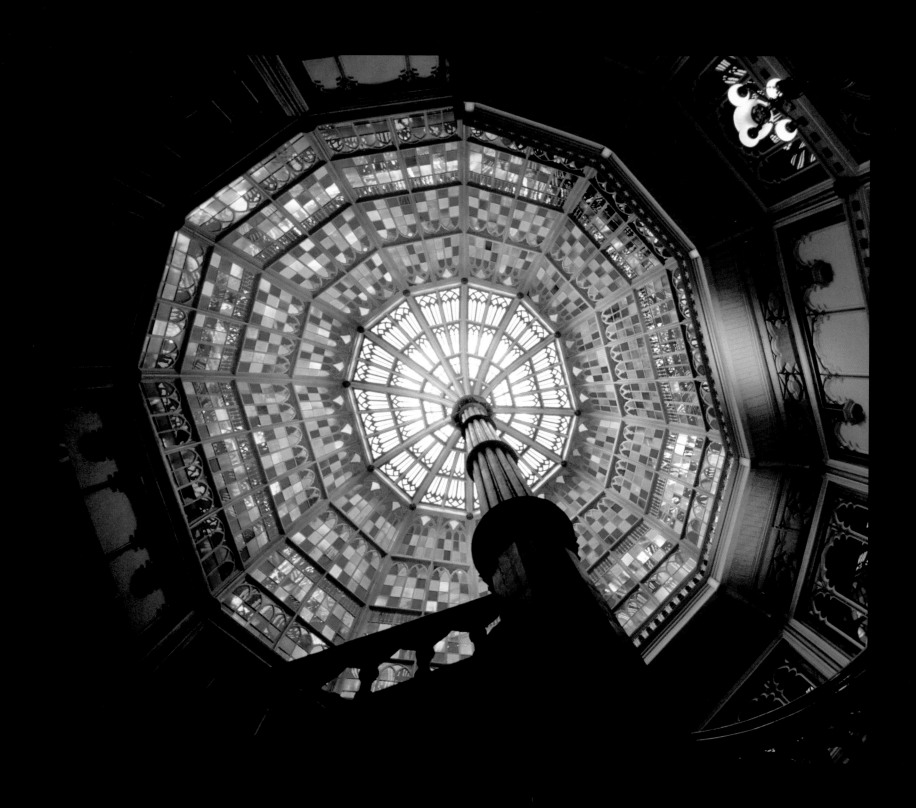

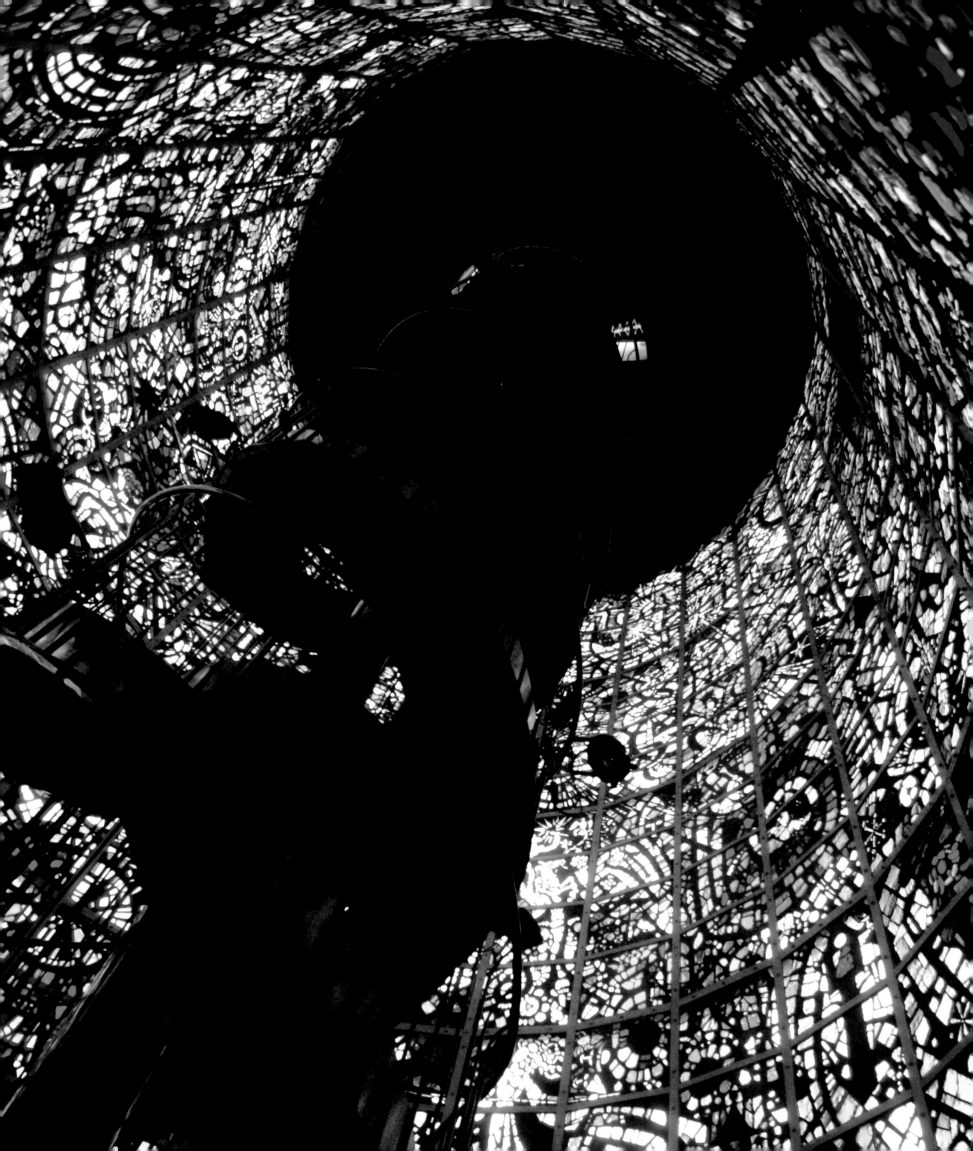

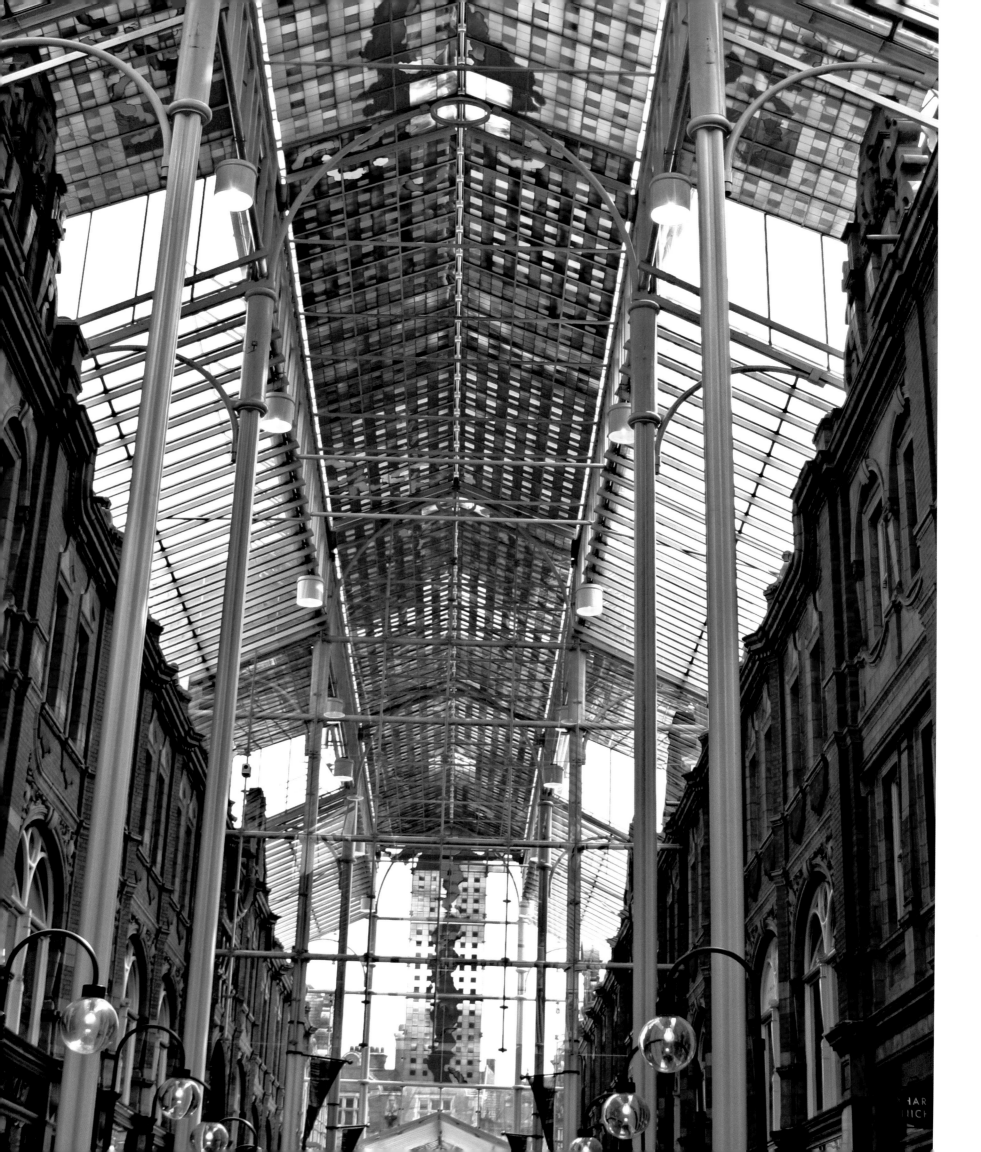

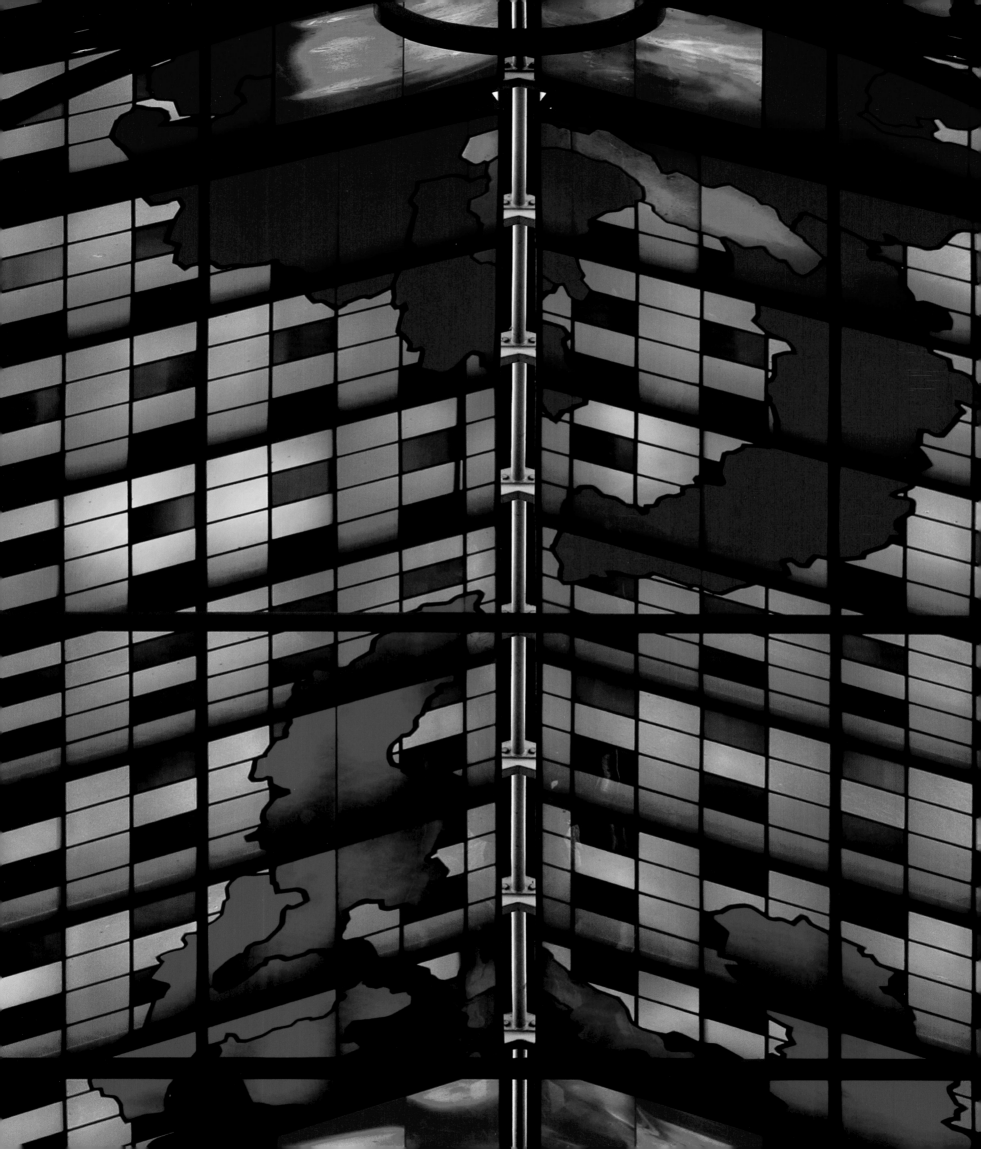

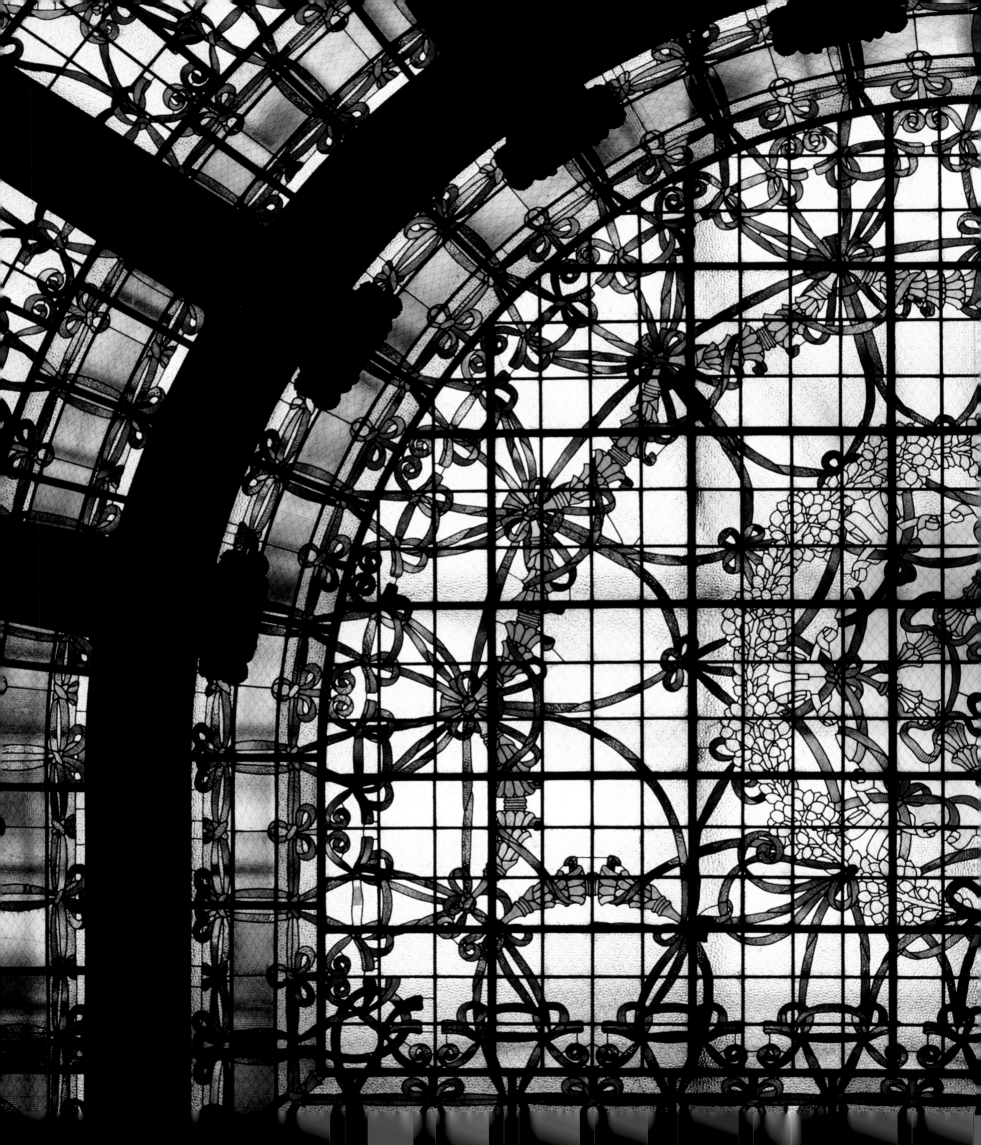

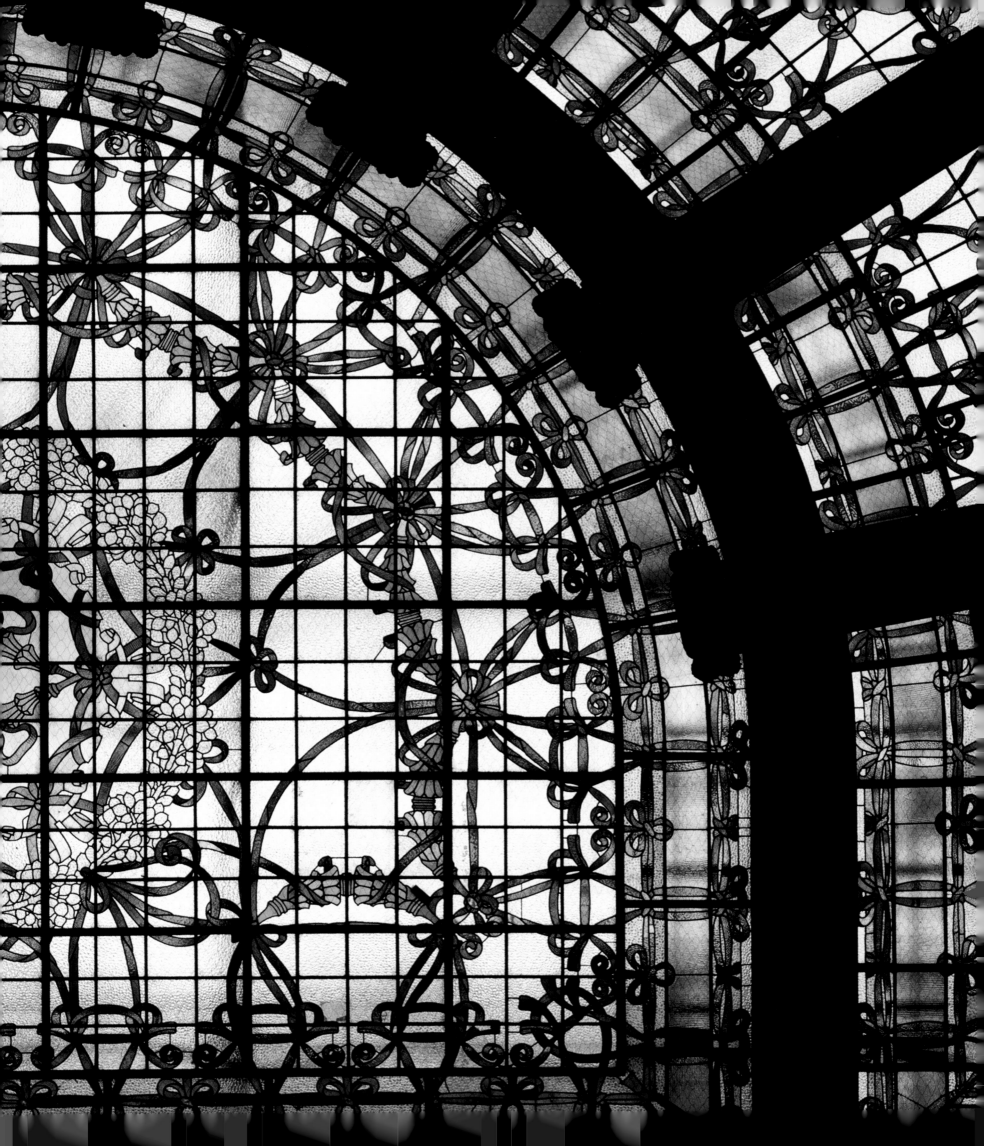

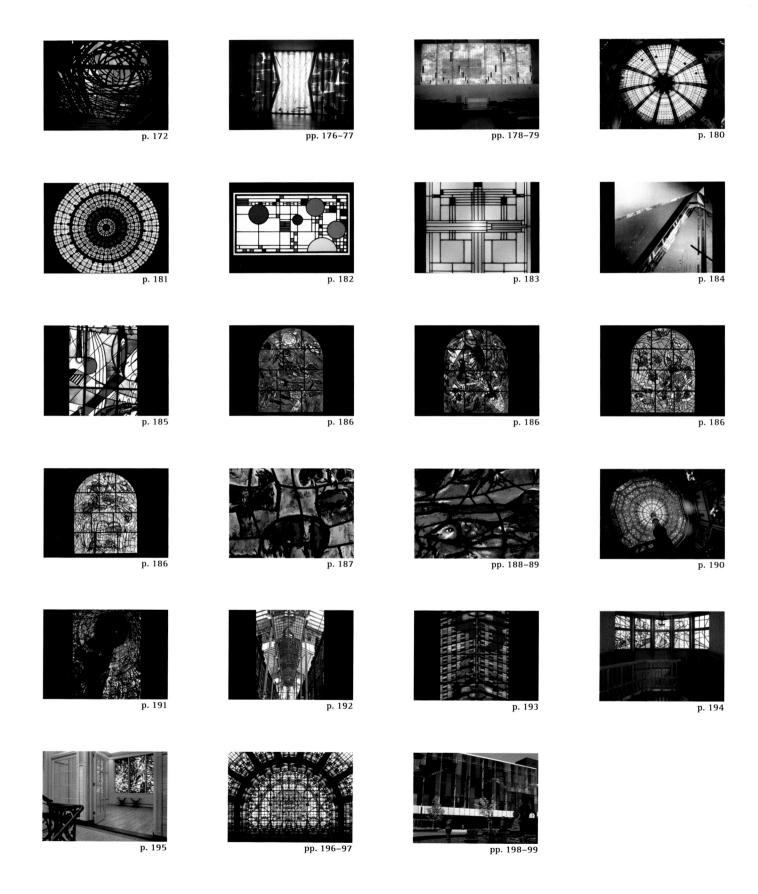

p. 172

pp. 176–77

pp. 178–79

p. 180

p. 181

p. 182

p. 183

p. 184

p. 185

p. 186

p. 186

p. 186

p. 186

p. 187

pp. 188–89

p. 190

p. 191

p. 192

p. 193

p. 194

p. 195

pp. 196–97

pp. 198–99

p. 172

The Catalan artist Joan Vila-Grau, who created the stained-glass windows in the Sagrada Familia in Barcelona, also made this decorative window in 1985 for the presbytery of the church of La Pau, in Barcelona.

pp. 176–79

In St Florian's Church in a modern religious complex in Munich, the transparent glass in the presbytery and the window by the altar, designed by Hella Santarossa, needed to satisfy the ecumenical demands of both a Catholic and a Protestant congregation, so spiritual concerns are conveyed entirely in terms of colour and light.

p. 180

The central glass dome of the Galeries Lafayette in Paris is typical of large department stores from the late 19th century.

p. 181

The Gellert Hotel in Budapest is famous for its magnificent glass skylight.

p. 182

This geometric stained-glass window by Frank Lloyd Wright, made in 1912, was removed from its original location in the house of Avery Coonley in Riverside, Illinois, and is now preserved in the Museum of Modern Art in New York.

p. 183

Ceiling of the dining room in the Ward W. Willits House in Highland Park, Illinois, designed by Frank Lloyd Wright in 1901.

p. 184

Decorative glass created in 1996 by José Fernández Castrillo for the Bayer offices in Barcelona.

p. 185

Stained-glass window by Georg Meistermann for the Westdeutscher Rundfunk building in Cologne, designed to recall the colours of music.

pp. 186–89

One of the most significant works in the career of Marc Chagall was the series of windows (1960) depicting the twelve tribes of Israel that adorn the synagogue in the Hadassah University Medical Center in Jerusalem.

p. 190

Interior of the dome in the Louisiana Old State Capitol, in Baton Rouge.

p. 191

This stained-glass tower at Hakone Open Air Museum, Japan, has an interior spiral staircase, allowing visitors to experience some highly imaginative and surprising effects. It is the work of Gabriel Loire.

pp. 192–93

Brian Clarke's glass roof for the Victoria Quarter, Leeds, seems to open onto an imaginary skyscape full of fantasy and colour.

p. 194

Stained-glass window by Dutch artist Jan Thorn-Prikker (1868–1932) in the Hohenhof Villa Museum in Hagen, Germany.

p. 195

Stained glass in the former offices of the Holland-Amerika Lijn shipping company in Rotterdam, built 1901–17 by the architects Johannes Müller and Droogleever Fortuyn. The building is now the Hotel New York.

pp. 196–97

Ernesto Basile (1857–1932) created this splendid roof for the Palazzo Montecitorio in Rome.

pp. 198–99

The striking colours of the façade of the Palais de Congrès, Montreal, Canada.

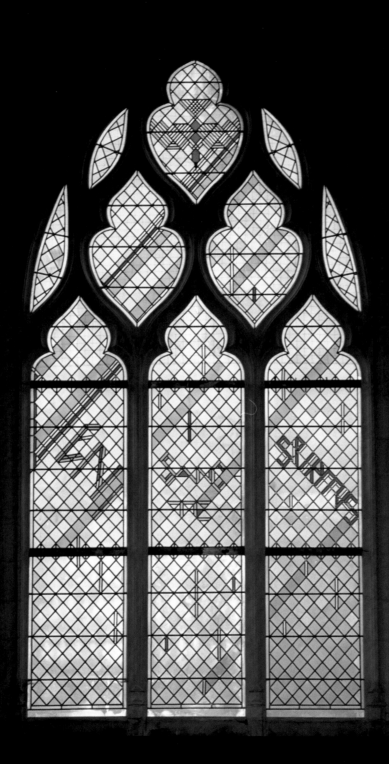

Conclusion

Stained glass has fascinated artists throughout its history. Its execution requires knowledge of a wide range of techniques, some specific to glass and others more general, such as glassblowing, annealing, moulding and etching.

In the 1960s, public institutions started to give artists the opportunity to experiment in this field, particularly in religious buildings. In the 1970s and 1980s, it became fashionable to commission multiple artists for a single building, but the time required to complete a stained-glass project – anything up to fifteen years – made it more practical to give all the work to one person, who was often asked to both restore old windows and create new ones.

In the 21st century, stained glass still has an important role to play in architecture, despite occasional communication problems between architects and glass artists. Stained glass has broadened its horizons to embrace techniques from other applied arts. The problems that it faces are the same as those facing any field of contemporary design, and the continuing debate between functional and aesthetic considerations is extremely pertinent to the relationship between architec-

ture and glass. The preponderance of functionalism, which may lead to a decrease in artistic and aesthetic value, is an issue that affects all of the decorative arts, glass included. It may seem that this functionalism has been superseded by the plurality of contemporary architecture, but this is not the case, since technological factors now have a vital role to play in every new building. Today's architects have to take into account not only the decorative contribution of stained glass but also a host of technical considerations, such as the interior temperature, the load borne by the walls, the scale of the building and the prevailing building regulations.

Although in recent decades stained glass has entered new fields of architecture, such as leisure facilities and workplaces, it is still primarily associated with religious buildings, largely due to the almost mystical relationship that it establishes with light, bringing images to life and enabling artists to create effects that would be impossible to achieve with painting or sculpture. This spiritual dimension still seduces visual artists, and even today many are unable to resist the lure of this fascinating medium by accepting commissions for stained-glass windows in churches both ancient and modern.

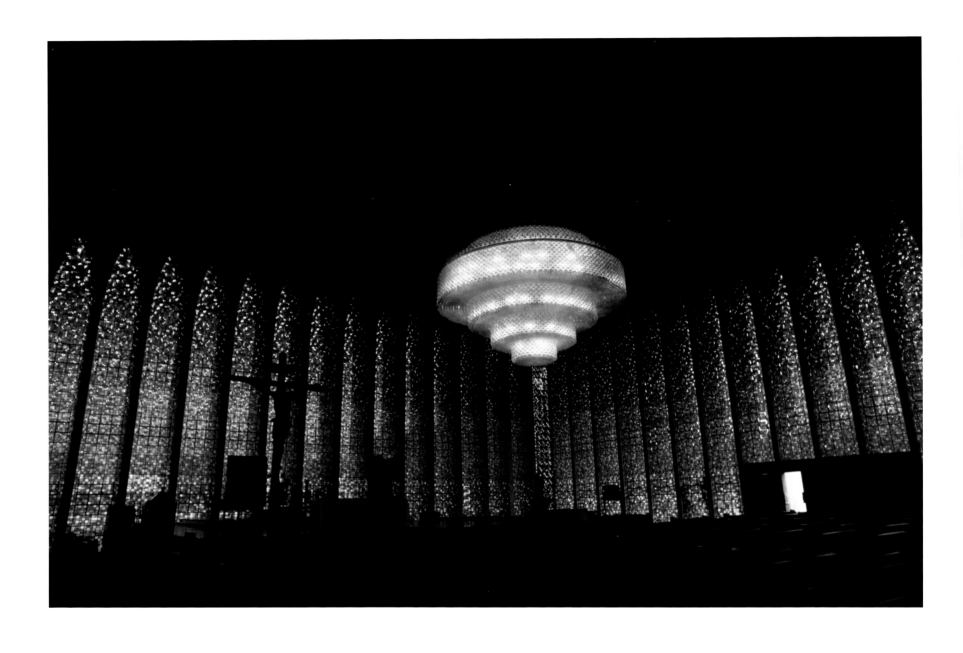

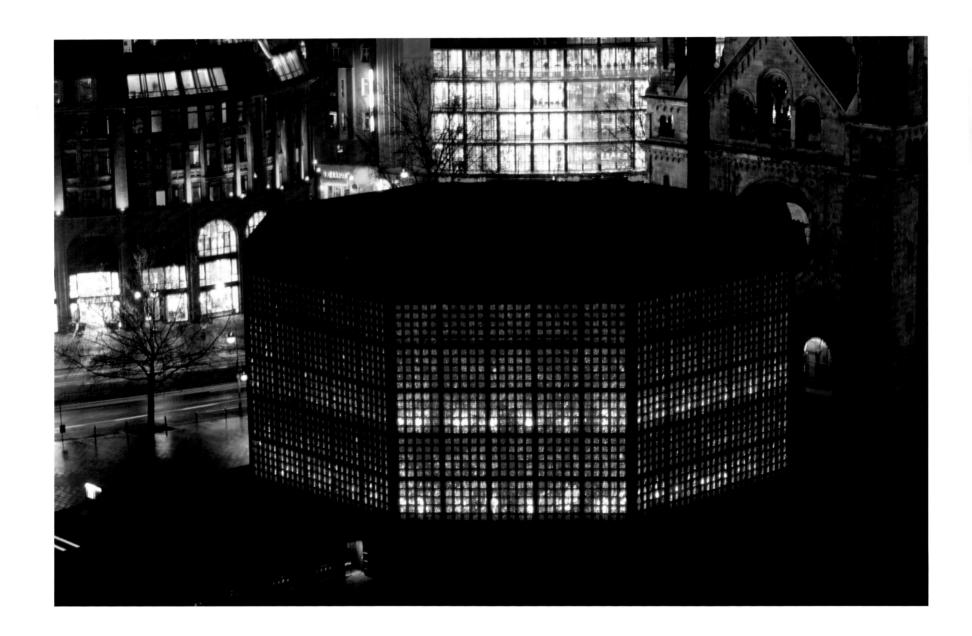

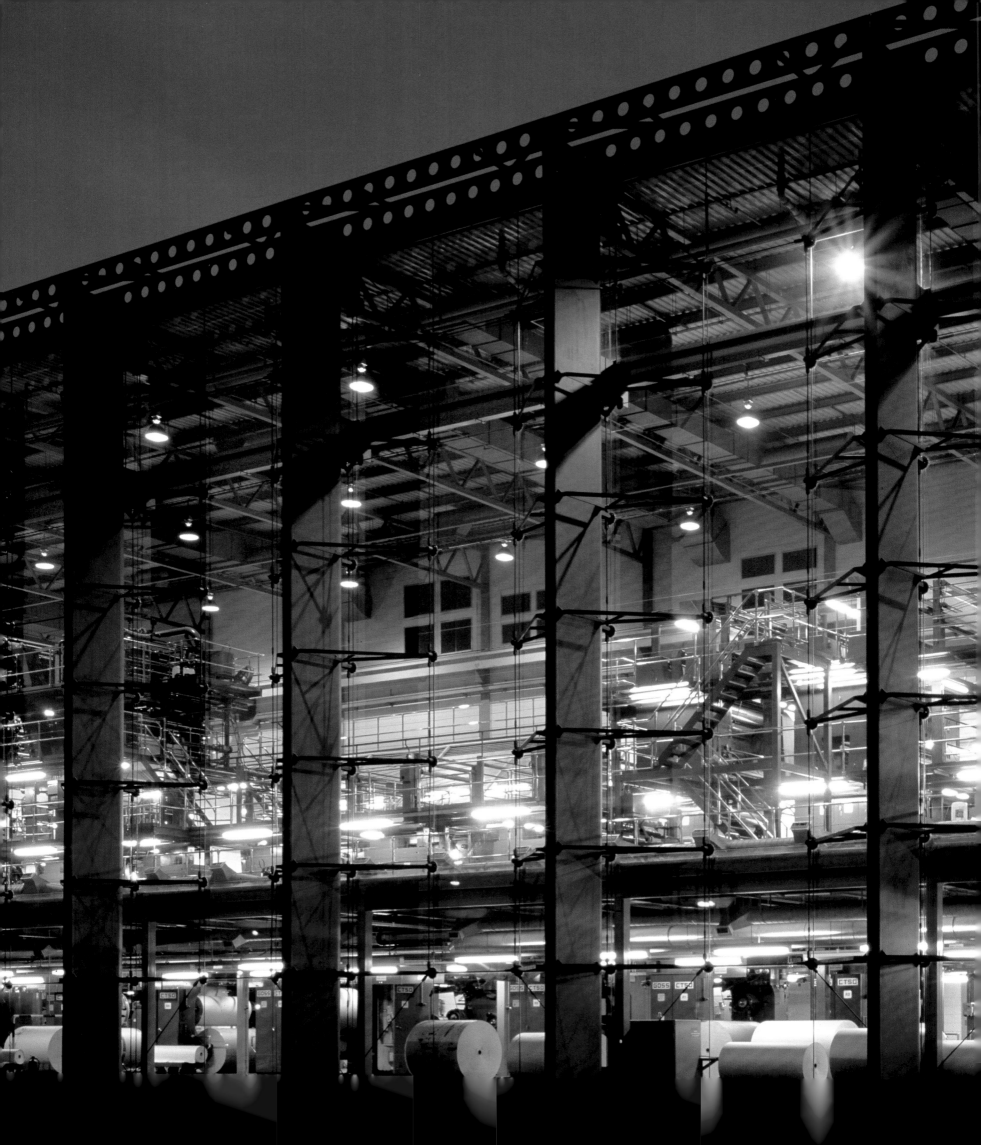

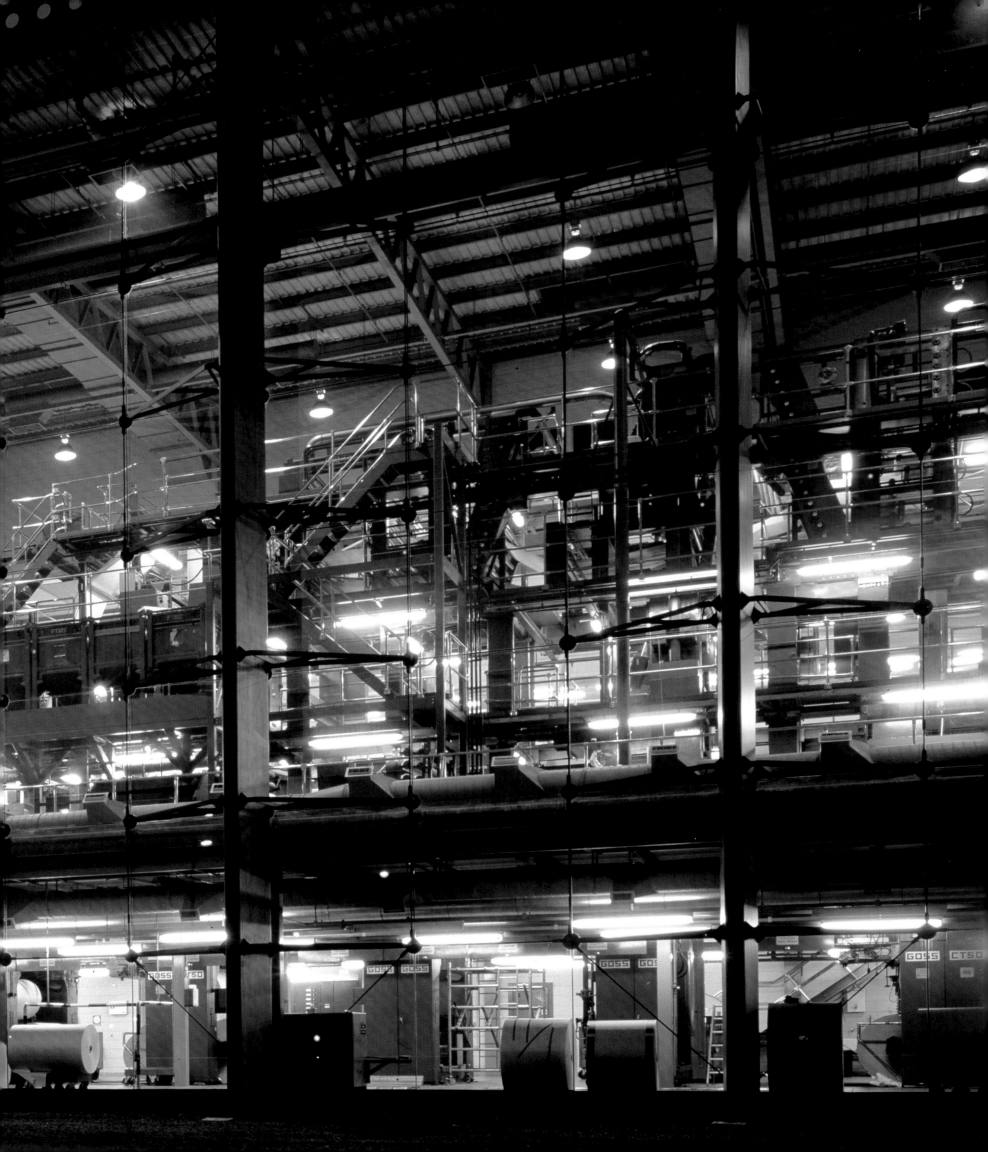

p. 202

p. 204

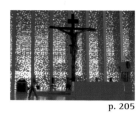

p. 205

p. 206

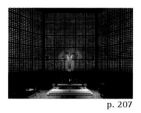

p. 207

pp. 208–9

pp. 210–11

p. 202

Jan Dibbets (born 1941) and Jean Mauret created a modern expression of spirituality in Blois Cathedral by setting lettering against a monochrome background with subtle geometric designs. This approach can also be seen in other recent works, such as the most recent windows for the Sagrada Familia in Barcelona.

pp. 204–5

The Dom Bosco Sanctuary (1957) in Brasilia, built by the architect Oscar Niemeyer, is characterized by a striking blue wall of stained glass, designed by Cláudio Naves and manufactured by Hubert na Doorne.

pp. 206–7

Exterior and interior view of the stained glass surrounding the polygonal Kaiser Wilhelm Memorial Church (Egon Eiermann, 1961) in Berlin, rebuilt after the bombings of World War II.

pp. 208–9

The Louvre Pyramid, designed by I. M. Pei and completed in 1989, serves as an entrance and distribution point for the different areas of the museum. Its use of glass and interior lighting attracts attention and has turned the pyramid into an important meeting place. The glass provides a view of the interior while also making a strong impact on the exterior setting.

pp. 210–11

The Financial Times *building in London skilfully integrates interior and exterior through the use of transparent glass.*

BIBLIOGRAPHY

Adam, S.: *Decorative Stained Glass*, London, 1980

Adams, H.: *John La Farge: Essays*, New York, 1987

Albers, J.: *Glass, Colors and Light*, New York, 1994

Andrieux, C. & P.: *Le vetrate: arte e tecnica*, Turin, 1988

Andrieux, C. & P.: *Vetrate tradizionali: arte, tecnica e restauro*, Milan, 1997

Armitage, L.: *Stained Glass: History, Technology and Practice*, London, 1959

Arnaud d'Agnel, G.: *L'art religieux moderne*, Grenoble, 1936

Baker, J.: *English Stained Glass*, London, 1960

Barral i Altet, X.: 'Arquitectura religiosa dels segles XIX i XX', in *Art de Catalunya*, vol. 5, Barcelona, 1999

Barral i Altet, X.: *Vidrieras medievales en Europa*, Barcelona, 2003

Barral i Altet, X.: *L'art du vitrail, XIe–XVIe siècles*, Paris, 2004

Beyer, V.: *Offenbarung der Farbe, Kunst und Technik der Glasmalerei*, Berlin, 1963

Blanchet-Vaque, C., Ladey, L., Langrené, C., Fabien D. & Viallat-Patonnier, C.: *Vitraux d'ici, vitraux d'ailleurs*, exhibition catalogue, Angle Art Contemporain, September 2001–January 2002

Blondel, N.: *Le vitrail: vocabulaire typologique et technique*, Paris, 1993

Bonnet, P. & Dilasser, M.: *Sculpter la lumière, le vitrail contemporain en Bretagne, 1945–2000*, 2000

Bontemps, G.: *Guide du verrier*, Paris, 1868

Bouchon, C. & Brisac C.: 'Le vitrail au XIXe siècle: état des travaux et bibliographie', in *Revue de l'art*, no. 72, 1986

Bouchon, C., Brisac, C., Chaline, N.J. & Leniaud, J. M.: *Ces églises du XIXe siècle*, Amiens, 1993

Bray, C.: *Dictionary of Glass*, London, 1995

Brillant, M.: *L'art chrétien en France au XXe siècle*, Paris, 1927

Brisac, C.: 'Viollet-le-Duc, cartonnier de vitraux', in *Actes du colloque international Viollet-le-Duc Paris 1980*, Paris, 1982

Brisac, C.: *A Thousand Years of Stained Glass*, Garden City, NY, 1986

Brisac, C.: *Le vetrate. Pittura e luce: dieci secoli di capolavori*, new ed., Rome, 2002

Brown, S.: *Stained Glass: An Illustrated History*, London, 1992

Chagall, M.: *The Jerusalem Windows*, New York, 1962

Clark, B.: *Architectural Stained Glass*, London, 1979

Connick, C. J.: *Adventures in Light and Color: An Introduction to the Stained Glass Craft*, New York, 1937

Corallini, A. & Bertuzzi, V.: *Il restauro delle vetrate*, Florence, 1994

Cowen, P.: *The Rose Window: Splendour and Symbol*, London, 2005

Debenedetti, A. (ed.): *Il vetro italiano 1920–1940*, Turin, 1996

Debuyst, F.: *L'art chrétien contemporain de 1962 à nos jours*, Tours, 1988

Didron, E.: 'Le vitrail depuis cent ans à l'Exposition de 1889', *Revue des Arts Décoratifs*, 1889–1890

Divine, J. A. F. & Blachford, G.: *Stained Glass Craft*, New York, 1972

Donche Gay, S.: *Les vitraux du XXe siècle de la cathédrale de Lausanne*, Lausanne, 1994

Donche Gay, S. & Huguenin, C.: *Le vitrail des années 1930 dans la cathédrale de Lausanne*, Berne, 2003

Duncan, A.: *Tiffany Windows*, London, 1980

Duncan, A.: *Louis Comfort Tiffany*, New York, 1992

Elskus, A.: *The Art of Painting on Glass: Techniques and Designs for Stained Glass*, London, 1980

Evans, D.: *A Bibliography of Stained Glass*, Cambridge, 1982

Forestier, S. (ed.): *Marc Chagall. Opera monumentale: le vetrate*, Milan, 1987

Fornari, S.: *El vetrate di Eva Fisher nel Tempio israelitico di Roma*, Rome, 1981

Frodl-Kraft, E.: *Die Glasmalerei: Entwicklung, Technik Eigenart*, Vienna, 1980

Garcia Martín, M.: *Vidrieras de un gran jardín de vidrio*, Barcelona, 1981

Gerstein, M.: *Lavorare il vetro*, Novara, 1998

Harrison, M.: *Victorian Stained Glass*, London, 1980

Harrison, M.: *Brian Clarke*, London, 1981

Heck, C.: *Conques: Les vitraux de Soulages*, Paris, 1994

Heinz, T. A.: *Frank Lloyd Wright: Glass Art*, London, 1994

Hill, M.: *Stained Glass: Music for the Eye*, Seattle and London, 1976

Kennedy, R. G.: *American Churches*, New York, 1982

Knapp, S.: *The Art of Glass. Integrating Architecture and Glass*, Gloucester, 1998

Koch, R.: *Louis C. Tiffany: Rebel in Glass*, New York, 1982

La vetrata liberty a Milano, exhibition catalogue, Milan, 1990

Lafond, J.: *Le vitrail*, Paris, 1966

Lafond, J.: *Le vitrail: origines, techniques, destinées*, Lyons, 1970

'Le vitrail', special edition of *Metiers d'Art*, nos. 2–4, 1977

Lee, L., Seddon, G. & Stephens, F.: *Stained Glass*, New York, London, 1976.

Longatti, A. (ed.): *Alfonso Salardi: Vetrate 1968–1973*, Lipomo, 1977

Marchini, G.: *Italian Stained Glass Windows*, New York, 1947

Marchini, G. (ed.): *Le vetrate: tecnica e storia*, Novara, 1977

Metcalf, R. & G.: *Making Stained Glass: A Handbook for the Amateur and the Professional*, New York, 1972

Moor, A.: *Contemporary Stained Glass*, London, 1989

Moor, A.: *Architectural Glass Art: Form and Technique in Contemporary Glass*, New York, 1997

Morris, E.: *Stained and Decorative Glass*, London, 1988

Oidtmann, H.: *Licht, Glas, Farbe*, Aachen, 1982

Ottin, L.: *L'art de faire un vitrail*, Paris, 1908

Perrot, F.: *Le vitrail français contemporain*, Lyons, 1984

Perrot, F. & Granboulan, A.: *Vitrail, art de lumiére*, Paris, 1988

Peterson, C.: *The Art of Stained Glass*, Gloucester, MA, 1998

Pezzella, S.: *Arte delle vetrate*, Rome, 1977

Pfulg, G. & Sprondel, G.: *Alfred Mannessier: Les Vitraux*, Romont, 1993

Pichard, J.: *L'art sacré moderne*, Paris, 1953

Pichard, J.: *L'aventure moderne de l'art sacré*, Paris, 1966

Piper, J.: *Stained Glass: Art or Anti-art*, London, 1968

Raguin, V. C.: *The History of Stained Glass*, London, 2003

Remmert, E.: *Jugendstilsfenster in Deutschland*, Weingarten, 1984

Reyntiens, P.: *The Technique of Stained Glass*, London, New York, 1967

Reyntiens, P.: *The Beauty of Stained Glass*, London, Boston, Toronto 1990

Rigan, O. B.: New Glass, New York, 1976

Robin, S.: *Églises modernes: Evolution des édifices religieux en France depuis 1955*, Paris, 1980

Schmitt, M.: *Die Glasmalereien von Anton Wendling in der Kathedrale unserer Lieben Frau Luxemburg*, Regensburg, 1999

Sewter, C.A.: *The Stained Glass of William Morris and His Circle*, New Haven, CT, 1975

Simard, G.: *Verriers du Québec*, Ottawa, 1989

Sowers, R.: *The Lost Art: A Survey of One Thousand Years of Stained Glass*, New York, 1954

Sowers, R.: *Stained Glass: An Architectural Art*, London, 1961

Sowers, R.: *The Language of Stained Glass*, New York, 1981

Stavridi, M.: *Master of Glass: Charles Eamer Kempe 1837–1907*, Hatfield, 1988

Sturm, J. L.: *Stained Glass from Medieval Times to the Present: Treasures to be Seen in New York*, New York, 1982

Tra vetri e diamante. La retrata artistica a Roma 1912–1925, exhibition catalogue, Rome, 1992

PICTURE CREDITS

Achim Bednorz: 150, 151

Aci / Alamy: 23, 76, 77, 85, 92–93, 95, 144–145, 148, 149, 155, 156, 157, 158–159, 176–177, 178, 179, 191, 192, 193, 198–199

Adalberto Ríos Szalay: 98–99

Adam Woolfitt / Corbis: 28–29

Aisa: 166

Album / AKG–images: 167

Album / Erich Lessing: 17, 48, 51

Angelo Hornak / Corbis: 32, 128

Araldo de Luca / Corbis: 196–197

Archivo Iconográfico SA / Corbis: 146

Arthur Thévenart / Corbis: 81, 181

Artur / Renate Ritzenhoff / Bildarchiv Monheim: 195

Artur / Wolfram Janzer / Bildarchiv Monheim: 120–121, 160, 161

Bettmann / Corbis: 112–113

Bildarchiv Monheim: 75

Bo Zaunders / Corbis: 22

Bob Rowan; Progressive Image / Corbis: 43

Carl and Ann Purcell / Corbis: 80

Catherine Panchout / Sygma / Corbis: 106, 107

Charles & Josette Lenars / Corbis: 118, 162

Dean Conger / Corbis: 65

Don Conrad / Corbis: 129

Elio Ciol / Corbis: 88

Eye Ubiquitous / Corbis: 205

Farrel Grehan / Corbis: 132

Florian Monheim / Bildarchiv Monheim: 11, 111, 137, 143, 168, 169

Florian Monheim / R. von Götz / Bildarchiv Monheim: 210–211

Foto Scala, Florencia: 15, 20, 119, 182,

Index

Page references in *italics* refer to illustrations.